3ds Max Modeling for Games

3ds Max Modeling for Games
Insider's Guide to Game Character, Vehicle, and Environment Modeling

Andrew Gahan

ELSEVIER

AMSTERDAM • BOSTON • HEIDELBERG • LONDON
NEW YORK • OXFORD • PARIS • SAN DIEGO
SAN FRANCISCO • SINGAPORE • SYDNEY • TOKYO

Focal Press is an imprint of Elsevier

Focal
Press

Focal Press is an imprint of Elsevier
30 Corporate Drive, Suite 400, Burlington, MA 01803, USA
Linacre House, Jordan Hill, Oxford OX2 8DP, UK

Recognizing the importance of preserving what has been written,
Elsevier prints its books on acid-free paper whenever possible.

Library of Congress Cataloging-in-Publication Data
Gahan, Andrew.
 3ds Max modeling for games : insider's guide to game character, vehicle, and environment modeling / Andrew Gahan.
 p. cm.
 Includes index.
 ISBN 978-0-240-81061-4 (pbk. : alk. paper) 1. Computer animation. 2. Computer graphics. 3. 3ds max (Computer file)
4. Computer games—Design. I. Title.
 TR897.7.G32 2008
 006.6′96—dc22

 2008024133

British Library Cataloguing-in-Publication Data
A catalogue record for this book is available from the British Library.

ISBN: 978-0-240-81061-4

For information on all Focal Press publications
visit our website at www.books.elsevier.com

Typeset by Charon Tec Ltd., A Macmillan Company. (www.macmillansolutions.com)

08 09 10 11 12 5 4 3 2 1

Printed in Canada

Working together to grow
libraries in developing countries

www.elsevier.com | www.bookaid.org | www.sabre.org

ELSEVIER **BOOK AID**
 International Sabre Foundation

To Lisa and Robert

Contents

Acknowledgments

Thanks to:

Laura, Chris, and Georgia and Monica at Focal Press.

Dave Wilson, for being the catalyst to write.

Matt Southern, for introducing me to Laura and getting this started.

The guest writers: Dave Wilson, Dave Griffiths, and Tom Painter.

Mike Engstrom (http://www.engy.org), Simon Nuttall (http://www.iconized.com), Colin Murphy (http://www.lruce.planetunreal.gamespy.com), David Milton, Brook Banham (http://www.middlecott.com), and Andrej Svoboda, for the gallery images and all their help.

Everyone at UVLayout (http://www.uvlayout.com).

Ben Cloward, for the use of the shaders (http://www.bencloward.com).

Ryan Clark at Crazy Bump (http://www.crazybump.com).

Alex Figini for the character concept.

Rachel Norton for the warehouse scene concepts.

Everyone at Autodesk, especially Caroline (http://www.autodesk.com).

And a special thank you to everyone else who helped me along the way by reviewing the chapters and correcting my mistakes.

Finally, thank you, for picking up the book.

Introduction

Why This Book Was Written

This book was written with one single goal in mind: to teach people who are relatively new to 3ds Max how to produce great results in the smallest amount of time possible.

The idea of writing a book came about when I had purchased yet another "how to use 3ds Max" book online without flicking through it first. I purchased the book because I was keen to start researching training for 3ds Max and how people are currently going about learning Max. I started to read through the book and was amazed at what they were teaching, but also overwhelmingly shocked at what they were getting the readers to produce—the end results were shocking, even laughable. I thought to myself, "If that's the way they are teaching how to use 3ds Max, I don't want to learn it."

It's great to know how to do something, but if what you ultimately produce is unusable, then what's the point?

A colleague of mine (Matt Southern) heard my ranting about how I felt about the book and told me that he had been contacted through the IGDA (Independent Game Developers Association) by a publisher looking for writers and that I should do something about it. So many months later, here it is.

As you become more experienced in modeling, you'll discover that there are many different methods of producing the same piece of work. All that I am offering in this book is one particular method for each tutorial: the one that I believe is either the fastest or the easiest or the one that I think produces the best results for the least amount of time.

About the Author

I'll keep this short and sweet, as I know your primary interest is how to model the scene on the cover and start making money as a professional modeler, not to hear all about me.

I started in the games industry in 1992 as a Junior Artist for Digital Image Design. They came to my college, and after seeing my graphic design work, offered me a summer job making games. I jumped at the chance, and without any portfolio or experience at all, started training on my first game. I progressed to Senior Artist, developing flight simulators and military training systems, until the studio was bought by Infogrammes

around 1998. I became Lead Artist when Infogrammes sold the studio to Rage, left and became Art Director at a small startup called Lightning Interactive. I switched again to join my old friends at Evolution Studios (Evolution was set up when Infogrammes bought D.I.D., with Martin Kenwright leaving and taking six people with him). I progressed through the ranks again at Evolution studios, becoming Art Manager on some of the later World Rally Championship games on PlayStation 2, and then to my current role as Producer/Outsource Manager. At the time of this writing, I have completed work on MotorStorm™, Sony's PS3 launch title, and am currently working on MotorStorm 2 and a number of unannounced projects.

If you're interested, here is the list of games that I have helped develop:

- Robocop 3 (Amiga)
- TFX (PC)
- Inferno (PC)
- EF2000 (PC)
- F22—Air Dominance Fighter (PC)
- Total Air War (PC)
- Wargasm (PC)
- GTC Africa (PS2)
- World Rally Championship (PS2)
- WRC II Extreme (PS2)
- WRC 3 (PS2)
- WRC 4 (PS2)
- WRC 5—Rally Evolved (PS2)
- MotorStorm (PS3)
- Pursuit Force 2 (PS2)
- MotorStorm 2 (PS3)

About the Book

There is so much information crammed into just one book, so I have had to keep it as concise as possible. I cover only what you need to complete each tutorial and nothing else. This book is designed to get you up to speed as quickly as possible producing great artwork and is not designed to teach you how to use all aspects of 3ds Max. If you're looking for a book to teach you the ins and outs of Max, then there are plenty to choose from. Personally, I'd rather keep my hard-earned cash and press the F1 key—the built-in help can show you all the functions you'll need to get started.

The book is arranged over nine chapters, starting from getting to grips with the basics, moving onto some low-poly modelling, and culminating into a couple of fairly advanced builds. I've arranged the content of every chapter to be part of a similar theme to enable you to use most of the assets that you learn to build the final showpiece scene at the end. I realize that this approach is slightly limiting, but I decided that it would be best to teach you to model a number of things in the same style rather than a whole load of different things in different styles, just for consistency.

About the Contributors

Here are the guest writers, in their own words.

David Wilson

Over the last three years, I have been involved in the production of Motor Storm™ at Evolution Studios, a critically acclaimed game that has been celebrated for its gameplay and graphical excellence. I have significant next-generation experience and the work I have produced in recent years is the current benchmark for real-time graphics in the games industry.

I have also worked remotely as a freelance artist for clients internationally, building assets for games such as Need for Speed Underground.

I am currently using my game production experience on a BA (Honors) undergraduate degree course in Computer Games Modelling and Animation at the University of Derby, UK. I am enjoying the opportunity for working with people who have raw enthusiasm about games and are at the beginning of their journey in games development. I want to shape the way that students understand games and develop the relevant skill sets needed by the next generation of artists.

David Griffiths

I have been in the games industry now for over ten years. I graduated from Blackpool & The Fylde College (part of Lancaster University) in the UK with a degree in Technical Illustration. I started my career in the automotive industry, working freelance on site for a company called I.V.M. in Germany. I moved naturally into games, starting out with flight simulators. Some of my notable roles in the games industry have been working as a Lead Artist for Pandemic Studios in Santa Monica, California, when I worked on Star Wars: The Clone Wars. On Clone Wars, I was able to add to the Star Wars Universe, where I designed the TX-130 Fighter Tank and the G.A.T. vehicles (amongst many others), which were used in other games, comics, story books, and have even been made into model kits. The Fighter Tank has a very strong fan base, which is cool. Mercenaries was another great game to work on for Pandemic and Lucas Arts; it hit every major console. I have also had the privilege to work on the smash PS3 hit MotorStorm.

Tom Painter

As a child, I would waste many a sunny day on my ZX spectrum and Amiga; by the time I was a teenager I had developed an addiction to Street Fighter 2 that was roughly equivalent to that of a bad drug habit. Encouraged by my father, I decided I would pursue a career in games.

After my studies, I got my first break in the games industry as a pixel artist working at Tiertex on Nintendo Game Boy Advance titles. When Tiertex dissolved, I joined Evolution Studios as an environment artist for the WRC series of games on the Playstation 2.

Introduction

In 2005, I moved to Pandemic Studios in Australia to work on Destroy All Humans! 2. I changed roles to become a character artist working on Saboteur and two top-secret titles in progress (project B and project Q).

Now it's 2008 and I've just founded Big Man Production, a specialist-character production company working for clients in the videogame and advertising industries.

I love working in 3D, because the job never gets boring—there's always something new to learn, or new ideas to implement.

Let's get started!

Chapter 1

Low-Poly Asset 1 (30-minute tutorial)

Introduction to Modeling

This first tutorial is designed to get complete beginners up to speed on the basics of modeling using primitive objects and applying textures in the simplest way. In the games industry, we lay out the textures in a slightly different way than in this tutorial. You'll learn that technique in Chapter 2, which covers more complex mapping techniques, but to get any complete beginners through their first complete object build, I have explained the most straightforward method first. This chapter also introduces you to some of the preferences, settings, and shortcuts that will speed up your modeling and give you better results.

Setting Up 3ds Max

To begin with we'll start with some basic settings for 3ds Max. Go to Customize > Preferences > Files. Enable Auto Backup, set number of Auto Backup files to 9, and set Backup Interval (minutes) to 10 (see Figure 1.1), then click OK.

Next we'll set up the units we'll be modeling in; these vary from studio to studio,

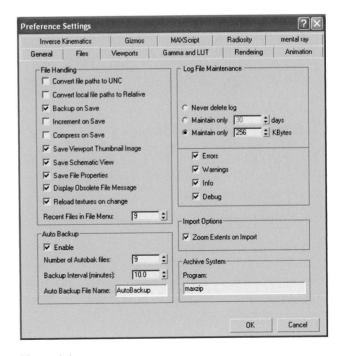

Figure 1.1

but in this book, one unit equals 1 cm. Go to Customize > Units setup … and, select Metric, and then click OK.

We will now begin to model a simple object. First, we'll create a primitive object and scale it approximately to the correct dimensions. We will then apply texture maps to the object, UVW map it, and do some quick renders of it using 3ds Max's built-in scan-line renderer.

If you don't understand what I mean by "UVW map", search for the term using the new InfoCenter, or press F1 for help and search for the term "Unwrap UVW Modifier"—it explains everything you need to know about this. This goes for anything you don't understand or aren't sure of—just search through the help feature and it will all be explained to you. Feel free to browse the help too. You'll find lots of cool things that would otherwise take you many years to find out on your own.

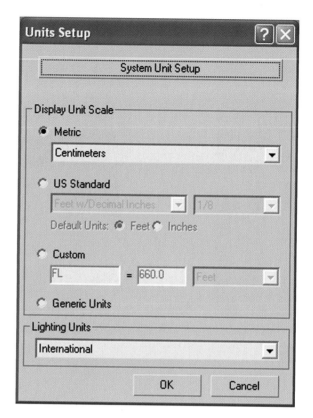

Figure 1.2

Creating a Cardboard Box

First we're going to create the box (Create > Standard Primitives > Box) and set the dimensions to 45 × 45 × 50. If your box is being displayed in wireframe in any of your viewports, just right-click in the viewport and press the F3 key.

With the box selected, right-click it and select Convert to editable mesh from the Quad Menu.

Now you need to save your progress. Always name your files with a relevant name to make it easier to find your assets later. As this is the first save file, we'll create a few folders to store all the files that you'll be working on while using this book. Go to save the file (File > Save as …), create a folder called 3D Modeling for Games, then create another folder inside the one you've just created called Chapter 1. Now save your file as Cardboard box1.max or Chapter1_001.max.

We have completed the modeling part of this tutorial. Now we have to apply the texture maps to the faces of the box and our first asset will be complete.

Figure 1.3

Figure 1.4

3ds Max Shortcuts

There are a few viewport configurations to help you to speed up the mapping of the box. Go to Modify, click the Configure Modifier Sets button, and select Show Buttons from the menu.

This action displays a set of buttons beneath the Modifier List rollout menu that can be configured to have all your most often used modifiers. Set the Total Buttons value to 10 and add Edit Mesh, UVW Map, and Unwrap UVW to the buttons, as we will use these modifiers the most in the first few chapters of the book. Do this by finding the modifier on the alphabetized list and drag it onto the button. To find a modifier on the list easily, just keep typing the first letter of it on the keyboard and you will cycle through all the modifiers with that letter (for example, press "E" for Edit Mesh). Then click OK to close the Configure Modifier Sets window.

Figure 1.5

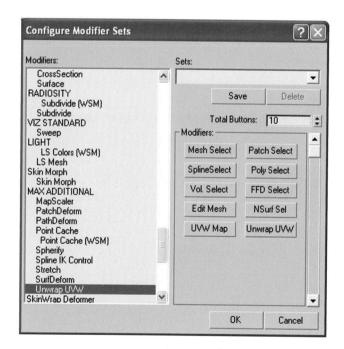

Figure 1.6

Texture Mapping Your Box

With your box still selected, go to Selection, click Element, and select the box. This should highlight all the faces (press F2 to toggle the highlighted selection).

Now click UVW Map from your newly created modifier set and check Box Mapping from the Parameters menu.

Next, right-click UVW Map in the Modifier stack and select Collapse All from the pop-up menu, then click Yes—you want to continue at the prompt, as we don't need to preserve the stack in this instance.

With your box still selected, click on the Material Editor (on the top toolbar) and change the standard material to a multi-sub object material as shown in Figure 1.8, clicking OK to discard the old material. If you keep the old material by accident, don't worry—it doesn't matter either way in this instance, as we are creating new ones.

Figure 1.7

Figure 1.8

To keep this first tutorial simple, I have already prepared the texture maps that you'll be using from photographs. In Chapter 3, we will cover this process in a lot of detail, showing how to take photographs, how to modify them in Photoshop, and how to apply them to models.

To add the textures into the material editor, select the material ID from the vertical list and load in the texture map for each side of the box. Although there are ten materials displayed in the editor, we'll just use the first six listed: Material #2 through Material #7 in my case. Yours could have different names, depending on how you have used 3ds Max previously. Don't worry if your names don't match mine at this point, as they can be renamed.

Click on the first material in the list, next to ID 1 (Material #2 in my case) and assign a Bitmap material to it. To do this, click the small square button on the right of "diffuse" in Blinn Basic Parameters, select Bitmap from the top of the pop up menu, and click OK.

Figure 1.9

Now load Box1_top.jpg from \Chapter 1\Textures\ on the accompanying DVD.

There are two ways to assign the next material to ID 2. The first way is to click on the Go To Parent button, then click the Go Forward To Sibling button (as shown in Figure 1.11a and b).

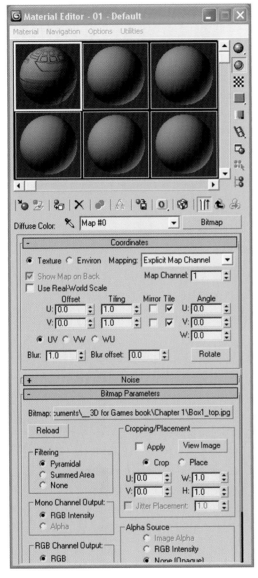

Figure 1.10

Figure 1.11a

Figure 1.11b

The second method is to click the Go To Parent button twice, then select the second material in the list (as shown in Figure 1.11c).

Then repeat the process of clicking the small square button to the right of "diffuse" in Blinn Basic Parameters, selecting Bitmap from the top of the pop-up menu, and clicking OK.

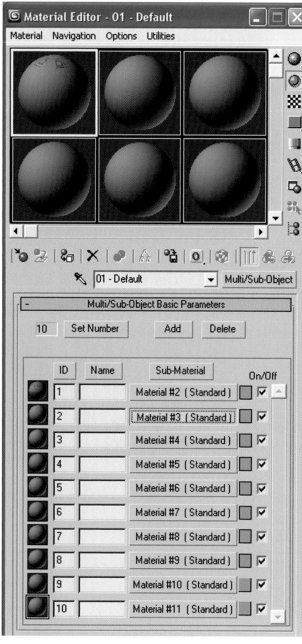

Figure 1.11c

As you assign each material a texture map, click the Show Standard Map in Viewport button () so that when you Assign Material to Selection, the textures are visible on the object.

Repeat this process for ID 2 through ID 6, loading the remaining five texture maps into the material editor and ending with Box1_base.jpg being assigned to ID 6.

Here's how they should be assigned:

ID 1 — Material #2 — Box1_top.jpg
ID 2 — Material #3 — Box1_sid1.jpg
ID 3 — Material #4 — Box1_ sid2.jpg
ID 4 — Material #5 — Box1_ sid3.jpg
ID 5 — Material #6 — Box1_ sid4.jpg
ID 6 — Material #7 — Box1_base.jpg

Remember that your Material number may differ from the numbers I have. As long as you match the ID (number)—for example, ID 1 goes with the corresponding texture map, in this case Box1_top.jpg—you'll be okay. Also *make sure* that you remember to select Show Standard Map in Viewport .

Now that we have assigned texture maps to all of the materials, we will apply the material set to the box and apply the material IDs to the faces of the box, allowing us to see the texture maps.

With the box still selected as an editable mesh, click the Assign Material to Selection button to assign the material set that you've just set up to the box you're mapping. At this point, you should see that a lot of the box's faces now have texture maps on them. These currently correspond to the default face IDs, which are not necessarily the ones we want, so let's go through and check each face of the cube individually to make sure that the correct texture map is applied to the correct face on the box.

For this model, we must do this carefully, as some of the packaging tape on the box wraps around onto the adjacent faces. Look out for mistakes when you complete the model.

To get the correct map onto the correct face, first select the face of the box that is on the top of the box in the perspective viewport. Go to Selection and select Polygon. Scroll down from selection until you get to the Surface Properties rollout box and in Material, make sure that Set ID: is set to 1.

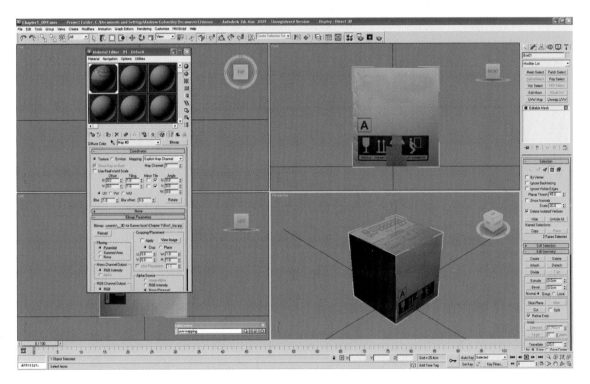

Figure 1.12

In the perspective view, select the polygon on the left-hand side and assign the ID to 4. Depending on how the box mapping oriented each of the box faces when we mapped it, the texture map may not be oriented the correct way. If this is the case, we'll need to modify the UVW Mapping coordinates to correct it.

From the Modifier List, click the button Unwrap UVW, which adds the Unwrap UVW modifier to the modifier stack. Below the modifier stack, adjust the vertical scrolling menu until you find Parameters. Once you have found the Parameters section, click Edit. The Edit UVW window will pop open.

From the pull-down menu at the top right of the new Edit UVW window, click on the rollout and select Map#1 (Box1_side1.jpg). Now we need to select all of the vertices (left click, drag bounding box around all

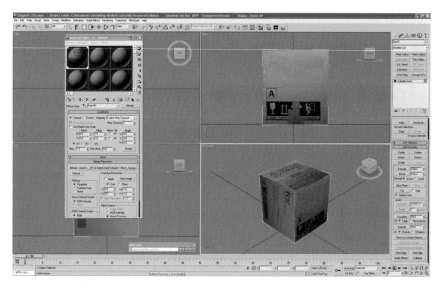

Figure 1.13

Figure 1.14

vertices, then release the left mouse button). You'll know if you've gotten them all as they all change to a red color (see Figure 1.15).

Now we need to rotate all the vertices to the correct orientation on the cardboard box, but first press the "A" key on the keyboard to activate the Angle Snap shortcut. We rotate the vertices (select Rotate at the top left

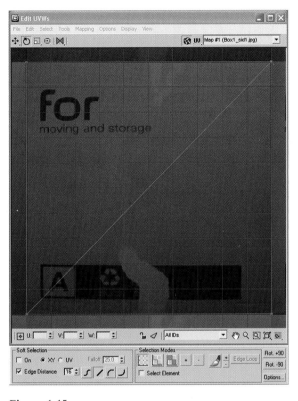

Figure 1.15

of the Edit UVW window) until the text on the texture map is the right way up on the cardboard box model in the viewport.

There are a few options that I like to set to help me see the map more clearly when doing this type of mapping. At the bottom right-hand corner of the Edit UVW window, click Options. This step brings up some extra settings for editing the UVWs. Uncheck Tile Bitmap and set brightness to 1, which is useful in that it will help you see the texture sheet a lot more clearly. This option can also be set from the top menu, by selecting Options > Preferences (Ctrl + O) and adjusting it in the Display Preferences menu.

Next, right-click Unwrap UVW in the modifier stack and select Collapse All, then select Yes to clear the stack.

Now we'll continue mapping the rest of the cardboard box. Left-click on Editable Mesh in the Modifier Stack and press the "4" key on the keyboard (the shortcut to Select Polygon).

Figure 1.16

Other useful shortcuts of this type are:

1 = Select Vertex, 2 = Select Edge, 3 = Select Face, 4 = Select Polygon, and 5 = Select Element.

With Edit Polygon selected, select the other visible front polygon in the perspective view.

Repeat the mapping and unwrapping procedure on the second side that you can see in the perspective viewport, but this time, set the ID of the face of the box to ID 3.

To see what you are doing more clearly in each of the viewports, right-click on the name of the viewport and select Smooth and Highlights from the pop-up window.

Figure 1.17

On this occasion, the second box side texture map on my model is the correct way up, so there is no need for me to unwrap the UVs. If yours doesn't match this, repeat the previous process.

To help you to see the model more clearly while in the Perspective view, click on the Maximize Viewport Toggle (bottom right of interface). Now click on Arc Rotate Selected (to the left of the Maximize Viewport Toggle) and rotate the object so that you can clearly see the rear two sides of the cardboard box. You can also close the material editor or minimize it for a good look at all sides too. Feel free to have a play with the new floating controllers (in the top right) of each viewport to change your view, too.

Select the polygon on the left and assign it ID 2. If the texture map is not orientated correctly, quickly right it by following the mapping procedure from mapping the first side of the box (Unwrap UVW, Edit, Select Map#2 box_sid1.jpg, select vertices, rotate to correct orientation).

Collapse the stack again, press "4" and select the fourth side to map. This time, set the ID to 5 and adjust the UVW mapping, if necessary, so that it matches the example.

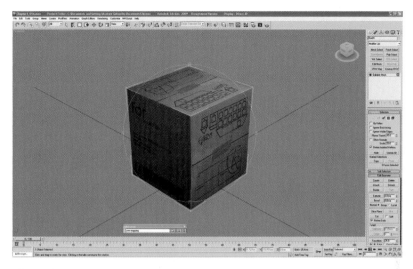

Figure 1.18

Figure 1.19

Finally, rotate the Perspective view (Arc Rotate Selected button) and select the bottom polygon of the cardboard box. Set the ID to 6 and adjust the mapping, if necessary. On this side of the box, pay close attention to the packaging tape on the texture map and make sure that it lines up correctly with the tape wrapping around onto the sides of the box. Once you're happy with it, that's it—you're done. Congratulations on completing this model!

Figure 1.20

Figure 1.21

Common Problems

When building assets like this one, always make sure that all of the texture maps are the same size and resolution. Differences in resolution have a massive impact on the quality of your finished model, and even if the maps are supplied to you, always check their size and color depth to make sure that they match where they should.

With models containing patterns that wrap around the object, make sure that they line up correctly on all sides.

Rendering Your Model

To produce quick renders of your model for an object database or for a progress portfolio, first we need to set up the environment.

At the top of the screen, select Rendering then Environments and Effects from the dropdown menu, or alternatively press "8" for the shortcut. For this type of quick render, I usually set the Global Lighting Ambient to around 150, the Tint to approximately 200, with the intensity at 0.5, and the background color set to something neutral or close to white (around 230). In this case, as I'll be using the render just to put in a progress portfolio, I'll be using 230 for the background. It will help the object stand out and will be a lot less messy to print in color.

Figure 1.22

Once you're happy with the settings, close the Environment and Effects window and rotate the viewport until you're satisfied that the view is showing off the best of the model. I like the detail in the cardboard on the top of the box and I also like the staple details with the rips on the sides, so they will be most prominent in my render.

Go to Rendering, Render or type F10 as a shortcut, opening up the parameters for the scanline renderer. In Output Size, click the 800 × 600 button and click the Render button (bottom right of parameters pop-up). You should now have a render of your cardboard box. If you want a render that is

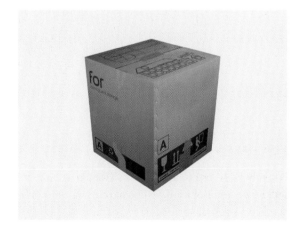

Figure 1.23

of a slightly higher resolution, instead of clicking the 800 × 600 button, click the Image Aspect lock button and type in 1920 (or whatever size you like) and press Return and then the render button. You can render images at any size you like.

Try adjusting the Ambient light, Tint, and Background color settings until you render an image that you're happy with. But keep the render nice and clean if it's for a portfolio. You can always add it to a themed style sheet in Photoshop for your final portfolio later. Keeping it clean will enable you make any style changes later on a lot more easily.

Moving On to Chapter 2

In the next chapter, we will be building a slightly more complex asset. You will learn how to lay out the texture map, making the most of the available area, and we will also look at a slightly more complex method of laying out the UVs for the texture. We will be using some new tools to create the new asset including Slice, Extrude, and Scale, and we will be producing another render for your portfolio.

Well done for getting to the end.

Chapter 2

Low-Poly Asset 2 (1-hour tutorial)

Modifying Primitive Objects and UV Mapping

Congratulations, you're at Chapter 2 already! Hopefully, you've managed to complete the first tutorial without encountering any problems. If you skipped the tutorial, try to at least flick through it so that you know what we've covered, especially the 3ds Max setup information and the UVW mapping. As we have to cram so much into this one book, we will not be repeating things. Because of this, I advise you to complete the tutorials in order so that you don't miss anything, even if you know what you are doing. There could be something important that you miss, which could cause problems for you later on, if you don't understand it.

On to the second tutorial. This time we will be creating another primitive object and using a lot of different actions, including: Editable Poly, Select and Uniform Scale, loading background images, keyboard shortcuts, object properties (see-through and backface cull), Boolean (Cut & Union), deleting faces, and Target Weld for vertices.

Let's get started. For this tutorial, we will use some reference photos (already provided in \Chapter 2\Textures\) to build a fairly simple model. It will involve slightly more modeling than the first tutorial and a little more complex mapping. We will use the reference photos as a guide to model from, and we will use them again to create the texture map.

First, open up 3ds Max and start with a new scene (File > New, select the new all and click OK). The first thing we need to do is load the first photo into 3ds Max to use as a guide. While in the Top viewport, press Alt + B to import a background image.

Make sure that you check the options Match bitmap, Display background, and Lock zoom/pan. From Files on the DVD, open Img_0301.jpg from \Chapter 2\Textures\, then click OK. You could also create a flat plane of polygons and map the image to it for reference.

You should now see the photograph of the top of a dirty plastic barrel in your Top viewport. Go to Create > Geometry, make sure that Standard Primitives is selected, and click on Cylinder. Then click in the

Figure 2.1

Top viewport, approximately in the center of the barrel in the photo, and create a Cylinder that is roughly the circumference of the barrel. Don't worry about the height at this point, as we will adjust it in a moment. Next, set the parameters to 12 Sides and 3 Height Segments. Click Select and Rotate and rotate the cylinder so that the top and bottom edges are horizontal as shown in Figure 2.2.

Now maximize the Top viewport (Alt + W) so that the top view is full-screen. Go to Modify and right-click on Cylinder and convert to Editable Poly.

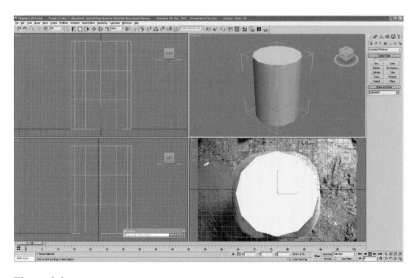

Figure 2.2

Figure 2.3

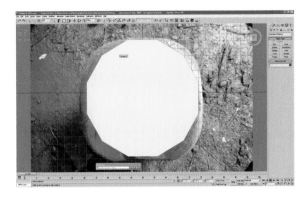

Figure 2.4

Feel free to modify the cylinder so that it matches the photograph more closely (as pictured in Figure 2.4) using Select and Uniform Scale and Select and Move from the top toolbar. Click Editable Poly and select Vertex, if it's not already selected. We need to make the cylinder slightly squarer to match the photo by selecting groups of vertices and moving them either horizontally or vertically. The completed shape doesn't have to be perfect, so don't spend too much time getting the form right. I used Select and Uniform Scale and selected four groups of vertices at a time. When you're finished, the object should look roughly like this image:

Click Alt + W again to reveal the other viewports and we'll open up another image to use as a guide. While still in the Top viewport, click Alt + B and uncheck Display Background (because we are finished with that image).

Right-click on the Front viewport and zoom out from the barrel using Zoom Extents (in the bottom-right corner) and the left mouse button. If you aren't sure what any of the buttons on the toolbar are, just hover the mouse over them for a second and a pop-up dialog box will tell you. We've zoomed back from the image slightly; now we need to import another background image (Alt + B).

Figure 2.5

Load in Img_0300.jpg from\Chapter 2\Textures on the DVD; this time, uncheck Lock Zoom/Pan and then click OK.

As this photograph was taken from a different angle to the model we're building, I've unchecked Lock Zoom/Pan to let me rotate the object and zoom in and out. This will allow me to set the right height for the cylinder, which we'll now call the "barrel". Click Select and Rotate from the top toolbar and rotate the barrel 90 degrees, so that it lies on its side. If angle snap is off, turn it on (press the A key) before starting to rotate the barrel. You should be left with something that looks like this:

Figure 2.6

Using Select and Move, as well as Select and Uniform Scale, move the barrel over the photograph and set the height of it, so that it looks like this:

Figure 2.7

We have the basic dimensions of the barrel, we can start to model the details and make it look a bit more realistic. As this is a low-poly object, we won't be adding lots of details—just enough to round off the edges and add the handle shape on the top. The rest of the detail will come from the texture map.

We need to create the slight curves to the top and bottom of the barrel. To do this, we will scale the center vertices on the x-axis. Click Editable Poly, go back to the Front viewport, and drag-select the center vertices. Click Select and Uniform Scale and drag them out so that they look something like this:

Figure 2.8

Click Editable Poly again to turn it off. Click Select and Rotate and rotate the barrel back 90 degrees into the upright position that it was in earlier. Click Alt + B and turn off Display Background. Finally, click Zoom Extents All (Shift + Ctrl + Z).

If you like, you can click in each viewport and click F3 to toggle Wifeframe/Smooth + Highlight and also click F4 to toggle View Edged Faces, so that you can see your work so far more clearly. For details on the other shortcuts on the F (function) keys and all the preset shortcuts in 3ds Max, go to Customize > Customize User Interface and scroll down the list to see what the default hotkeys are. You can also assign your own here. If you make any changes, remember to save the settings.

Let's get moving. In the Front viewport, type 1. This selects Vertex in Editable Poly (try pressing the keys 2, 3, 4, and 5, one at a time, to see how these work as shortcuts). Type Alt + W and then drag-select all of the very top row of vertices and then Ctrl + drag-select the very bottom row of vertices. Click T for Top viewport and click Z for Zoom Extents.

Click Select and Uniform Scale and scale the vertices in to give a slight bevel to the top and bottom of the barrel. If you drag towards the center of the barrel when scaling, look at the coordinates at the bottom of the

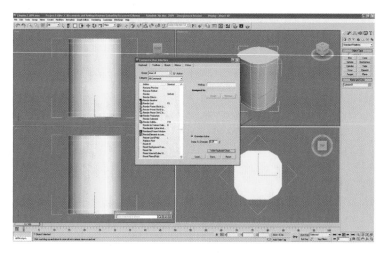

Figure 2.9

screen (just right of center). Drag until you hit 90 percent, which should look about right. Again, you don't have to be especially accurate on this.

Click F to go to the Front viewport and scale the same set of vertices a little on the y-axis until your barrel looks something like this:

Figure 2.10

There are two ways we can go with the build at this point. We could leave the model as it is now and create a texture map for it, and call that complete (which would be reasonable for a low-poly object), or we can model some detail on the top. In this case, we'll model the detail on the top, as I want to show you a really cool tool called Boolean.

Type T to select the Top viewport, then F3 to see the wireframe of the barrel. Click Create > Standard Primitives > Cylinder and make sure that Height Segments is set to 1 and Sides is set to 12. Click in the center of the barrel and create a cylinder that is about half as wide as the barrel. Type F for the Front viewport and then Shift + Ctrl + Z to Zoom Extents. You should now have the barrel and also a cylinder in the scene. Click Select and Move, and move the cylinder up so that it intersects with the top of the barrel, something like this:

Figure 2.11

Remember to save your work regularly as you model. It's really easy to get swept away with the progress, and you can spend many hours on something—only to lose it all in a crash. Try to save regularly and have the autoback function set (see Chapter 1). We all usually only remember to save just as our computers crash, which is obviously too late.

Performing the Boolean

Let's move onto Boolean. Select the barrel and press P (for the Perspective viewport) and F3 if the meshes aren't Smooth and Highlight–shaded. Click Create. Where Standard Primitives is displayed, click on the rollout menu and select Compound Objects.

You should see Morph, Scatter, Conform, ShapeMerge, Boolean, and others. Boolean is a powerful tool and can be quite confusing until you get the hang of it. First, you need two objects; it works best with solid "closed meshes"; that is, where there are no holes in the mesh. These are called Operand A and Operand B—think of these as Shape A and Shape B. There are four different types of Boolean in 3ds Max 2009: Union, Intersection, Subtraction, and Cut. If you search for "Boolean Compound Object" in the 3ds Max 2009 help (F1) or the

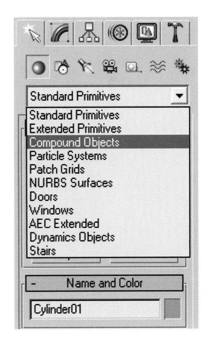

Figure 2.12

InfoCenter, it explains what all these are in detail. It is well worth reading the explanation and then creating two objects in a different file and playing with the different types to see what results you can get.

For this model, we will be using Cut. With the barrel still selected, click Cut from the Operation selection on the right of the workspace, then click Pick Operand B (choose the other shape), and then click to select the cylinder, as shown here:

Figure 2.13

This step will cut the barrel with the shape of the cylinder, but leave you with a solid mesh.

To finish off the Boolean work, click on Modify, right-click on Boolean, and select Edit Mesh.

Figure 2.14

Figure 2.15

Fixing Your Mistakes

One of the most important parts of modeling something that you haven't modeled before is that you may not build it perfectly from start to finish, and you may have to modify your work. This approach can be a lot quicker than going back to a save file or (even worse) rebuilding something. If you've followed the tutorial accurately up to this point, you will have made a small mistake that was included deliberately on the last action. Before we performed the Boolean, it would have made progressing easier if we had rotated the cylinder that we were using to cut, so that the top and bottom edges were horizontal. Rather than going back to a previous save file, we'll just fix it at the polygon level.

First, you need to be in the Top viewport. Make sure that the barrel is still selected and type 4 to go into polygon mode. To make sure that you have the center polygons selected, press F2 (Shade Selected Faces Toggle) to display what you've got selected. If you don't have a mouse with a scroll wheel, it's a good idea to get one, as the wheel can be used to zoom in and out of the scene.

We need to rotate the polygons only a small amount, but looking at the barrel, it's impossible to see which way it should be. So we need to have a look at the edges of the polygons. Press 2 and drag-select the whole barrel. This step will show you how you where all the hidden edges are.

There are two ways to line the polygons up the way we want them. The first is to select just the edges we want to rotate and then rotate them, but the quicker way is to press 4, make sure the center polygons are selected, and rotate them making sure that angle snap (A) is on.

Figure 2.16

Figure 2.17

Figure 2.18

25

Figure 2.19

As you can see by the shadows that have appeared on the surface (smoothing), we have turned some of the polygons so that they now overlap. We just need to type 2 to modify the edges again and then select Turn from the Edit Geometry toolbar on the right.

Then we just need to click on the edges that are cutting through the corners of the central circle of polygons on the top of the barrel, turning them so that the polygons no longer overlap. If you see any other particularly long and thin triangles, you might want to turn the edges of those too, to tidy up the mesh.

Next we will add the final details to the top of the barrel. First, let's extrude the center polygons to create the dip in the top of the barrel; then, we'll create a simple handle form.

Figure 2.20

Press P to jump into the Perspective window, then Z (Zoom Extents) so that you can see what you're doing. Buttons like Zoom Extents (Z) have a small triangle in the corner to show that they have multiple options. Left-click and hold on the triangle and the various options will be made available. In this case, there are two options: Zoom Extents and Zoom Extents Selected. I usually prefer Zoom Extents Selected, as it zooms into the selected part of the model only, usually making it easier to work. Have a look at all the other buttons and get familiar with what they do—getting up to speed with these early will save you a lot of time.

Figure 2.21

Next we need to Extrude the top center polygons to create the sunken form of the top of the barrel. Still in Editable mesh, select Extrude from Edit Geometry, then click on the center polygons (select them if they have been unselected), and drag the mouse towards you. This will create the extrusion. Obviously, if you had clicked and pushed forward when extruding, you would have created the same form, but as an addition to the geometry rather than a subtraction. Next, just scale the polygons to create the indentation on the top.

Now, we need to create a handle. We'll use Boolean again, as it's nice and quick. From the Top viewport, create a new cylinder in the center of the barrel. Give it eight sides and one height segment, and rotate it so that the top and bottom edges are horizontal. Then convert it to an Editable Mesh and scale it to the rough shape of a handle. Make sure that the handle shape intersects with the barrel shape, as we will be using Union, but also that it stays in the center of the barrel and doesn't overlap the sloped edges of the indent. Just before you perform the Boolean, select the barrel instead of

Figure 2.22

the handle. As before, select Create, Compound Objects, Boolean and make sure that Union is selected, click Pick Operand B, and then click to select the handle. Don't worry if the barrel suddenly changes color. It is just picking up the material from the cylinder (meaning that you didn't select the barrel before picking the handle as the Operand B). If this happened, just undo and try again. As we'll be texture-mapping the barrel, the color of the base material doesn't matter, but you may pick up some properties from the handle that could affect the way we map the barrel, so make sure you have the barrel selected before you click Operand B.

As we left a small gap between the handle and the edge of the barrel on the top of the barrel, let's join that up next. First select Modify, then right-click Boolean and convert to Editable Mesh. As we're not sure what the Boolean has done to the mesh, let's have a look by going to Edge select (press 2) and drag-selecting all the edges on the top of the barrel (or using Ctrl + A). As you can see, there are a few of really thin polygons

around where we join the handle and the barrel together, so let's clean them up by selecting Edit Geometry and Turn. We'll turn each of the long edges until we get something that looks like this:

Remember to confirm that Ignore Backfacing is selected so that you don't accidentally turn edges on the back of the object by mistake. Errors like this can be quite time-consuming to fix if they go unnoticed—as you won't really want to use Undo if you've done a lot of modeling. Extra care should also be taken when welding vertices, as the errors can be difficult to undo if unnoticed.

Figure 2.23

Now we're going to weld a couple of vertices to make the handle look a little more realistic and like the reference. First, select Edit from the main toolbar at the top of the screen and select Object Properties to open a pop-up box. In Display Properties, check Backface Cull and click OK. By checking Backface Cull, all the polygons will be displayed only as one-sided. Next, we need to delete a few polygons and weld the vertices to fill the hole. If you weld the vertices first, you may unknowingly create some inner-facing polygons. Not only will these affect the smoothing on

Figure 2.24

the object, but they can also make some of the UVW unwrapping confusing. Now let's delete the unwanted polygons. Rotate the barrel until you can clearly see the far side of the handle. Now we're looking to delete the three polygons that make up the join between the handle and the edge of the barrel. Type 3 to select Face Selection and make sure that you can see which faces you have selected. Select the six faces and click Del to delete them.

Next, we need to fill the gap by target-welding the vertices. Hit 1 to go to Vertex selection and select Target from the Weld menu. Select the vertices on the open edge of the handle and drag them onto the vertices of the edge of the barrel. If the vertices seem to be sliding on a single axis, press F8 and then try again. You should now be able to move the vertices on multiple axes. Even without clicking F8, if you were to drag the cursor onto the correct vertex to weld, it would still have done it correctly. If you rotate the barrel

around, enabling you to see the back of the handle to complete the weld accurately, you should end up with a shape like this:

Now that we have the basic form of the top of the barrel, we need to compare it to the reference photo again and manipulate the top vertices so that they match the photo. Type T for Top Viewport and then Alt + B to load up the background image. Select Img_0301.jpg \Chapter 2\Textures\ and select Lock/Zoom Pan and Display Background and click OK.

Figure 2.25

There are a couple of different ways in which we can manipulate the model and still see the reference photo. One is by pressing F3 to toggle wireframes, and the other is to set the image so that it is see-through. With the object selected, right-click on it to open up the Options fly-out. In Transform (bottom right), select Object Properties, select See-Through from the Display Properties, and click OK. This option changes the look of the object, enabling you to see both the polygons as well as the reference photo behind it. Now we just need to match up the vertices with the photo using Select and Move and also

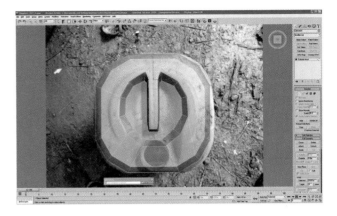

Figure 2.26

Select and Uniform Scale. To accurately select the lower vertices to taper the handle, jump into Perspective view and select them individually before returning to the Top viewport to spread them out.

The last part of modeling that we need to complete before we start texture-mapping is the flattened area around the spout. In the Front viewport (shortcut F), make sure that the top of the handle is flush with the top of the barrel and that the vertices are laid out similar to Figure 2.26.

Press F3 and rotate the barrel forwards slightly. Select the two edges on the top of the barrel nearest to you and move them down so that they are level with the indent on the top of the barrel. Once we've selected the edges, we need to jump back to the Front view (shortcut F) so that we can see how far we need to move them down. Hit F3 to make this easier. Moving these edges down has highlighted how a few of the edges need to be turned so that the curves on the barrel look more realistic.

Press F2 and then Ctrl + A to display all the edges. Have a look to see whether you can improve some of the curves by turning edges. This isn't important; it just improves the form of the model when viewed from some acute angles.

Texture Mapping the Barrel

Now we need to move on to texture-mapping the barrel. This time we will be using just one texture map to map the whole of the barrel. Again, the texture map has been created from the reference photos, but this time all the

Figure 2.27

photos have been blended together in Adobe Photoshop as they would be for use in a game. We'll cover creating textures from photos in the next tutorial, but for this one, use the texture map that I've already created.

First of all, let's get rid of the background image and return the barrel to solid shading (Alt + B, uncheck Display Background Image, click OK. Then right-click on the barrel, select Object Properties, uncheck See-Through, and click OK).

Figure 2.28

Next we need to open up the Material Editor (on the top toolbar or click M). Then click the map button next to Diffuse in Blinn Basic Parameters. In Blinn Basic Parameters, click on the box next to Bitmap to load the texture and select Drum001_004.tif (on the DVD under \Chapter 2\Textures\) and click Open. Next, click Assign Material to Selection; you should see the texture map applied to the barrel object.

You can now close the Material Editor. At this point, although we have applied the texture map to the object, the only mapping coordinates on the barrel are from when you initially created it, so we need to apply new ones. We'll map the sides of the barrel first and then we'll map the top and bottom.

Go to the Front viewport (F) and Zoom Extents so that you can see the whole barrel. If the top of the handle is sticking out above the barrel, select the vertices and drag them down so that they are level with the top of the barrel.

Select Editable Mesh if it isn't selected already and then select Edit Polygon (shortcut 4). Drag select all of the barrel's side faces, including the small bevels on the top and bottom. Take care not to select the extra polygons that make up the handle detail on the top.

Next, click UVW Map from the modifier list (refer to Chapter 1 if you haven't completed it) and check Cylindrical in Parameters > Mapping. On this model, we will try to wrap the top mapping over smoothly from the sides, so we also need to check Flip in the V Tile Mapping parameters. Press F3 and go to Perspective view to see what you have.

Although the mapping looks really rough and there seem to be parts of the barrel

Figure 2.29

map everywhere, we should at least see the texture map wrapping continually around the sides of the cylinder.

Next, we're going to slightly rotate the mapping on the sides of the barrel so that the top and the sides line up. Rotate your view around the barrel so that the handle is pointing away from you and then click on UVW Mapping in the modifier stack to select the sub-tree (which will turn yellow to indicate the mode change). Then choose Select and Rotate and rotate the mapping (not the model) until the handle on the map roughly lines up with the handle on the model (even though it is below it).

Figure 2.30

Next, we'll adjust the UVW coordinates so that the top and bottom details on the texture map are no longer seen on the sides of the barrel. Select Unwrap UVW from the modifier list and then select Edit from the Parameters rollout. The Edit UVW box should appear on screen.

Now go to the top right-hand corner, open up the drop-down menu, and select the texture map, which is map #1 in the list. This step shows the texture map and also how the polygons are laid out on it.

We now need to move some of the vertices around in the Edit UVW window so that the texture map fits our barrel model a little better. First select the bottom two rows of vertices in the window and move them vertically up just past the top details on the texture map. If you hold Shift down while you move them, they will move in a straight line up or across.

You can close the Edit UVW window now and have a look around your barrel. You

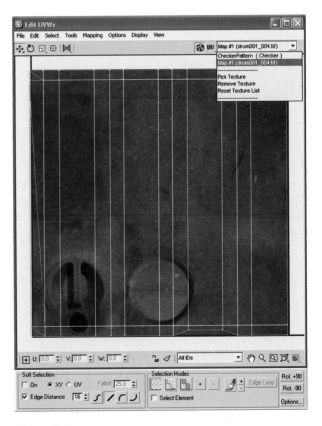

Figure 2.31

should now see that the sides of the model are mapped. All we have to do is map the top and bottom and we're pretty much done.

As the top and bottom mapping will be pretty much the same, we can use one planar map to apply mapping coordinates to both the top and bottom. We will then unwrap them separately, as we have just done.

Now we will add Edit Mesh to the stack from the Modifier List (the button above UVW Map, refer to Chapter 1 if it isn't there). Then press 4 to edit polygons and from the top menu choose Edit > Select Invert (Ctrl + I) to select all the remaining polygons to map. You should now have all the polygons on the top and bottom of the barrel selected.

We now need to go to Top viewport (shortcut T) and click UVW Map and make sure that Planar is selected in the Mapping Parameters.

Scroll down the right-hand side to Alignment and select View Align. The texture map will be aligned to the Top viewport, not the model's transform. Select Fit (still in Alignment) so that the texture fits to the selected polygons only, with no overlap.

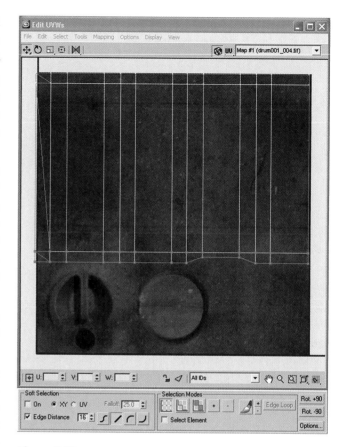

Figure 2.32

Finally, in Mapping, as we know that the top and bottom only take a small amount of the texture page, we can set the U Tile to 0.3 and the V Tile to 0.3. This step makes unwrapping the UVs a bit easier, as they are now closer to their final position. You should now see the texture map for the top of the barrel almost aligned.

Select Unwrap UVW (from the modifier list), then select Edit and pick Map #1 from the drop-down menu in the Edit UVW window that appears. Using Zoom Region, we need to get in close

Figure 2.33

to the vertices so that we can adjust the UVs accurately. Click Ctrl + A to select all the vertices. Now we can scale them up so that they fit the rough shape of the barrel a little better. Don't worry too much about getting them pixel-perfect at this point, we can always fine tune them later. You should end up with something like this:

We can now close the Edit UVW window and have a look at what we have so far. To really see what we've got, we need to add another Edit Mesh to the Modifier stack and press F4 so that we can see the joins in the mapping between the top of the barrel and the sides.

Figure 2.34

Without using programs like Maxon's BodyPaint 3D (http://www.maxon.net), it is extremely difficult to create textures that wrap seamlessly around 3D models, so don't worry too much if you can see a slight edge. Most imperfections like this will never be seen in a game, so we don't dwell on them. If however, you are working at a studio and this problem arises…well, you know what to put on your purchase request.

Now we're on the home stretch. All we need to do is adjust the UVs on the bottom of the model and we're done—or almost done.

Jump into the Front viewport and deselect all the polygons on the top of the barrel (hit F and then Ctrl + Alt + Z) and deselect the polygons on the top of the barrel (click Select Object and while holding Alt, drag and deselect the top polygons). Click P for perspective view, rotate the barrel so that you can see the bottom polygons, and we'll map the last part.

Once again, select Unwrap UVW from the modifier list, select Edit (from parameters), and select Map #1 from the drop-down menu in the Edit UVW window that appears. All we need to do now is to slide the vertices along to the right to match up with the bottom of the barrel, and we're almost done. Now click Ctrl + A to select all the vertices and move them into place using the Move tool.

Once again, close the Edit UVW window, apply an Edit Mesh to the model,

Figure 2.35

and press F4 so that you can see the model fully mapped. If there are any areas that look stretched, select the polygons and edit the UVW unwrapping until you are happy. Render the model in the same way that you rendered the cardboard box from Chapter 1, print it, and add it to your portfolio.

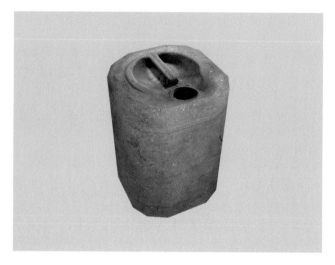

Figure 2.36

Congratulations! You've completed the second chapter and I hope that you learned a few new techniques. With the skills that you've learned so far, you should be able to make almost any low-poly object. So well done—you're on your way.

Chapter 3

Creating Texture Maps from Photographs

In this tutorial, I cover the basics of creating texture maps from photographs. We'll be creating the type of texture maps that we used in the cardboard box and plastic barrel tutorials. We will then create some alpha maps and a model to put one of the maps on to.

Camera

The first thing to consider when taking photographs to be used for texture map creation or reference is what camera to use. When I was in charge of camera equipment at Evolution Studios, almost every time someone new asked to sign a camera out, I was asked, "Which camera can I take?" My response was always, "Which camera do you know how to use?" All too often, when given a choice of cameras, most people will take the most expensive, or the one with the most megapixels, or the one with the biggest lens. Well, you would too, wouldn't you? But there is absolutely no point if you don't know how to use it.

So we need to take some photos to use as reference. If you don't have a digital camera, you should probably think about buying one if you're serious about doing 3D professionally. You don't need to fork out thousands on 12-megapixel SLRs; a decent compact digital camera will do, at least for now. As I've been doing this professionally for fifteen years, I have a few to choose from, but one of my favorites is a little Canon Digital ELPH (or IXUS in some countries). These ultra-compact cameras are great because they have a flash and a reasonable zoom, and they are small enough to put in the pocket of your jeans, so you will never miss a photo opportunity. I always carry a Canon ELPH with me wherever I go.

Photo Shoot

Ideally, you should try to take reference photos on a neutral day. A light overcast day is ideal, as it means that you won't have any shadows on your photograph. England is great for this, but if you live in one of the sunnier areas of the world, pick a time when there aren't long shadows across everything that you want to photograph.

Taking photos in bright light or where there are a lot of shadows on the subject matter can mean that you have to do a lot of retouch work (sometimes many days' worth), as you'll need to go through and retouch every image you want to use as a texture. It may be worth postponing the photo shoot to another day, if you can, to prevent this kind of extra work.

One final point to consider when you are taking reference photos is that if you see something that is really good and you can't miss taking a photo of it, remember to take more than one shot. When you see a great photo opportunity, it's a terrible shame to stop the car and take the shot, only to find out when you get home that it wasn't properly exposed or that you shook the camera, or whatever. If it's worth stopping to take one shot, it's worth taking a few.

There is a fantastic book written by Luke Ahearn called *3D Game Textures: Create Professional Game Art Using Photoshop* (Focal Press, ISBN-10: 0-240-80768-5). If you are new to modeling or creating texture maps, I highly recommend that you buy this for your bookshelf. It covers most aspects of creating texture maps and how to use them, in far more detail than I can do in one chapter here.

Creating the Cardboard Box Texture Map

On to the texture creation for a cardboard box. I chose this model for its simplicity. The model had only six polygons, which we mapped with six separate texture maps. I have included a number of photographs of boxes which I have taken in fairly good conditions. These can be found on the DVD under \Chapter 3\Source Files\ box photos\. As in the first tutorial, we are not too concerned with laying out all the sides of the box on one texture sheet; we're just quickly throwing the textures out, for you to get modeling quickly.

If you can, take some photos of something yourself, instead of using the ones provided on the disc. This is a great habit to get into, and you'll learn far more by completing the whole exercise yourself. You'll also be able to add this model to your portfolio if you use your own photos, which we will cover in a lot more detail in Chapter 9. From whatever source, you should have six photos of a box-like object. You may have decided to take photos of a cereal box, a DVD player, or even a piece of furniture, but as long as you have some photos of a square or rectangular object, we can progress.

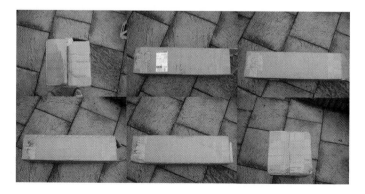

Figure 3.1

Next, upload the first photograph into Photoshop and drag some rough guide lines around the straight edges of the box. We're going to use these to make sure the box is square when creating the texture. Then, using the Rectangular Marquee tool, select an area around the box in the photo and crop the image. Make sure that you don't crop to the guidelines—we need a little extra to play with.

Figure 3.2

Figure 3.3

With the cropped area still selected, use Edit > Transform > Skew to line up the edges of the box roughly with the guide lines. Once the box texture is approximately squared and the Skew modifier hasn't distorted the image, crop it at the guidelines.

Figure 3.4

Figure 3.5

If the box has slightly rounded corners, use the Clone Stamp tool or the Healing Brush tool to tidy up the edges and corners of the image. Then go to Image > Image Size and rescale the image to a size that we can use in game.

In this case I've selected 256 × 256 pixels. This size might be considered fairly large for a lot of game engines, for such a small asset, but as this will be primarily for a portfolio composition, let's keep it quite high. You don't have to scale the proportions down at all, but it helps to make scenes more believable if all the pixels in the scene are approximately the same size.

To explain this a little more, if your next asset to be built were half the size of this box, you would probably want to use a texture map that is half the size. That way, if they are positioned next to each other in the scene, one won't look like it's of a higher resolution than the other.

After repeating this exercise with all the other photos of the box, you should be left with a set of six new texture maps. You could speed up this process by taking only a photo of the top of your box and a photo of one of the sides and then using only two textures on the box that you build. This is a great trick for texture memory usage in a game (you'll use much less texture memory) and you'll also be able to complete the build in a fraction of the time.

Here are the completed textures:

Figure 3.6 *Top*

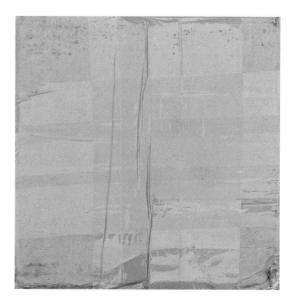

Figure 3.7 *Bottom*

Figure 3.8 *Side 1*

Figure 3.9 *Side 2*

Figure 3.10 *Side 3*

Figure 3.11 *Side 4*

Creating the Barrel Texture Map

First, open up the reference photos from the DVD (\Chapter 3\Source Files\Drum Photos\. You definitely need Photoshop for this part of the texture creation process, as you'll have to use some of Photoshop's tools to create the seamless blends. You should see that we have a top and bottom for the barrel and also four side photos.

What we are going to try to do is to recreate the key parts of the barrel from the photographs provided and fit it all neatly onto a 1024 × 1024 texture page. This time, instead of cropping each photograph and using the resulting image for each side of the model as we did with the cardboard box, we're going to blend key parts of some of the photographs together to make something that looks believable and is also laid out neatly. In the games industry, it's very important to have very efficient texture pages. An efficient texture page uses up as much of the page as possible and does not have lots of gaps or unused space that the model doesn't use.

As you can see from this flower image, there is the least amount of texture map waste around the flower as

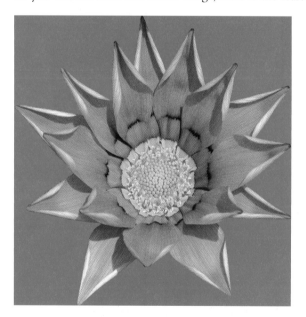

Figure 3.12

possible (shown in green). This is a good example of minimizing waste on a texture sheet. Although there is quite a lot of waste (shown in green), it is the least amount possible to produce the right effect.

There are a few different ways by which to create texture maps for models like this, but here is the method that I think is most appropriate for this exercise. First of all, we need to think about how the barrel texture can be laid out or unwrapped. We want to represent the key components of the photos and we want the barrel to look as realistic as possible when we finish.

For this model, I think that there should be three main parts to the texture map: the top, the bottom, and the sides. To make the model look realistic when it is mapped, we want as few joins on the texture map as possible, as all of the edges on this model are rounded. If we were modeling an asset like the cardboard box again, this issue wouldn't matter, as the joins on each of the sides are hidden by the corners and also by the smoothing groups. But for this model, we'll need to treat the edges differently.

Although the barrel shape has flat sides, its corners are rounded, so in this instance we should consider mapping the sides with cylindrical mapping. This means that the texture for this part of the model needs to "tile" (that is, to wrap seamlessly around the model). With this in mind, we will dedicate most of the texture page to the sides, but we'll also make sure that it covers the top area of the texture completely (from left to right) so that we can use the Offset tool in Photoshop. This approach will enable us to tile the texture and thus to seamlessly map all the sides on the barrel.

To keep the texture resolution roughly even across the model, allow the top and bottom of the barrel around 30 percent of the height of the texture page as shown in Figure 3.13.

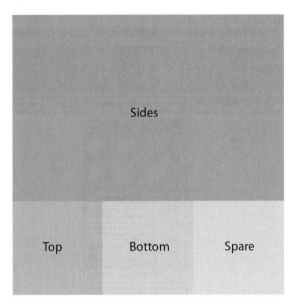

Figure 3.13

Dividing up the texture map in this way should give us plenty of room for the top and bottom details and also enable us to tile the side's part of the map easily in Photoshop. It does, however, leave us a small area spare. We can use this for any extra details that we haven't thought of yet, or maybe a label or some other feature not on the source photo. Dividing up the texture page in this way will mean that we will not be using each side of the barrel directly from the photograph. As texture pages need to be either square (512 × 512) or divisible by two (1024 × 512), we would have to cram and stretch the four sides of the barrel into this area, which wouldn't really work, as it would cause distortions.

A texture that is divisible by two could be used, which would give us plenty of room for the four sides and the top and bottom, but again we would still be stretching the photo reference to use the texture page efficiently, so we will opt for the first layout, as it is closer to the reference.

Obviously, if you never intend to put your texture maps into a game engine, you could make them any size or shape you like. The best way to do this is to model your barrel, then take screen grabs or wireframe renders

Figure 3.14

of the front, sides, top, and bottom, and use them as a guide for your map. There are also other plug-ins and tools that help, but these are the simplest methods to get you started.

Let's get started with the texture map creation. First, open up the reference photos from \Chapter 3\Source Files\Drum Photos\ on the DVD and copy and paste the components that you'd like to see on your texture map into a new Photoshop file. Once you have the main components for the sides, crop the image and save it out. Next, flatten the image by going to Layer > Flatten Image. This step should give you with a nice canvas to start to work on.

Figure 3.15

Next, use a combination of the Clone Stamp tool (shortcut S) and the Healing Brush tool (J) to cover up the parts of the texture map that we don't want. Start with the really dark areas and the lines that don't line up by replacing them with the more generic parts that we do want. If you have an older version of Photoshop, you'll probably just have the Clone Stamp tool. Don't worry—you'll do just fine using that.

If you haven't used these tools before, here are some basic instructions. Start by holding down Alt and left-clicking the area of the texture map that you want to clone from, then just left-click and hold to paint over the area that you want to change. Experiment with the opacity settings of the tools for varied effects.

One thing to watch out for when creating texture maps with these tools is not to repeat obvious areas of the texture. This sort of repetition really stands out and ruins the illusion of your model being real. Any bright spots or dark creases should only exist once or be completely removed. The horizontal lines around the barrel should be removed too, as we'll add these back in later.

Figure 3.16

As you can see from this image, after only a few minutes of cloning and healing, the texture map is starting to take shape.

Continue this process until you have eliminated all the areas of the texture map that we don't need and you have a fairly generic barrel texture. If the Healing tool is taking a long time to calculate, just resize the image so that it is smaller and use slightly shorter brushstrokes; this should improve the update speed.

Figure 3.17

Let's next make sure that the image tiles. To do this, we use the Offset tool in Photoshop: Filter > Other > Offset and select an offset so that the join mark is roughly in the center of the image.

Use the same Heal and Clone tools to remove the join line down the center of the texture map. Once the join is removed, we can either leave the texture map as it is or offset it back to its original position. I always like to offset it back, but there's no need, as this texture map now tiles on the horizontal axis. Once finished, you should end up with something like this:

Figure 3.18

Figure 3.19

Now we need to add the other details of the texture map. As we didn't create the first part of the texture page with any size considerations, let's do that next. We need to start to lay out the texture map so that the new components will be in the right place and at the right scale. We need to create a new image to lay out our map, so create a new file measuring 1024 × 1024 pixels. Go to Edit > Preferences and set the rulers to measure in pixels, then press Ctrl + R to show the rulers, if they are not already displayed. We next need to create a few guidelines to help us with the proportions of the rest of the texture. To do this, click on the ruler on the left hand side of the image and drag a guide out to 341 pixels. Just drag it out to approximately 341 pixels and use the Move tool (V) along with the Zoom tool (Z) to make it accurate. Do this again from the left margin to 682 pixels and again from the top margin to 682 pixels. This should give you perfectly measured guidelines to fit the top and bottom of the barrel on the texture map.

Next, cut out the top and bottom of the barrel from the photo reference and lay them out in the gaps on the texture map.

Figure 3.20

Figure 3.21

Figure 3.22

Then clone and heal the areas around the top and bottom of the barrel so that they blend into the surrounding area. You can adjust these joins once you have the texture mapped onto the model. We might make these areas slightly lighter or darker, depending on their corresponding edge on the model. We then fill in the blank space on the map with base texture or we can choose to leave it blank, so that we know there is some spare room on the texture map, should we come back to this model in the future to make changes or add details.

Finally, create a new layer and draw the dark and light lines across the sides to suggest that there is extra detail where there isn't—and our texture page is complete.

Creating Alpha Maps

"Alpha maps" are partially transparent maps used for 3D models that need to create the illusion of complexity without having lots of polygon detail. One of the most popular uses for alpha maps is foliage (trees, bushes, and plants). For instance, when creating the illusion of lots of trees in an in game environment, if we were to model

and texture every leaf on a tree, not only would it take the artist a long time, but it would also be expensive for the 3D engine to run. If you needed to show thousands of trees in a game, then the problems would be thousands of times worse. Alpha maps do not come without cost, but they are usually preferable than this approach, called "poly modeling", where thousands of instances of the model are to be used.

So, to create an alpha map from a photo, we first need to take the reference image. It can be really useful if the photo is taken with a neutral background to the image. Good examples include taking a photo of a tree against the sky, holding up a white sheet behind a bush, or even just photographing leaves against a white foam board. Obviously, smaller items like chocolate bar wrappers or leaves can just be scanned, but remember to make sure that they are clean before you scan them. We don't have to use a photograph to create alpha maps: we can also create them from scratch in Photoshop or a similar graphics package.

Once you have the reference image to create the alpha map from, remove all of the extra pixels on the photograph that you don't want to be included on the image. For this step, I use Photoshop again. Open the image in Photoshop. (If you are using an application other than Photoshop, you should really think about upgrading, as it is the industry-standard package for this type of work.) Once you have the photograph loaded up, create a duplicate layer of the image. I always create an extra "empty" layer beneath my duplicated background layer, which I fill in neon pink or green so that I can clearly see what I am taking away and what parts of the photograph remain.

Remove the parts of the photograph that you do not want to see on the 3D model in the alpha map. I tend to use the Magic Wand tool or the Eraser tool for this. There are a number of plug-ins for Photoshop that help to do this, such as Fluid Mask 3 from Virtus, but the Magic Wand and Eraser tools work well enough for most artists.

Figure 3.23

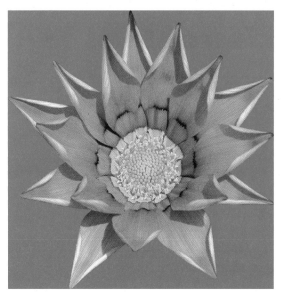

Figure 3.24

Once you have the flower cut out, use the Magic Wand tool to select the empty area. Go to Select > Inverse so that you now only have the flower selected. Finally, use Select > Modify > Contract and contract by 1 pixel. The reason we are reducing the selection by 1 pixel is to prevent a halo on the areas around the edges of the alpha.

Create a new layer with a white background (RGB 255,255,255) and fill the selected area in black (RGB 0,0,0). The white area of this layer will be the part of the texture we see in game on the alpha map and the black area will be the transparent part. The RGB values are important when creating alpha maps, as 0,0,0 is completely invisible and 255,255,255 is completely opaque, so if you were to choose values between, they would be semi-transparent.

We now need to copy this whole layer (Ctrl + A and then Ctrl + C) and then copy it into an alpha channel in the Channels tab (next to the Layers tab). To do this, click the Channels tab and then click on the tiny arrow on the right-hand side, just right of the Paths tab. This will open up a fly-out box. Click New Channel on the fly-out box and name the channel Alpha 1 (it may default to this). Paste the alpha information into this channel by using Ctrl + V. The final thing to do is to invert this channel so that the flower part is white. To do this, go to Image > Adjustments > Invert or just use the shortcut Ctrl + I. Our alpha channel is complete. Now we need to save the image as Flower.tga.

Figure 3.25

It's important to save this image with a TGA extension, as it is a lossless format, but more importantly, TGAs support the alpha content of the file via the alpha channels, which will be picked up in 3ds Max. You could also use PNG or DDS for your alpha maps, but they are not as straightforward and therefore aren't covered here.

Alpha Maps in 3ds Max

To view this map in 3ds Max, create a simple primitive object and apply our Flower.TGA texture map to it. First we need to open up 3ds Max, go to Create > Box, create a box of any dimensions, and then hit Z to Zoom Extents All. With the box still selected, go to Modify > UVW Map > select Box from the mapping parameters.

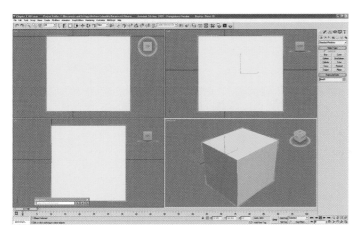

Figure 3.26

Next, open up the Material Editor (shortcut M), click Diffuse > Bitmap, and then load \Chapter 3\Source Files\Flower.tga from the DVD. Still in the Material Editor, click the Assign Material to Selection and Show Map in Viewport buttons and you should see the flower image mapped neatly on all sides of the box.

Next, click the Go To Parent button in the Material Editor and open up the Maps rollout menu. Check the box on the left of Opacity and then click the None button to the right to open the Material/Map Browser window. Double-click Bitmap and open up the Flower.TGA file as before. This time, in the Bitmap Parameters select Alpha in the Mono Channel Output box. This basically tells 3ds Max that we want to alpha this bitmap. Go to Rendering (click F10) and then click the Render button; you should see our flower alpha map clearly rendered against the background (which I have made light grey in Figure 3.27).

Figure 3.27

Alpha maps can be used on models with any number of polygons. As long as you take care to lay out the UVs properly, you can work with any number of polygons and bitmaps, just like any other type of modeling. Alpha maps can also be separate files to the diffuse texture and don't need to be in an alpha channel defined within the TGA file. They can be other file formats, too. The reason we use TGAs (or DDS) for alphas is that we don't need to define and load a separate alpha map into the game engine, which makes it more economical, but it also means that we don't load up the wrong alpha map or delete or modify it by accident.

Next we'll create another alpha mapped model to be used in a scene in Chapter 8.

Creating a Tiling Alpha Map

For this exercise, we will create another texture map from a photograph, but this time we'll make it tile in both the X and Y axes. We need to start with some source material. We're going to make some chicken wire from this reference photo:

Figure 3.28

As you can see, it's not the greatest reference photo in the world, but often you have to make do with what you can get your hands on, and this is a good example of making something good from very little.

Start to build up a reference library of your own by filing good reference images when you find or take them. This habit will help you immensely if you turn professional. Most artists that I know have a secret stash of photos that they've taken throughout the years of stuff that they've either needed in the past or that they think will come in handy at some point.

Common models like traffic cones and street signs often come in handy for populating all sorts of virtual worlds, so if you take a good set of reference photos once, they can serve you for many years. Construction vehicles like diggers and tractors come in handy too—not to mention generic trees and plants. As you travel around, keep your camera handy and build up your collection. Remember to organize your photos so that you know where everything is, or even meta-tag them so that you can search them like a database.

Let's move on with the texture map. Just like with the flower alpha map, make a copy of the background layer and add a brightly colored layer in between so that you can see what you're erasing. Take out all the areas of the map you don't need. For this particular map, it's probably best if we just use the Eraser tool (E) instead of the Magic Wand tool, as the pixels that we want to delete are closely matched in color to the ones we want to keep.

Figure 3.29

Keep on erasing until all you have left is the chicken wire part of the texture. Create a new image measuring 512 × 512 pixels and paste our piece of chicken wire on it. Using all the tools we've used before (Copy and Paste, Clone, Skew, Offset…), keep working on the texture until you have a basic tiling pattern.

Figure 3.30

Figure 3.31

Use the same techniques as earlier to create the alpha version of the texture and add it to the alpha channel of a TGA file or save it as a separate alpha TIF file.

It's good practice at this point to fill in the bright neon color with one a little closer to the chicken wire color; this step will help prevent halos or green pixels from showing on the model if your alpha map does not match perfectly.

Finally, we need to create a chicken wire model onto which we will map the texture. Here is the texture mapped onto a simple box, tiled ten times in both the U and the V.

Figure 3.32

Figure 3.33

Congratulations! You've now completed Chapter 3—well done. You should now have the ability to create most primitive objects in 3ds Max and also to create texture maps for them in Photoshop.

At this point, feel free to move on or to play around with what you have learned so far. And don't feel that you have to rush on to Chapter 4. You will probably retain all the stuff you've learned so far much better if you go over it a few times, so maybe before you move on, practice what you've learned and reread these first few chapters—it might help speed you along in the long run.

The next chapter is the first one from a guest writer in this book. Davie Wilson, a lecturer from Derby University in the United Kingdom, covers the theory and construction of Normal Maps.

Chapter 4

Normal Mapping

David Wilson

Introduction

A "normal map" is the latest buzzword for artists creating assets for next-generation videogames. These maps are used to increase the level of detail and fidelity in modern videogames. Creating a normal map is an additional process that increases the amount of time to create an asset. Normal maps are applied to a model like a texture, but a common mistake is to treat them as conventional textures. There are a number of reasons why your approach to creating and applying normal maps should be different from conventional model construction and texturing. This chapter explains the concept of normal mapping and how to create and implement normal maps efficiently and effectively.

There is more than one type of normal map. We will focus on the most common type used for games development. This is a "tangent-space normal map", or "tangent map". You can identify this type of normal map easily, as it is mostly blue in color.

It's All in the Lighting

An object appears three-dimensional because of how it is lit. The contrast between the parts of the objects that are lit and the parts that are in shadow define the form.

The shapes illustrated in Figure 4.1 are the same; the shape on the left has no lighting attributes, whereas the shape on the right has lighting and shading applied, and it is quite clear to see that the shape has a three-dimensional form.

Figure 4.1

The Role of the Normal Map

Having an understanding of how games are lit will help you to understand how to use normal maps. Game lighting tries to replicate real lights in an economical and simplistic way. Each surface on a model has a normal direction (imagine a perpendicular line extending from the surface of the polygon). See Figure 4.2.

If the normal direction is aligned with the direction of the light, it receives the maximum light value. However, if the surface is facing the opposite direction, it receives no lighting values and therefore is in shade.

Modern games that implement normal maps use a "per-pixel lighting engine". In a per-pixel lighting engine, normal maps are used to describe the normal direction of each pixel of an object. They do this by using Red, Green, and Blue channels in the texture to store a directional value that describes their normal direction in either x, y, or z. The example below is a normal map which represents a hemisphere.

The red and green channel uses a grayscale value ranging from black to white to represent the normal direction along the x and y axes. In a tangent map, the blue channel can represent only a positive value, so the grayscale value represented ranges from 50 percent gray to white.

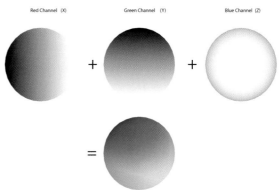

Figure 4.2

Figure 4.3

When these values are combined, they create a normal direction for each pixel applied to the model. This is interpreted by the lighting engine as to how the surface should be represented when lit. These details react to lighting in real time as if they are actually modeled into the surface. The detail of a normal map is restricted only by the resolution of the pixels applied to the model and the compression used in the texture.

Using Normal Maps in Practice

There are two main types of detail that normal maps are used to represent; these can be categorized as follows.

High-frequency detail

These are small surface details like scratches, lumps, and bumps. These are typically produced from images using an automated process, because modeling this type of detail would be time-consuming.

Low-frequency detail

This type of detail describes the overall form of a complex object that typically can be projected as surface normal information onto the UVs of a game resolution object of less detail. The resulting normal map gives this object the appearance of having a higher level of detail to describe its form. This process is time-consuming, as two models have to be created to produce the final result, so it is usually reserved for organic or feature assets. For this reason, this technique is popular when creating characters.

These techniques can be combined to create more complex normal maps that are created in a realistic timescale.

Creating a Weathered Door with a Tiled Normal Map (2 Hours)

The following tutorial will focus on how to create a normal map for a simple scene asset. The important difference between this type of object and a character is mainly time. When making games, you are always working with a deadline. A character that is central to the action could take up to a couple of months to create. It would undoubtedly be constructed in high resolution first and the details from this model would be projected onto a game resolution version using a normal map; it would have a complex shader network with many texture maps. In contrast, an environment or scene asset would be part of a collection of assets and therefore would not have the same level of time allocated to it.

In this exercise, we will create a door with some panel detailing. This door is part of a dilapidated warehouse scene, so it must look relatively scruffy. This is straightforward to model and texture and it serves as a good host for the type of normal mapping process common for a simple game asset. By the end of this tutorial, you will have created a door with a tiled normal map that will have been created using a combination of surface transfer techniques, as well as by generating normal mapping detail directly from bitmaps. In reality, given that this door is meant to be weathered, I would probably choose to not tile it but instead would make the texture unique. However, this exercise demonstrates the process of tiling a normal map on a simple object well, and this is a valuable lesson to learn for your own projects.

Following are some reference photos of a door; these can be found in \Chapter 4\images\ref\ on the DVD. The first task is to look at the details.

Figure 4.4

55

The door on Figure 4.4 will be used to help create the detail for the normal map. The image shown in Figure 4.5 will be used as reference for the weathered and distressed look of the door that will be applied to the final model.

Figure 4.5

Let's create a normal map for this door. The door has a natural repeating form; therefore, it is relatively easy to create a repeating tiled texture. The following figure is a good example of high-frequency detail. The grain of the wood would take far too long to model; because this detail does not form any complex shapes in the surface, it is an ideal candidate for automatically generation from the photographic reference.

Figure 4.6

Figure 4.7 is an example of how low-frequency and high-frequency detail can be combined.

Figure 4.7

To get the best representation of the panel relief, this detail should be modeled and then projected onto a game detail surface. This type of detail would be very hard to replicate using an automated process.

Figure 4.8 shows a quick test of the effect of converting an image into a normal map, to qualify our reasons for using two different processes to create the door.

This preview is taken form Ryan Clark's Crazy Bump software (we will discuss this later). The normal map has been generated from Figure 4.9.

Figure 4.8

Figure 4.9

As you can clearly see, the high-frequency detail has transferred really well. The low-frequency detail is more confused as to how it should be displayed. This process interprets highlights and shadows as height information. This does not work very well on any forms that go beyond simple surface detail, as these tend to have shadows baked into the texture. This is why modeling these shapes in 3ds Max and combining them together at the end will give us the best result. With that in mind, let's open 3ds Max.

Creating a Reference Model

First, we'll create a reference box that defines the size of the door (it's important that we get a good idea of the scale of the object that we want to create). We'll apply a reference-tiled texture to it. This process will allow us to see where any extra faces need to be added to allow the texture to tile correctly. Follow these steps:

- Open 3ds Max.
- Go to File > New.
- Create > Standard Primitives > Box.
- Drag a box in the front viewport.
- Set the following values in the Parameters rollout. The values are approximately the size of a door in millimetres.

 Length: 2000
 Width: 800
 Height: 50

Applying a Texture

A template of the texture is created from a photo of the door. We will use this as guide for laying out our UVs to tile correctly. It is just for layout, so it's saved as a JPEG with the dimensions 1024 × 512. It is advisable to use power of two textures, as that is what will be used in the final game texture. Also I recommend making the textures double the size that they are expected to be for the game; this allows you more options for changing them if necessary.

Figure 4.10

The above texture is the reference tile that will be used as a template for our normal map. To check whether it will correctly tile when complete (see below), it is color-coded, so that it is easy to see how it should tile. When tiled across the model you should end up with something that looks like Figure 4.11.

Although this looks like a bit of a mess, it is useful to lay out the tile in Photoshop and create markers that will help define UV layout. These markers help with orientation and scale. They show where seams will occur, so I can plan to blend those areas. I will apply this to the reference model that we have created to show how the door should look when the UVs are correctly placed. Preparation time here prevents fundamental mistakes from being made later.

Here's how to apply a material. First, press the M key to call up the Material Editor. In the available material slot, open the Maps box (by clicking on the plus sign). Click on the diffuse map slot to open the material map browser. Click on the bitmap. Now navigate to the folder containing the door_fulltile.jpeg image (\Chapter 4\images\ on the DVD). Click Open. In the Material Editor, your texture should be applied to a material slot. To view it on your door model, click on the Show Standard Map in Viewport button (it should be highlighted yellow when active).

Figure 4.12

Figure 4.11

Figure 4.13

Now select the material in the slot and drag it onto your door shape. You should now have your material displayed on the reference door object like Figure 4.13:

We can now use this material to help create the actual door model.

Creating the Door Model

We will split the model into parts, which will allow it to tile more convincingly. This is more work than just applying a texture over the whole mesh, but will save us texture space.

Create a copy of the model. Hold shift down and move the model to one side (in the front viewport). Right-click on the model and select Convert to > Convert to editable mesh. Apply a blank material to this mesh (this will make it easier to work with). In the Modify panel, rename box02 to Door.

Figure 4.14

Figure 4.15

In the Selection drop-down, click Vertex mode.

In the Front viewport, set the top row of vertices and pull them down level with the point on the reference mesh where the tile repeats, as shown in Figure 4.15.

Switch to Face Mode. Select the top face of the box (it may be easier to do this in the Perspective viewport). Under Edit geometry, click Extrude and pull up the face level to the top of the reference box (as shown in Figure 4.16).

This will be your door. We now need to create a material for this model that has the un-tiled version of the texture to help us set up the UVs correctly. You can do this by applying the Door_setup.jpeg (from the DVD under \Chapter 4\images\) image to the map slot in the current material that you have applied to the door model. This is the same method with which you created the full tile material previously.

Setting Up UVs

Go to the Modify tab. From the modifier list, add a UVW modifier and make sure that it is set to Box in the Parameters section. Right-click on the model and select Convert to > Convert to editable mesh. Under Selection, select Face Mode and select the largest face on the front of the door (the upper one).

Now select Unwrap UVW from the modifier list (by selecting Face, only this face will be affected by this modifier). Under Parameters, select Edit to bring up

Figure 4.16

the Edit UVW panel. It will help if you set the background image to display the texture set in your material. This can be selected from the drop-down list in the top right-hand corner (the default is a checker pattern).

Use the Move, Rotate, and Scale transforms to move the UVs to match the reference image (Figure 4.17).

It may help to toggle Angle Snap to on (shown in Figure 4.18).

Now repeat this process for all the faces on the Door model.

For the edges of the door, I have reused the edge of the door texture. The seam is on the corner, so it will

Figure 4.17

not matter if it repeats in that direction. Make sure that you try to keep the pixel resolution similar to that on the front of the door.

It is important that you do not mirror any UVs, as they will also reverse the normal map. Everything that should look like it is pointing out will be lit like it is pointing in.

Figure 4.18

Figure 4.19

Creating the High-Resolution Components

We first need to look at creating the low-frequency detail for the normal map for the door. For this, we need to create a new scene. Don't forget to save this scene first.

Select File > New. Create a plane and set the following parameters:

Length = 1024
Height = 512

These values represent the size of the texture that will be applied to this plane and ensure that you have the correct ratio for the normal map that is created.

Apply a material using the door_setup.jpeg to the plane (the material should be created the same way as before). This will form the reference plane for our low-frequency map.

Now we need to add some detail. In the Front viewport, create a new plane the size and position of one of the panel details. Move this smaller plane in front of the reference plane. Hit the F4 key to display the wireframe. This will make the following steps easier to see.

Figure 4.20

Select the new plane and apply a new material to it. In the Basic parameters, set the opacity to approximately 70 percent so that you can see the reference plane behind it. Right-click the plane and select Convert to > Convert to editable mesh. In the Selection section on the Modify tab, toggle Face Mode. Select the face of the plane. Click the Extrude button and extrude the face back towards the reference plane, like Figure 4.21.

Now move and scale the face so that the edges replicate the form of the first ledge on the panel in the reference texture image. You may want to change the opacity of the material depending on the view in which you are working.

Repeat this technique by extruding the main face in and out and scaling it. It is usually a good idea to slightly exaggerate the indentation, as this trick will make the normal map more prominent.

Figure 4.21

Note that you should avoid sharp angle changes, as they have a tendency to create strange artifacts in normal maps. You should have something that looks like Figure 4.23.

To create the square panel, make a copy of the panel you just made. Move the panel into position. Level with one edge. On the Modify tab, under Selection, choose Vertex Mode. Select the vertices on one side that are not aligned. Line them up with the reference image. You should now have something that looks like Figure 4.23:

Figure 4.22

Creating the Low-Frequency Normal Map

First, name your panels Panel01 and Panel02. Rename your Reference plane to Ref01. Now make sure that panels 01 and 02 are aligned with each other and are both placed just in front of Ref01. Now press the 0 (zero) key; this shortcut calls up the Render to Texture dialog box. You can also find this under Rendering > Render to Texture. Under General Settings, pick a folder that you would like all your rendered assets to be placed in. Select Low01. This should show up under the Objects to Bake section. Check Enable under Projection Mapping. Then click the Pick button. Select your two panel objects.

Figure 4.23

Under Mapping Coordinates, make sure that Use Existing Channel is selected and the channels are set to 1; this will make sure that the texture coordinates on the Low model will be used for basis of your normal map. Under Output, click the Add button. The Add Texture Elements dialog box will pop up. Select Normals Map. As you can see from the list, you can bake out all manner of things using this technique. For now, we will concentrate on the normal map.

You will now have some new options under Output. These are specifically for the output of the normal map. First give it a name and select File Type. TGAs or TIFFs are the best, as they have no compression. Next, set the size of the texture. The measurements given here are in pixels:

Width 1024
Height 512

Click Render. What is rendered does not look like a normal map. Don't worry—it isn't a normal map. If you open the folder that you specified in General Settings, your normal map will be in there. Mine looks like this:

Figure 4.24

You will notice a lot of pink; this is nothing to worry about. There was no surface to transfer in this space, so the surface transfer process has not worked correctly in this area. We won't be using it, though, so this doesn't matter.

Finishing the Low-Frequency Normal Map

The next part of this tutorial is based in Photoshop. We will be creating and organizing the elements that will make up the final normal map. This is not a Photoshop tutorial, and these results can be created in any good piece of image manipulation software. For the purpose of this tutorial however, the following operations are in Photoshop.

Open Photoshop. Open your low-frequency normal map. Open the Door_setup.jpg file (from \Chapter 4\ images\ on the DVD). This will be used as a template for arranging your normal map to follow the UVs that have been set up correctly.

Cut out the panel elements in the normal map using the rectangular marquee select tool and paste them onto new layers in the Door_setup image. You can then move them into the correct positions.

Setting up some guides that follow the major sections of the door is a good idea, as this image will become the main reference for creating the final normal map. To access the guides, you must make sure that both Extras and Rulers are selected in the View menu. If you drag out from a ruler, then a guide is dragged along with your mouse pointer. The guides make it easier to consistently snap to these areas with other tools selected.

You can make copies of and move elements of a normal map. You cannot rotate these, though, as the color relates directly to their orientation. You should end up with some that looks like this:

Now we should make a neutral (flat) background colour for these elements to sit in. Create a new layer and fill it with a color with the following RGB values:

R 128
G 128
B 255

These values match a perfectly neutral or flat surface normal color. The background layer should fit behind all the panel details. It should look like this:

Figure 4.25

Figure 4.26

At this point, let's preview what has been created so far. Save your file as door_setup_normal.psd. Flatten this image (Ctrl + Alt + E) and save as Door_LowF_normal.tif.

Ryan Clark's Crazy Bump is a very useful tool for previewing normal maps as well as producing them. At the time of print, this program was in beta and may have changed from how it is described here. You can download

it from the following Web site: http://www.crazybump.com. Once installed, open Crazy Bump. Click the Open button in the bottom left corner. Choose File > Open Normal Map. Browse to and open Door_LowF.tif.

You will be presented with two windows. The main window shows you the normal map and gives you options for editing it. The smaller window is the Crazy Preview window. This should default to having your normal map applied to a cuboid. If this is not the case, you can change it to a cuboid in the bottom right-hand corner drop-down.

Follow the instructions on the screen to rotate the cuboid and the light. This step will give you an idea of how well it has worked. You can already see that constructing this type of detail using this process works a lot better than trying to generate it automatically from a bitmap. It should look something like Figure 4.27 (note that this example is offset slightly to view it better).

Figure 4.27

Creating the High-Frequency Normal Map

Next, we'll create the high-frequency bitmap that will be converted into a normal map. We will create a grayscale bitmap that represents the grain of the door. To do so, open Photoshop. Once again we will use the Door_setup image as a starting point.

First, we need to get some reference for the grain on the door. This reference will be taken from the original door reference photos gathered (we benefit from the door being virtually white). Hide all the layers with the other normal map parts on. You won't need these for this section. As before, you have to manipulate the images into place to fit the template.

When creating a bump map for auto-generation, you need to remember that they are generated using grayscale values. If you want something to stick out, it has to be between 50 percent gray and white. If you want it to be recessed, then it must go the opposite way. You should end up with something like Figure 4.28.

The inner panels have been made darker so that they will appear recessed. I have made a note of all the areas where the texture needs to tile and

Figure 4.28

overlaid and blended sections so that the texture can be repeated. The good thing about creating normal maps this way is that you can set them up to tile very easily using this method. It is important to note that this step must be done at this stage, because when the normal map is created, it will no longer behave like a conventional texture and editing it will be time-consuming and prevent it from working correctly.

If you have to hand-edit the normal map, you should work on each color channel individually. Remember that the lighting information is stored in each channel in the following ways:

- Red is lit from left to right
- Green is lit from top to bottom
- Blue represents depth

It is also important to note that depending on your video card, you may need to invert the green channel for it to work correctly. The best way to make sure is to try it both ways to determine the correct method for your card.

Once you have edited the map, use NVIDIA's Normal Map filter to renormalize the normal map so that it will display correctly. The Normal Map filter can be downloaded from here: http://developer.nvidia.com/object/photoshop_dds_plugins.html. To use this filter, make sure that your normal map is flattened and selected. Under filters, choose NVIDIA tools > NormalMapFilter. Under Alternative Conversions, select Normalize Only. This step ensures that each channel adds up to 1, which basically means that it will work correctly as a normal map.

When you are happy with the result, save it as door_highF_setup.tif. Open Crazy Bump. Click the Open button. Select File > Open photograph. Browse to and select Door_HighF_setup.tif. You will be instructed to wait as it generates a normal map preview. In the main Crazy Bump window, you will see a representation of your normal map. In the Crazy Bump Preview window, you will see the normal map applied to a cuboid, as in Figure 4.29.

As you can see, all the detail comes through as it should. By making the panels darker, these areas already appear recessed. We will now add the low-frequency map to this model to help define these forms. In the main Crazy Bump window, select Open Normals Mixer. A Normals Mixer dialog box will open. Select Add

Figure 4.29

Figure 4.30

Another Map. Select File > Normals; browse to and select the low-frequency normal map that you created (door_lowf_normal.tiff). You should end up with something that looks like Figure 4.30 in the Crazy Bump preview.

When both maps are combined, you get an idea of the effect the normal map will have on the model in game. It is possible to combine maps and generate normal maps in Photoshop using the NVIDIA Normal Map filter and using overlay layers, but I prefer this tool, as it gives good artistic feed back in real time. You always know that these maps will work properly, as they will always be normalized.

You could experiment further with the values in Crazy Bump to get something that suits your purpose. In the Normals Mixer, you can control the strength of both maps. In the main menu there are a number of controls that can change the look of your normal map. Feel free to experiment until you get the result you want. When you are happy with your normal map, click the Save button.

Figure 4.31

Select Save to File and save the file as Door_Normal.tiff. It should look something like this:

Figure 4.32

Viewing in 3ds Max

Now that we have created a normal map, we want to see it on the door we have created. Let's begin by opening 3ds Max. Open the Door file that has a complete set of UVs applied. Open the Material Editor and select a vacant slot. Under Blinn Basic Parameters, select the diffuse color swab (default is gray). This will call up the Color Selector. I am selecting an off-white to display the door. I have used the following values:

- Red 245
- Green 243
- Blue 228

Apply this to the door.

Figure 4.33

Click and hold over the blue checked box, select the pink checked box, and make sure that it is toggled on to display (yellow highlight). This step will allow the material to use hardware rendering, which is necessary to display the normal map correctly on your graphics card. Under Maps, select the bump slot and make sure that the amount is set to 100 (default is 30). From the Browser menu, select Normal Bump. Under the Normal Bump Parameters, select the bump slot. From the browser select Bitmap, then browse to and select Door_Normal.tiff. You should now have something in your viewport that looks like Figure 4.34.

Congratulations—you have created a tiled normal-mapped asset using a combination of next-gen techniques. The way we have tiled this Normal Map works in our favor: any seams you have should be able to be tiled in the same axis. Otherwise, you will get strange artifacts around the seams.

Creating the Final Look of the Door

Our door is very clean-looking and would look totally out of place in the dilapidated warehouse scene it belongs in. The geometry and UVs are in place for a full door, so now it will be easy to edit this door to look like sections are missing. However, we will first apply a diffuse texture to the model to give it a weathered bare look.

I have created this textured from weathered wood reference using the normal map as a guide. I have not added lots of baked-in shadow information (a practice often seen in textures created for games). The reason for this is that the normal map describes the form of the object, so it is not needed.

Figure 4.34

Figure 4.35

When this is applied, the door will look older and more weathered and now fits a warehouse-style environment.

Moving On from This Lesson

Now that you have created a full door, you can go on to create variations of this door by removing sections to create doors with panels missing, or pieces of wood that can be littered throughout the scene.

Figure 4.36

Figure 4.37

Summary

Here is a summary of what we now know about normal mapping:

- Normal maps create more work for the artist. Always consider whether you actually need one.
- Tangent maps are used mostly in games.
- Normal maps are used to describe both low- and high-frequency detail. Different production techniques are used to produce these effects. Combining these effects is the quickest way to get good results.
- Spending time preparing a UV layout saves you time in the long run.
- Tiled textures can be more work to prepare, but give you more resolution/save texture space.
- Do not flip UVs; doing so will make your normal map display incorrectly.
- Building individual details and combining them in image manipulation software is a quick way of developing complex low-frequency detail, without long build and render times.
- Normal-mapped elements can be moved and scaled but not rotated in image manipulation software.
- Avoid sharp angles, which can create strange artifacts in the normal map.
- The quality of the normal map is dependent on its resolution and compression.
- Normal maps cannot be edited like normal textures.
- Normal maps can display differently depending on the software and hardware used.
- Normal maps successfully tile along the same axis.
- You do not need to bake as much shadow information into your diffuse map when using normal maps.

Chapter 5

Creating Complex Objects from Primitives (1-hour tutorial)

This chapter is the final one aimed at entry-level modeling. It covers the creation of a fairly complex-looking model from primitive objects. We will be building part of the drive train of an old scrapped vehicle that will include the axle, the differential, and various parts of the wheels and suspension.

Look around—most of the things that you see can be made from primitive objects (box, sphere, cylinder, and so on). If you then combine these with a few texture maps and add a bevel here and there, you will be able to create almost anything you need to build fairly easily, using the skills you've learned so far and a few new ones from this chapter.

For this model, we will first create a group of primitive cylinders with slight size or scale modifications and then add them together to create something that looks a bit more complicated. We will then look at how the Loft Compound Object tool works and how to create a fairly complex model from primitive objects. Once you get to know these techniques, you should be able to model most low-poly models fairly quickly.

We will be concentrating on speed for this exercise, so the dimensions for the primitive objects are only a guide. Feel free to make this model more or less complex and also to experiment with adding bits from your imagination as you go along. If you really want to push the boat out, get yourself off to your local scrap yard and ask permission to take some photos for a project you're working on. You'll be surprised what you can get access to if you ask. If they say no, don't worry about it—there are plenty of others that will. Or you can look for copyright-free images on the Internet.

Creating the First Cog

Open a new scene in 3ds Max (Ctrl + N) and create a new fourteen-sided cylinder with Radius set to 20 cm, Height set to 10 cm, and the Height Segments and Cap Segments set to 1.

We will now create a texture map for this cylinder, UVW map it, and use Copy to create all the cogs that make up the model we're building. At this point, it might be a good idea to save your scene, as we will be working in Photoshop for the next step. Feel free to leave 3ds Max running unless you have performance problems when running multiple applications at once on your PC.

Figure 5.1

Creating the Cog Textures in Photoshop

Fire up Photoshop (or your preferred photo-editing package) and load in our reference photo Chapter 5 Ref 001.jpg from \Chapter 5\Source Files\ Reference Photos\ on the DVD.

As you can see, it is a close-up photograph of some cogs that will make up part of the scrapped vehicle. We're going to use this photograph to create the texture maps for the first part of our model. We will then UVW map these textures on to the ten or so cylinders, which we will create to build this part of the model.

As in Chapter 3, we will be cropping parts of the reference photo to create our new texture maps. Looking at the reference image, you can see that there are a number of parts of the photograph that will be suitable for this exercise. When creating texture maps like this one, we need to crop as much of the image as possible (to keep the resolution of the texture map high), but without cropping parts of the cogs that curve too much on the image. As we will need to texture maps to tile on the x axis (left to right), we want to minimize the amount of

Figure 5.2

Photoshop work. Cropping the curved parts of the image too would make this process take longer to correct in Photoshop.

Obviously, you could create the texture maps from scratch, but if you're not too confident in Photoshop, this is the quickest and easiest way of getting the model built. As this model is ultimately going to be part of quite a complex scene, don't get too bogged down with getting every measurement perfect. Don't be sloppy, though, as there will always be someone who will spot unmapped areas and dodgy texture maps.

On the reference photo, I have highlighted areas of the image that I think will be good to crop and make into tileable textures. You should be able to crop any of these areas and make them into textures that tile left to right fairly easily using the Photoshop tools Scale, Rotate, Skew, Distort, Perspective, and Warp by selecting Edit > Transform. Play around with these tools and see what they do. For this type of very quick, simple modeling, they are really useful.

In Photoshop, create a new color file that is 512 × 512 pixels square; this will be the first texture map for the cogs.

Select the reference photo Chapter 5 Ref 001.jpg from \Chapter 5\SourceFiles\Reference Photos\ on the DVD and use the Rectangular Marquee tool to select one of the areas of the photo as shown in Figure 5.3.

Use Ctrl + C to copy the area. Now click on your new 512 × 512 file and paste (Ctrl + V) the copied part of the reference photo into the new file. As the reference image was taken with an 8 megapixel camera, there should be plenty of detail in the cropped area for you to use as the basis of your texture map (as shown in the following figure).

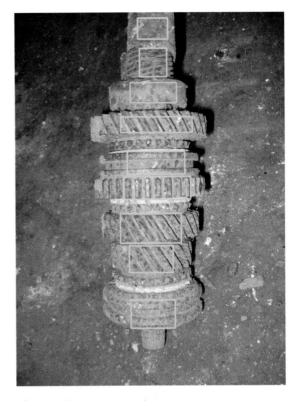

Figure 5.3

Figure 5.4

Now we just need to tidy up the area that we want to keep using the Clone Stamp tool (S) or Healing Brush tool (J), as well as Scale, Skew, and so on. We also want to make sure that the map tiles horizontally using Offset from Filter > Other > Offset.

Repeat the process another couple of times for different cog patterns and you should end up with a texture map that looks a little like the ones provided in \Chapter5\Source Files\Textures. Feel free to load Chapter 5_Teeth01.tif from \Chapter 5\Source Files\Textures\ on the DVD if you prefer. I have taken some of the shine off the teeth to level the texture a little bit, which will help reduce scintillation (flickering or flashing of the pixels) when moving around the scene.

Figure 5.5

Figure 5.6

Also feel free to produce a few more of these maps, as we have just done, to give your model some variety; or, if you prefer, you can stick with the ones provided.

Finally, we need to create one more texture map, which we will use for the ends of the cogs. As we have no reference photo for the ends (as is often the case), we must improvise. We can either create a rust texture from scratch with a circular pattern on it, or we can find something that is close enough and do a quick Photoshop job on it. For this example, let's take an existing photo from the DVD, \Chapter 5\Source Files\Reference Photos\Chapter 5 Ref 002.jpg, and manipulate it into something that is close enough for us to use. The photo reference is of the top of an old gas cylinder.

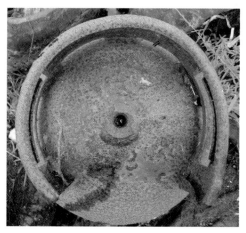

Figure 5.7

All we have to do is crop the central part of the image and reduce it to a 512 × 512-pixel square. Next, use the Healing Brush tool (J) to remove all the dark edges where the cylinder curves into shadow. As the pixels have a different pattern to the ones on the cog textures and are a lot sharper, crop a section from the smooth part of the cog reference photograph and paste it onto our new texture. Then scale it up so that it covers the whole page.

Change this layer to Overlay and create a new layer for the texture map. Then take one of the predominant lighter colors from our first cog texture and fill the layer. Finally, change this layer to Overlay too and reduce the opacity to around 24 percent. The whole process should look like this:

Figure 5.8

Although the changes are quite subtle, they are still important.

Now that we have our texture maps completed, close Photoshop and go back into 3ds Max. We have one cylinder created and a couple of texture maps for the sides and ends, so we need to UVW Map it, then duplicate it, and then modify the UVW Mapping on the duplicates.

UVW Mapping the Cogs

With the cylinder selected, apply a UVW Map modifier, check Cylindrical mapping from the Parameters rollout menu, and click Fit if the mapping doesn't fit roughly to the shape of the cylinder. If the mapping doesn't fit because the cylinder was not created in the Top view, go to Select and Rotate from the top menu, then click on UVW Mapping in the Modifier Stack (so that it turns yellow) and adjust it in the relevant view until it fits. Alternatively, recreate the cylinder in the Top view.

Now we need to create the materials for the mapping. Open up the Material Editor (shortcut M), click Standard, and choose Multi/Sub-Object for the material type, discarding the old material.

Click on the top material in the list (in this case Material #0), click on the square next to Diffuse, and double-click Bitmap from the Material/Map Browser. This action should open up a new window to load the first texture map. Browse to \Chapter 5\Source Files\Textures\ on the DVD and load Chapter 5_Teeth01.tif.

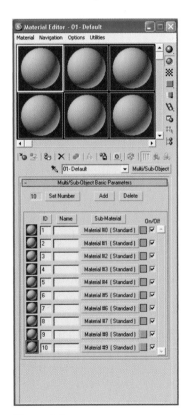

Figure 5.9

Click the Assign Material to Selection button and also the Show Standard Map in Viewport button. You should now see at least some of the faces with the new texture map on them. If you can't see any of the rusty texture map in the cylinder, confirm that some of the cylinder's polygon IDs are set to 1. If they're still not showing, go back and repeat creating the material or double-check that you clicked both the Assign Material to Selection button and the Show Standard Map in Viewport buttons.

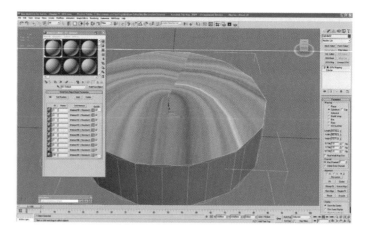

Figure 5.10

Next we need to set the material IDs for the side polygons (as they are not showing the rusty texture on them) and move onto mapping the sides and ends. Close the Material Editor for now (or minimize it) and rotate the viewport so that we can easily select the side polygons of the cylinder. If you use Rotate, be sure that you have unselected UVW Mapping in the Modifier Stack (still highlighted in yellow), so that you're rotating the view and not the mapping coordinates.

At this point, we can add an Edit Mesh modifier to the stack to allow us to continue with the mapping or we can right-click on the UVW Mapping modifier and select Collapse All from the list, converting the cylinder to an editable mesh (agree to the statement by clicking Yes to continue). In this case, let's convert to an editable mesh. Click Editable Mesh in the Modifier Stack (so that it is active and turns yellow) and select polygon from the Selection Menu or by typing 4 on the keyboard.

Next, select all the side polygons, then scroll down in the command panel (menu bar on the right-hand side) and set the Material ID to 1 (located between Surface Properties and Smoothing Groups).

We now have the sides of the cylinder mapped. It doesn't look very good at this point, because the cylinder is using the whole of the texture map (which was designed to be chopped up to be used on multiple cogs) and because the texture is stretched right round the cylinder, as we're not tiling it. First we'll get the tiling right and then we'll work on the UVW Unwrap.

Figure 5.11

As before, apply a UVW Map modifier and choose Cylindrical. This time, in the Parameters rollout menu, change U Tile from 1.0 to 3.0, to see what it looks like.

We can now clearly see the cogs, but it doesn't quite look right, so we need to tile the map a few more times. Try a few different numbers to see what looks about right. Depending on your map, or how big you want the teeth on this first cog, choose what you think feels right. If you're not sure, have a look at the reference image or load it into the background (Alt + B) if you want to get it looking precise. I've decided to tile this 6 times by setting the U Tile to 6.0.

Remember to only use whole numbers and not fractions (for example, don't use 5.5), as this is a tiling texture. If you use a fraction, you will see a seam on the mapping where the two ends of the mapping join. On this texture you might not see it, but don't fall into the habit of sloppy mapping—it will definitely be spotted if you show this type of work in an interview.

Now that we have sorted out the horizontal or U tiling, we need to look at

Figure 5.12

Figure 5.13

the vertical or V tiling. Because we created the texture map to tile along the x axis only, we need to crop the mapping. There are two ways we can do this. The first way is the one that we used in Chapter 2 (by using Unwrap UVW > Edit and moving the bottom vertices up on the texture map) as shown in Figure 5.13.

This method can be tricky if you're tiling the texture map a large number of times. It can be fiddly to get the vertices to the right place on the map and eliminating seams. So instead, let's adjust the mapping in the Modifier Stack. Click UVW Mapping in the Modifier Stack (turning it yellow). As the cog part of the texture map takes up around a third of the map, we can set V Tile to 0.3. By using Select and Move from the top menu, click and drag the mapping vertically upwards until the top of the cog texture lines up with the top of the cylinder. Fine-tune the V tile by using the up and down arrows until there is no seam.

Now that we've finished mapping the sides, we can move on to quickly mapping the top and bottom. As the cogs have a very similar diameter, we'll be using one texture for all of the top and bottom polygons. If you decide to create cogs of significantly differing diameters, you might want to create a few alternative texture maps so that there is no obvious repetition of your textures.

Figure 5.14

Open the Material Editor (M) and add the texture map that we created for the ends of the cogs. If you minimized it earlier, just maximize it again and click the Go To Parent button (above the Multi/Sub-Object button). Otherwise, you should see all ten materials.

Select the second sub material in the list, and just like before, select the texture map to use as the diffuse map (click the square next to diffuse, double-click Bitmap from pop-up window) and open Chapter 5_Teeth03.tif from \Chapter 5\Source Files\Textures\ on the DVD. Once again click the Assign Material to Selection and Show Standard Map in Viewport buttons. We now have both the texture maps in the multi/sub-object material to complete the first cog.

Figure 5.15

Go to the Top viewport, add an Edit Mesh modifier, and click on Selection Polygon (4) and select the top polygons of the cog. Make sure that Ignore Backfacing is not checked, so that you're selecting the bottom polygons, too. We need to set the Material ID to 2 in Surface Properties > Material (from right-hand menu) and then click UVW Map from the Modifier list. You should now see the top cog texture clearly on the cog. Finally, collapse all in the Modifier Stack and save your work.

If the texture map that you created for the top doesn't match the color of the map for the sides, open it in Photoshop and adjust the Hue, Brightness, Contrast, and/or Saturation to make it a closer match. For the texture I created, I just needed to alter the Hue a small amount. In the viewport, it won't match perfectly, due to the shading on the sides of the cylinder—this will be the same in most game engines too, so don't worry about it.

Creating the Rest of the Cogs

To complete the last part of this part of the build, we need to duplicate the cog that we have created and then adjust the mapping on the sides to give us the variety we need. We can do this randomly or use the reference photo as a guide. Select the cog in the Front viewport and shift-drag to make copies (select Copy from the prompt), then, once you have enough copies (ten or so), we can move on to scaling them.

Figure 5.16

Once we have all our cylinders scaled, we just need to map the edges of them from the first texture map we created. Then add the second map with teeth in the third material slot and change the polygon IDs and tweak the UVs until we have all the teeth mapped and UV'd differently.

We should then end up with something that looks a little like Figure 5.17.

To tidy up this model and optimize it, go through and delete all the tops and bottoms of the cogs that aren't seen. To complete this stage of the model, we

Figure 5.17

should attach all the cogs together by using Attach from the Edit Geometry rollout. Select one of the cogs, select Attach, then click all of the other cogs in turn. Give the cogs a name at this point and save your file again.

If you wanted to create a much higher-resolution version of the cogs, instead of using simple cylinders for each cog you could extrude a shape or loft a more complex shape along a spline; I'll cover this next.

Creating More Complex Cogs Using Loft Compound Object

Open a new file in 3ds Max; then, in the Top viewport, create a twenty-two point star via Create > Shapes > Star. Don't worry about the size at this point; just get it looking roughly similar to the one that I've created.

Next, go to the Modify panel, right-click on the "star" name and convert it to an editable spline. With the star shape still selected, click on the words "Editable Spline" so that you can modify the spline at the vertex level. The "Editable Spline" text should be highlighted in yellow if you have done this correctly.

Select the outer vertices as a group and chamfer them by dragging the arrow on the Chamfer Modifier in the Geometry panel. Then do the same with the inner vertices until you end up with something like Figure 5.19:

Figure 5.18

Now that we have the basic "loft" shape, we need to create a "path" for us to loft it along. In the Left viewport, go to Create > Line and with Snaps Toggle on (click S if it is not already selected), create a vertical line by clicking with the left mouse button, moving the mouse vertically down, and clicking with the left mouse button a second time. To end the line, right-click, and you should be left with a vertical line. Don't worry about the length of it for now, as we can adjust that later.

Figure 5.19

To create a loft object, we need to loft a shape—in this case, our star—along a path, which is our line. To do this, go to Create, and in the Geometry section, select Compound Objects from the drop-down menu. Select Loft from the Object Type menu.

If you haven't been through the Loft Object section in 3ds Max's help (shortcut F1) or InfoCenter, you should take a look at it. It explains lofting in a little more detail and covers a few things that I won't be covering in this tutorial. Just search for "Loft Compound Object" in the Help or InfoCenter; it explains loft as well as all the other related topics.

Figure 5.20

Figure 5.21

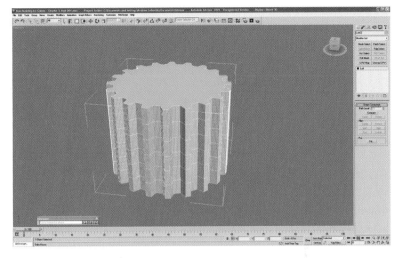

Figure 5.22

With the line you have just created still selected, click on "Get Shape" from the Creation Method menu and then click on the star or cog spline that you created. You should instantly see the lofted object. Hit the P key to go to the Perspective view and view your cog. Next, press F3 and then F4 to see the subdivided geometry detail.

As you can see, the 3D cog that we have created is fairly complex—much too complex for the type of scene we will be creating later on, so we need to reduce the detail a little bit. To do this, open the Skin Parameters menu in the Modify panel. Reduce the Shape Steps and Path Steps both to 0 to remove all of the subdivided polygons. This step reduces the cog's polygon count from around 7000 to around 600, which is much more render-friendly.

Always try to be aware the default settings on tools and modifiers. If you keep a close eye on what you're doing and check polygon counts regularly, you won't fall into the trap of creating geometry that you don't need and you'll learn not to waste polygons where you don't need them. You can do this by pressing the 7 key when you have an object selected. This action displays the Polygon and Vertex totals in yellow in the top left of the viewport for the selected object. Or, if you want to see the totals of the objects in your scene, you can go to File > Summary Info..., which displays all the relevant info in a pop-up window.

Finally, with a quick Collapse To Editable Mesh and a Rotate of the top vertices, you can create the angular cog.

Figure 5.23

To complete these cogs, we would create a basic rust pattern for them and map them in the usual way by applying a cylindrical map for the sides and a planar map for the top and bottom.

As mentioned earlier, all of the models created from the tutorials will be used to create the final scene, with a few other similar models provided on the disc. With this in mind, and to keep the complexity of the final scene down, we will continue building the simpler version of this model. If you want your version of this tutorial to be high-res,

Figure 5.24

feel free to continue with the more complex version, following the same steps—just with higher-resolution geometry.

Creating the Axle

For the next part of the build, we need to take a look at the other reference photos.

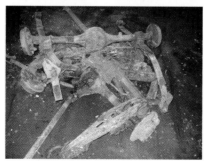

Figure 5.25

As you can, see there is a real jumble of parts for the axle, wheel hubs, differential, suspension, and so on, but most of this can be made fairly simply with primitive objects. We could really go to town and spend all day modeling every single part of this jumble accurately, or even a number of days modeling every nut and bolt, but it really isn't necessary for this asset. What we are trying to do is to create the illusion of detail and complexity by creating simple objects and duplicating them to make the model look more complex than it actually is.

We will create a couple of cylinders and a box for the drive shaft, a couple of cylinders for the wheel hubs and axle, and a few more primitive objects for the suspension, differential, and other details. As this model will be inside a skip or in a corner of the scene, we can keep it low on detail with a simple texture map applied to it.

So that we don't go overboard with detail, we will block out the main parts of the model with primitive objects and have a look at how many polygons we're using; then we will keep adding details until we are satisfied that the object is looking complex enough.

We need to have a look at the reference images Chapter 5 Ref 003.jpg, Chapter 5 Ref 004.jpg, and Chapter 5 Ref 005.jpg (located in \Chapter 5\Source Files\Reference Photos\ on the DVD) and start to block out the main parts of the model with cylinders and cubes.

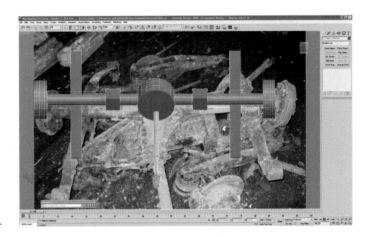

Figure 5.26

Now, using the techniques you've learned so far (Move, Scale, Rotate, Boolean, and so on), start to work each of these primitives to give them a little more form. Before you convert any of the cylinders to an editable mesh, try to work out how many height segments you'll need for each part. If you get it wrong, just select the polygons on the end and extrude to create more subdivisions.

Start to work into each of the primitives and add the odd bevel and simple nut and bolt for details.

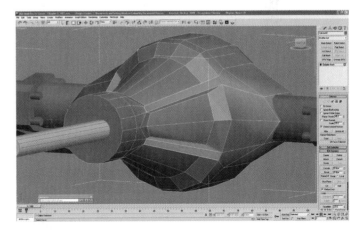

Figure 5.27

Here I am halfway through creating the differential (Figure 5.28). I have scaled groups of polygons and rings of vertices and have begun to extrude groups of polygons to add a little more form.

Remember that this is an exercise in tricking the viewer into believing that there is a lot of detail with primitives, so don't worry about getting everything exactly like the photograph. Feel free to add springs, wheels, disc brakes, or anything else you can make quickly from primitives. Springs can be made very quickly with Create > Geometry > Dynamics Objects (from the rollout menu) > Spring (from Object Type menu). Remember that springs are very complex and need a lot of polygons, so don't create too many for this model.

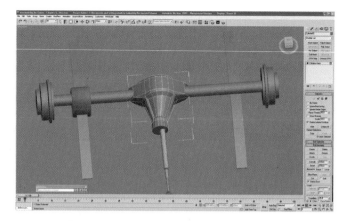

Figure 5.28

Hopefully, you now have the start of something that looks a little bit like the reference photo (or much better, depending on whether you decided to use your imagination). We should now start to add a few more details and then start thinking about texture mapping everything.

As you can see in Figure 5.29, I've added a few parts to the main axel and something onto one of the leaf springs. I think I'll wait until I get these mapped and textured before I copy them, modify them, and use them on other parts of the model.

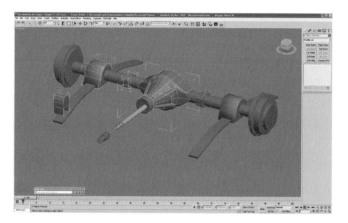

Figure 5.29

Finally, in Figure 5.30, I have bent round one of the leaf springs using the Slice and Bend modifiers, added a few nuts and bolts, and "reference copied" a few more of the parts to complete the modeling. It's important to check Reference when copying small details that you want to keep the same (like the nuts and bolts). If you want to make a change to them, you have to change only the original one, and all the others inherit the changes. Have a look in the help (F1) for more on this and the other ways of copying.

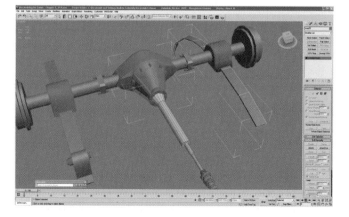

Figure 5.30

On to the unwrapping and texturing. As this is a slightly more complex object than we made in the earlier chapters, we will be unwrapping all the components separately. Once you're happy that everything has been unwrapped, we will scale all the separate parts, moving them around so that they fit on one texture page, using up as much of it as possible. Then finally, we will create the texture page and this model will be complete—well, almost complete.

First of all, create a new Standard material in the Material Editor (M). Use TextureGrid.jpg from \Chapter 5\Source Files\Textures\ on the DVD for the Diffuse Map, as we have done before, and then assign it to all of the objects in the scene except for the cogs. We have already mapped and textured the cogs, so they don't need to be done again. Select all of the objects in the scene and click Assign Material to Selection to do this. You should see the entire set of objects change color; most of them will have a checkerboard pattern on them.

Figure 5.31

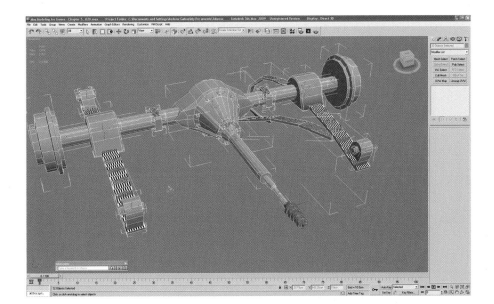

Figure 5.32

Now we just need to go through each of the objects and modify the UVW mapping coordinates so that none are stretched and then lay them out so that they are not all overlapping, so that we can create a neat texture map.

For this object, all duplicate components are copied as references—they will require less work to unwrap and map but look the same. This approach reduces the required texture area if parts have the same mapping coordinates and also speeds up the build.

In the following figure, I have moved all the components around so that they roughly fit on the texture page. I have allowed some of the longer components to stretch beyond the boundary of the texture page, as this will be a tiling texture, and this method produces a slightly higher resolution in those areas for free.

I have temporarily set the background in the Edit UVW window to brown to make it easier to see where all my components are. Don't worry if some parts look a bit too busy; I will create a generic rusty area on the map that I will use for all the long components. This is why all the UVs are stacked on top of each other. You could lay everything out very neatly, so that every single piece has its own UV space, but I have chosen resolution over originality in this case.

So if we just apply a very basic rust material to the object in the Material editor, you can see that it is starting to take shape.

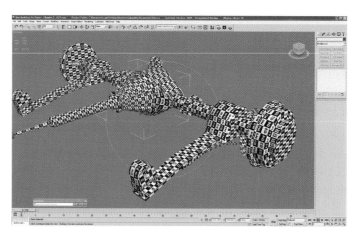

Figure 5.33

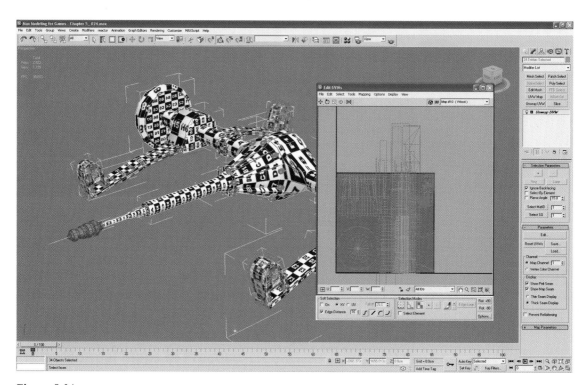

Figure 5.34

The previous image is Chapter 5_Main1. tif from \Chapter 5\Source Files\Textures\ on the DVD. As you can see, it's nothing special, but when we use it instead of the checkerboard pattern, it will make the object look a lot more complete.

Now, with the creation of a quick spotlight (Create > Lights > Target Spot) and a quick Render (F10 > Render), you can see how your model is starting to take shape.

Now, depending on your preference for the final quality of your scene, you can leave this model as it is. As this isn't a key object, if you want to move onto a more challenging build, then feel free to save your progress here.

I have decided to work on the texture map a little more, to get a slightly more realistic and polished look. I grabbed a few parts of

Figure 5.35

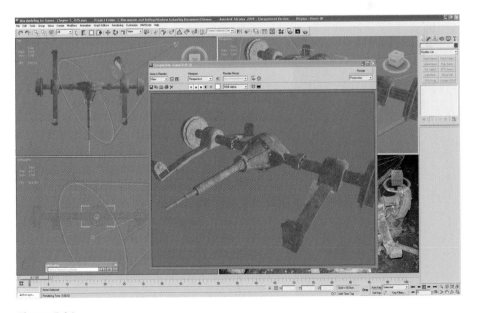

Figure 5.36

the reference photo and blended them onto a layer to add some interesting surface details. I then set the layer to "Luminosity" in Photoshop and set the opacity to around 85 percent for some slightly more interesting surface qualities and a dirtier look. Have a look at the texture pages side by side in the next two figures.

Figure 5.37

Figure 5.38

And here's the texture map applied to the finished object (Figure 5.39).

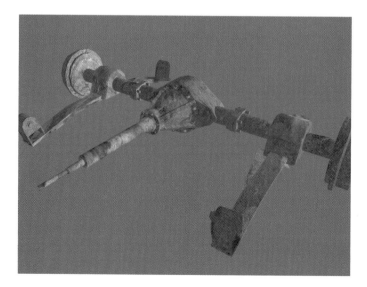

Figure 5.39

Now we just need to make sure that the cogs don't look too out of place when connected to the drive shaft. To do this, adjust the texture resolution of the cogs (reducing it), and then colorize the cog textures so that they match the rest of the object a little more closely.

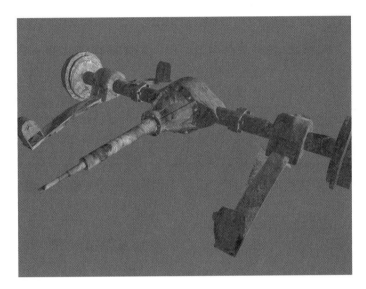

Figure 5.40

You can see, using basic modeling techniques and primitives, a little time and effort, and a sprinkling of texture work in Photoshop, you can make some fairly complex-looking objects very easily.

You could obviously take this model a step further by unwrapping every single part of the object and creating a more detailed texture map, but that would take a lot longer. The whole point of this tutorial was to complete something quickly. We will work on more complex textures and unwrapping in the next chapter.

Moving On to Chapter 6

Next, we will be putting all of the techniques that you have learned so far into making a slightly more complex object. Keeping with the abandoned warehouse theme, we will be building a 6500-polygon skip wagon. This time we will be using image planes and blueprints as a guide, and we will be using layers to help you to manage your builds. We will be using Boolean, Scale, Extrude, and Chamfer, and as mentioned, we will get into UVW mapping and layout in a little more detail.

Congratulations on getting this far. If you haven't done so already, take some time out from these tutorials and create some of your own creations.

If you're eager to move on and complete the next build, let's go!

Chapter 6

Low-Poly Vehicle

David Griffiths

Note from this book's author: David has taken a step-by-step approach for this tutorial; for every step and image there is a 3ds Max file with the same name. If you get stuck at any point, feel free to grab the 3ds Max file from the DVD and move on. Remember that you'll really benefit only if you do the whole build yourself, so try to solve your own problems instead of jumping ahead. You will improve much more quickly and will be a stronger artist at the end of it if you do.

Please note that the truck has been modeled to an arbitrary scale and will have to be resized to fit the final scene in which it will be merged. Also, for this tutorial I am trying to keep the viewports as uncluttered as possible (personal preference) so I am choosing to turn the Viewcube off. You can toggle this by right-clicking on the little house icon, then Configure, and you can turn it off in Display Options. Or you can go to Views > Viewcube > Configure and toggle it there. Some of the original (consecutive) build files have been removed in the text to speed up the build process for you (Files 23, 24, or 77 for example), please follow directly to the next instruction in the text.

File_0

Create vehicle planes. Once created, freeze the planes using Display/Freeze Selected and make sure to uncheck "Show frozen in grey" in the Display Properties, which is under the Freeze menu. Turn on the Poly Statistics in the viewport to keep a tab of the polygon budget (by typing 7 on the keyboard).

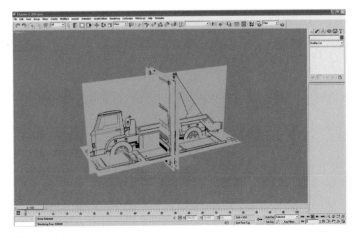

Figure 6.1

File_1

Create a new layer using the layer manager, by clicking main toolbar > Layer Manager > New Layer.

Figure 6.2

You can rename this layer to whatever you like, but I have just left it as the Max default name. In the Top viewport, create a box on this layer.

In the materials, give the box a color and set the opacity to something like 70 percent, so that you can see the vehicle planes through the box. Turn on edge faces and give the wireframe a color different from the material color. I have chosen black.

You can use the snap function if you want. Hold down shift when creating the box. I created it in the Top viewport and matched it to the size of the cab.

Figure 6.3

File_2

Right-click on the box to bring up the Max menu and convert the box to an editable poly. Scale the box, moving the vertices so it fits approximately around the truck cab.

File_3

Start splitting up the box along the z axis with subdivisions at key intervals that follow the details of the cab in the pictures. If you can't see the splits that you are making and you want to see all the edges, then make sure that you have the edges unchecked only in the object properties menu. Sometimes it is good to toggle edges on and off.

Figure 6.4

File_4

You should end up with something like this:

Figure 6.5

File_5

Split the cab directly down the center and delete one half of it. Now start moving the new vertices of the remaining half that you have made to fit the shape of the cab more accurately.

File_6

Now we need to make it more rounded by using the chamfer tool. As you can see, I have chamfered the outer edges once to make it more rounded, but it still needs much more work to make it rounded—and we need to tidy up the new edges that 3ds Max has given us.

Figure 6.6

Figure 6.7

File_7

I have added more chamfers to the edges of the cab and I have tidied up and moved the vertices to better interpret the roundedness of the shape. The edges can't be rounded too much, because that would give us too many polygons, so look for something that is fairly smooth, but still low enough on detail.

Figure 6.8

File_8

Here you can see that I have used the same principle to round the center section of the cab in the same way, keeping the detail low while maintaining the curves.

Figure 6.9

File_9

Now split the roof to create the same amount of detail in the form of the curve.

Figure 6.10

File_10

When adjusting the splits in the roof, you will need to move the vertices around to fit the shape of the cab. You can do this a number of ways: by moving the vertices by hand or scaling them. If you scale them, you might want to consider mirroring your cab model to make the scaling easier, as 3ds Max will by default scale from the center.

Figure 6.11

File_11

The cab needs a few subdivisions along the world x axis so that we can add more curvature to the roof and the rest of the body in general. I have deleted the other half of the cab again, as this is the way I like to work, although you could use the mirror instance so the other half is modeled at the same time.

Figure 6.12

File_12

With the subdivisions added, move the points to fit the curve of the roof more precisely. I recommend that you keep going through your entire cab model and keep refining it, because this is very important in 3D modeling. Adding new vertices, edges, and polygons can get out of hand if you don't watch what is happening.

File_13

Next, let's move the vertices in the new divisions we have made on the world y axis to curve the front and the back ever so slightly.

Figure 6.13

File_14

We need to add some more divisions along the world y axis so that we can create more detail in the side of the cab.

Figure 6.14

File_15

The cab has a lip just underside the roof, which needs to be modeled, and we can extrude that from the preparations we made earlier.

Figure 6.15

File_16

Let's look at creating some of the other features of the cab like the wheel arches. We need to create a shape that we can use as a Boolean to give us the shape. Create a cylinder. I have created one with twenty-eight sides.

Figure 6.16

File_17

Delete 3/4 of the cylinder so that you leave the quarter of the shape that will make up the wheel arch.

Figure 6.17

File_18

Extrude the outermost edges of the new wheel arch so that they extend past the bottom of the cab and out of the back of the cab. It is important that the edges go beyond the boundaries of the cab for the next Boolean.

Figure 6.18

File_19

To begin to make the shape of the start of the wheel arch, we need to create a Boolean with the cut/refine function. First select the Cab, then go to Create > Compound Object > Boolean and select Cut > Refine from the Parameters menu.

Figure 6.19

File_20

Now we can delete the polygons left in the Boolean function to create a hole, which will become the wheel arch.

Figure 6.20

File_21

Select all of the edges from the curve of the Boolean that we just created and extrude them to create a lip, which will form the protruding lip of the wheel arch.

Figure 6.21

File_22

Some of the extra lines and vertices that we created when performing the Boolean will have to be cleaned up. It is important to keep the model as neat and tidy as possible. We need to look for the extra vertices and edges and decide which ones can be deleted or welded. Obviously, if you delete vertices, you will create holes, so use something like Target Weld and Move instead.

Figure 6.22

We also need to create a few new edges to the wheel arch so that we can preserve the curve and keep it regular.

File_25

The wheel arch needs to be extended further out from the cab body. Select the edges at the back of the cab for the wheel arch and extrude them.

Figure 6.23

File_26

The edges of the wheel arch need to be curved around. This is done by scaling the outer vertices. The form of the arch needs to be altered slightly, so a little refinement is required.

Figure 6.24

File_27

We now need to start looking at the detailing on the doors and windows. I create these by using the divide edge function, but you could select polygons and use Slice if you prefer. We could Boolean these details, but most of the information for the door and front window could be put in manually; feel free to use the Boolean function for them if you're more comfortable with that tool, or whichever method you're most comfortable with. Remember to remove any unwanted detail after each Boolean transformation to keep your model neat and efficient. You should now have the seam of the door detailed as shown.

Figure 6.25

File_28

Select the edges of the door and add a chamfer modifier to them.

Figure 6.26

File_29

Clean up the undesired vertices that the chamfer function has given you. Some of the edges also need to be tidied up slightly to keep all the lines and edges flowing across the model. Try to keep a neat topology when creating any new faces or edges, and try to make sure that any new details are constructed from edges that neatly loop around the object.

Figure 6.27

File_30

Select the polygons that were created by the chamfer command and extrude them inwards by approximately 0.8. These polygons will be used to create the start of the door seam.

Figure 6.28

File_31

Now weld all the inner vertices of the seam together to create an inner groove. Your door seam is now complete.

Figure 6.29

File_32

Detail the seam of the front window, using Divide Edge (or Slice or whatever you prefer) as before. To do this accurately, you will need to jump into the Front viewport and outline the edges of the glass.

Figure 6.30

File_33

Chamfer the window edges and clean up the result.

Figure 6.31

File_34

As with the door, we need to extrude the polygons that the chamfer has given us. This time, instead of extruding them inwards, we extrude them out and then weld the outer vertices. This step will give us the raised edge required.

Figure 6.32

File_35

Next we need to create the door window with the help of a Boolean shape. First, create a box in the Side viewport with a couple of subdivisions. Manipulate it until it fits the window shape as shown.

Figure 6.33

File_36

Now we need to create the Boolean using cut/refine and clean up the result edges, vertices, or polygons.

Figure 6.34

File_37

We need to create a recess or lip as like in the real photograph/blueprints of the cab door. To do this, extrude the selected window polygons and then scale them to create the required indentation.

Figure 6.35

File_38

We will now create another edge in the door window all round the sill that we just created. To do this, divide all of the polygons right through the middle. To make sure that 3ds Max splits them in the center, turn on 3D snap with "midpoint" checked. Once created, the new midpoint vertices need to be scaled slightly outwards. You can use the scale tool or move the points manually. I've gone through and selected all the edges so that you can see clearly what I have created.

Figure 6.36

File_39

Now we need to repeat the same process for the rear windows. These will be created exactly like the door window, so just follow the steps again. You should end up with something like the following figure. Don't worry too much if yours doesn't match my example exactly—it doesn't have to be perfect.

Figure 6.37

File_40

Looking at our progress so far, the side windows we created look a little too square, making the truck look slightly fake or a bit too low-poly. It would be a good idea to round them off slightly by chamfering the corner edges. We should probably only do this once to keep the polygon count down on the truck. Feel free to make the curves more complex than I have if you want a better-looking vehicle, but remember that this is a low-poly vehicle.

Figure 6.38

As before, we need to clean up any extra vertices created and make sure that all the edges are clean and run round the object smoothly. I have chosen to make some of the edges visible, although this isn't strictly necessary. Unchecking "Edges only" in the Object Properties helps you see all the edges that define an object and therefore to see clearly what edges, if any, are causing problems.

File_41

Repeat the same chamfer process on the rest of the windows to make the windows look a bit more smooth and realistic.

Figure 6.39

File_42

We need to do the same recess-type structure around the front wind screen. This usually wouldn't be modeled, but because the final model won't have windows, we must show it to keep continuity. This recess lip is created the same way as for the other windows. I have selected the polygons here so that you can see what I've done.

Figure 6.40

File_43

Now we can start to look at the front lights. We need to Boolean a cylinder into the cab. The cylinder should be approximately twelve-sided (I wouldn't use fewer than twelve sides, but if you would like more fidelity and a smoother look to the light, use more sides; but always go up in twos).

Figure 6.41

File_44

The cylinder has now been Boolean'd from the cab. The Boolean was again set with the cut/refine option. As always, you have to clean the mesh. This is a common task to perform after every Boolean transform.you perform.

Figure 6.42

File_45

The new polygons that have been made for the light can now be extruded inwards so that we can start making the concave form of the headlight.

Figure 6.43

File_46

Once the polygons have been extruded, they must be made planar. An easy way to do this is to convert your model into an editable poly (if it isn't one already) and use the Make Planar function. In this instance, I used Make Planar on the y axis.

Figure 6.44

File_47

We need to scale these inner faces and extrude them again. Once the new sets of polygons have been extruded, we need to scale those, too.

Figure 6.45

File_48

Extrude another set of faces, but instead of scaling them, select all of the vertices and collapse them into one using Collapse.

Figure 6.46

File_49

Let's take a break for a moment and see how our truck is progressing.

Figure 6.47

It's important to stop every now and again when you are modeling, to get a drink or move around, or just to take a look at your progress. It's so easy to select one or two vertices too many when collapsing and take out a few that you didn't mean to. If you notice the mistake quickly enough, it won't do much harm, but if you fail to spot it because you're so busy detailing specific areas, it can cause you a bit of pain and some lost time. Remember to drink plenty of water when you are trying to learn something new and take a ten-minute break every hour or so—it really does make all the difference.

File_50

Let's take a look at the back of the cab where the engine would be. On the photographs, we can see that the cab appears to have been cut out to give the engine and gear box more space. The cab on this particular truck

Figure 6.48

also has a cover over the engine, so it can't really be seen. Some of the engine details from this part of the truck need to be guessed or researched further, as we don't have accurate blueprint information for this area. Make the cuts to accommodate the engine as shown.

File_51

Even though the engine cover is a separate object on the real truck, we will make it a part of the cab, as we don't want to spend the polygons to make areas like this separately. You may have noticed at this point that the blueprints don't

Figure 6.49

completely match the original photographs; this is because the blueprints incorporate some of the other details of the other skip truck (from the photos) including the fuel tank and generator on the back. Next, we need to extrude these edges to build this form up using scale on the vertical axis to get the edges/vertices level along the bottom edge.

File_52

Let's move onto the truck's front bumper. Once we have done this, we'll move on to the back of the truck. Obviously, the truck still needs lots of work, including an interior, but if we complete the back before of the truck before the

interior, we will get a better impression of how many polygons we have left to use for the interior. What may happen is that we go over budget anyway, even if we try to be conservative. If we do, we just have to trim polygons at the end of the build—this is quite common. If this does happen, always keep a copy of your higher-polygon model for future use.

Let's get on with the bumper. To start, extrude the polygons that we made at the very start of the truck build to form the rough bumper shape.

Figure 6.50

File_53

Move the vertices of the extruded polygons to match the bumper on the blueprints a little more closely. We can do this most effectively in the Top viewport.

Figure 6.51

File_54

We need improve how the bumper attaches to the cab. Show edges and turn the edges on the ends of the bumper. Make sure that you also make them visible to help you to do this.

Figure 6.52

File_55

Next we will delete the end polygons and create some new ends that are much closer to the blueprints.

Figure 6.53

File_56

We need to build the bumper ridge which runs along the top and bottom of the bumper. Select the polygons along the front of the bumper and extrude them, then scale them.

Figure 6.54

File_57

Select the new polygons that you have just created and extrude and scale them so that you end up with a depression. We will leave the truck's cab there for the moment and move onto working on the back. Remember to take a break, grab a drink of water, and have a look at what you've done so far.

Figure 6.55

File_58

Create a new layer for the back of the truck and freeze the cab layer or turn it off for now. Next, create a box and scale it to resemble the main bed of the back of the truck and taper the back.

Figure 6.56

File_59

Start to split the back up into the component parts like we did for the front cab, adding all the cross sections that we will need.

Figure 6.57

File_60

Now we will extrude and shape the trailer arms that come up from out of the trailer base. Again, we are using only Extrude, Scale, Move, and a little Rotate, just as we have before.

Figure 6.58

File_61

As you can see, the top of the arm is too thick, so detach this, make it thinner, then reattach it.

Figure 6.59

File_62

We need to fuse the model together properly, so divide edges and weld the vertices. Create new polygons to fill in the holes we just created.

Figure 6.60

File_63

The back of the trailer needs the rest of the structure building. To do this, make some more divisions at the bottom, so that you can extrude the necessary face.

Figure 6.61

File_64

Now the faces can be extruded and shaped to make the back structure and what will ultimately house the rear lights.

Figure 6.62

File_65

The end of the rear lights arm needs to be capped as shown in the blueprints. We can do this by extruding the sloped faces out and then extruding the sides faces as well. This will need cleaning up and welding when completed to make it neat and tidy.

Figure 6.63

File_66

The capped end has now been cleaned up.

Figure 6.64

File_67

Now we will start adding more detail to the trailer back. First, make an inner edge to lower the height in the middle by extruding the interior faces downwards.

Figure 6.65

File_68

As with the inner lip that we just created, we need to add more detail to the arm, as it has to have a thickness for the hydraulic system. Detach the arm and alter the width so that you can build an outer lip. Leave the arm detached, because this will be refined later on.

Figure 6.66

File_69

Refine the edge for the inner lip down the back of the rear light arm, as this will eventually make the gap for the arm to move in. Tidy up the vertices and edges and alter the lip widths so that they match each others thickness. Make sure that the model still lines up with the blueprints. You may find that you need to move some of the vertices to realign your model again.

Figure 6.67

File_70

Once you are happy with the divisions that you have created for the trailer lip, select the inner faces that need to be copied and moved downwards to create the recess. When you have selected the faces, move the faces down with the move tool while pressing the Shift key. This step makes duplicate faces.

Figure 6.68

File_71

You can now delete the original faces. Once deleted, create the faces that make up the sides of the inner recess.

Figure 6.69

File_72

Your trailer should now be starting to take shape.

Figure 6.70

File_73

The trailer back now needs to be closed up so that it looks like the back of the real skip truck. Make sure that the truck bed is roughly the same height as in the blueprint. Extrude the back edge down to create a vertical step, extrude it again to create an angled step, and then make a final extrude to create the last step down.

Figure 6.71

File_74

Now the new back can be integrated properly with the rest of the back. You need to fill holes to make the rear of the truck solid. Because this is difficult to see in orthographic blueprints, I suggest that you use your artistic eye in conjunction with the photographs and interpret the back the best you can. Take a look at this file to see

Figure 6.72

how I tackled the problem. Note that I have tidied up stray and unwelded vertices. I have also deleted the faces underside and reduced the polygons by welding vertices that I no longer needed.

File_75
To make the back more realistic, I have added a slight recessed section where the rear light arm flows into the back. This was easily created by extruding the inner face inwards and then deleting the polygons at the top and creating new polygons, which were welded together.

Figure 6.73

File_76
Now we can start to look at the underside of the truck. It must be created from imagination, because we don't have much information for this area from the reference photos. This bottom will be fairly simple. It is created by extruding

Figure 6.74

edges vertically and horizontally so that we can enclose the gap at the bottom. Look at the following figure to see how I finished off the bottom area. Make sure that whatever you create is tidy and that all vertices are welded. Don't worry about the underside too much. There is no plan for the truck to be flipped over, so it doesn't have to be perfect; just keep it clean and simple. Here's my interpretation of what the underside of the trailer might look like.

File_78

Now we can start modeling the trailer details. Start with the mudguard. First move the last two divisions left in the model to where the mudguard should be placed. On the underside between the two splits, create another division.

Figure 6.75

File_79

Extrude the face downwards to create the outer edge of the mudguard. Once extruded, shape the faces to resemble the mudguard shape. Split the mudguard in half on the inner face.

Figure 6.76

File_80

Pick the polygon that has been split on the outer back edge and extrude it until it reaches the first lip. Delete the inner poly and weld the mudguard inner faces to the inner lip. Tidy up remaining polygons that are no longer needed.

Figure 6.77

File_81

Select the inner open edges and extrude them roughly halfway to the middle of the trailer. Close the holes and weld all vertices.

Figure 6.78

File_82

Select the back face where the rear lights will eventually be. Extrude and scale the face to create an edge all the way around, then extrude the face once more inwards to create the rear light recess.

Figure 6.79

File_83

Create a cylinder with twelve sides and no divisions and place it where the stabilizer arm is going to be attached to the main trailer. Make it the same thickness as the trailer frame. Copy it and place the copy on the inner frame lip.

Figure 6.80

File_84

Copy the cylinder and move it to the inside of the trailer frame. Once you have both cylinders placed, join them to the trailer. For this step, I am going to use the Boolean union operation and then clean up the results.

Figure 6.81

File_85

The finished brackets have now been merged onto the trailer to make one object. I extended the inner bracket with the inner top faces so that it looks a little stronger.

Figure 6.82

File_86

We will now make the stabilizers. Create a new layer and create three circles using the splines menu on that layer.

File_87

Convert one of the splines into an editable spline and attach all of the them together.

Figure 6.83

Figure 6.84

File_88

Click on the vertex function in the spline menu and use the Refine button to add vertices to the circles at points where they will need to intersect with each other.

File_89

Delete the curves that are inside the points of intersection.

Figure 6.85

Figure 6.86

File_90

Use Create Line to attach the shapes together. Make sure the 2.5 snap is turned on and vertices are checked.

File_91

Use the Refine button again to add points to create the right angle shapes. If the vertices are curved, make them a corner point by right-clicking on the vertex and selecting Corner. Weld all the points together.

Figure 6.87

Figure 6.88

File_92

Extrude the shape using Modify > Modify list > Extrude. Make sure that Cap Ends is checked. Move the extruded shape into the right position. It will be easier to see what you're doing if you switch to the Perspective view for this.

File_93

Reduce the poly count on the stabilizer by cutting polygons from the curves of the semi-circles in the model. Use any method you like to do this—Editable Poly or Editable Mesh work equally well.

Figure 6.89

Figure 6.90

File_94

Create a box and Boolean it from the stabilizer. You need to Boolean the box from the arm that sticks out so you can add the hydraulic arm. The hydraulic arm is simply two cylinders. You can probably get away with using six segments in the hydraulic arms for a low-poly object, but again, if you want the model to look a little better for your portfolio, feel free to use a little more. Remember that you probably won't see this detail on the finished model, so don't get too carried away with it.

Figure 6.91

File_95

Make sure that the inner faces on the hydraulic arm are deleted, as you will never see these in the render.

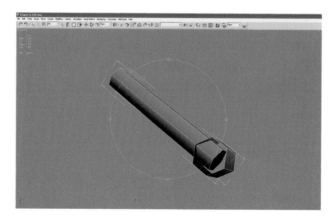

Figure 6.92

File_96

Attach this arm to the stabilizer. Create the little stabilizer wheels for the truck using cylinders of no more than twelve sides. Attach the wheels to the stabilizer arms.

You may have noticed that the stabilizer arm really needs a hole or channel built into the trailer to allow it to move, but because this will never be seen, I have omitted this detail. Feel free to model it if you feel that you need to or if you plan on being able to able to see underside the truck. This detail can be added in the texture to make it at least look like it has a channel built into it.

File_97

Now we can move back to the main trailer arm. Unfreeze the trailer layer and select the bottom edges of the arm and extrude them. Divide the edges in the center and shape the vertices to where they would hinge on the trailer.

Figure 6.93

Figure 6.94

File_98

Divide the edges once more to give the bottom edge an L shape. Clean up the edge and the polygons that are not required. Fill in the bottom of the arm.

File_99

At this stage, move some of the vertices in the channel we made where the arm can move. The bottom of the channel underside the trailer must be slightly adapted to allow the arm to hinge in the hole, but if the arm never moves, it's not terribly important.

Figure 6.95

Figure 6.96

File_100

At this point, I think it is a good idea to go through the trailer model again and make sure that the file is nice and clean and that all the vertices that should be welded are welded. It is a good idea to remove polygons that you consider to be no longer relevant to the model and just generally tidy it up after a mini-critique.

File_101

On the trailer arm, the ends of the struts that we created need to be rounded off slightly. This can be done manually by dividing the edge and moving the vertices to make it appear smoother. Also, the arm still needs to be modified slightly to resemble the trailer arm at the bottom, where it is hinged. The bottom needs to be lifted and we have to create a lip that is present at the bottom. We can do this by dividing the top edge of the arm and then detaching the arm hinge at the bottom.

File_103

Reattach the bottom hinge part of the arm, then Boolean the part of the arm that is attached to the hydraulic arm. This is exactly the same process we used on the stabilizer.

File_104

Let's build the main hydraulic arm. This again is simply a twelve-sided cylinder. Before we create the cylinder, we must pull the top edges down to make the inner lip thinner.

Figure 6.97

Figure 6.98

File_105

Create the cylinder with twelve sides. Once created, extrude the faces nearest the trailer arm and extrude them again to make the end piece. Then make attaching hinge cylinders at both ends of the hydraulic arm.

File_107

At the top ends of the trailer, extrude the faces and make the shape conform to the blueprints. The extruded polygons also need to be refined slightly and welded.

Figure 6.99

Figure 6.100

File_108

The bottom of the trailer needs an extra detail ledge that will rest on the truck chassis. This is done by creating an edge that runs from the front to the back; then the face can be extruded.

File_109

Create a new layer so that you can start a basic model for the truck chassis. This should be fairly simple, as we don't really have the polygons to spare for it. First, start with a box that will make up one side of the chassis and mirror it to create the other side.

Figure 6.101

Figure 6.102

File_111

Now we will create a wheel from a cylinder. The cylinder should be set with sixteen sides with height segments of 5. This setup makes the wheel fairly smooth when rendered but keeps the poly count reasonable and manageable. Move the wheel into position.

Delete the back face of the wheel, select the other side of the wheel, and scale the face to give the tire part of the wheel a more inflated look. You can (if you wish) set the smoothing groups so that you can see the tire section more easily to distinguish it from the wheel hub.

File_112

Select and scale the center polygons again to start creating the wheel hub. When you have made the rim, scale and extrude the already-selected polygons again continuously until you have created the hub. Use the photographs and the blueprints as the guide.

Figure 6.103

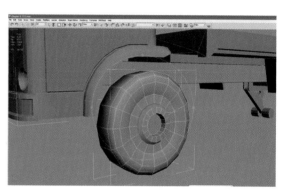

Figure 6.104

File_113

Select the hub part of the wheel and detach it. Then select the outer edges of the hub and extrude them backwards towards the inside of the tire.

Figure 6.105

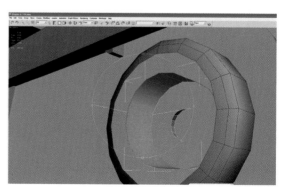

Figure 6.106

File_114

Select the extruded polygons created from the outer hub, then flip the normals to create the inner rim.

File_115

Reattach the hub to the tire and then fill in the whole left in back of the wheel. You can do this either by manually creating new polygons or by selecting the hub outer edge and extruding it to make a set of polygons, which you could weld to the tire's open inner edge. The front wheel now is complete. At this point, you can mirror the wheel to complete the set.

Figure 6.107

Figure 6.108

File_116

Next, we will move on to the rear wheels. We can modify the front wheels to make the rear wheels. The only real difference on the rear wheels are the hubs, so we won't have to make too many alterations. One thing to note is that the rear wheels are in sets of two. Select the front wheel, clone it, and move it into position by using Select > Shift-drag.

File_117

Select the innermost ring of faces on the hub and pull the polygons back.

Figure 6.109

File_118

Select the inner edge of the hub and scale it outwards to make it wider than it currently is. Do the same with the next edge, continuing inside the hub.

File_119

Copy the new rear wheel and move it inwards to make the rear wheel a double wheel. At this point you could keep the wheel separate, but for this model it will be connected in order to save polygons.

Figure 6.110

Figure 6.111

File_120

To keep the polygon count down, delete all the extra polygons from the hub facing outwards and the inner ring.

File_121

Now delete the opposite face on the outer wheel, but keep the inner hub faces.

Figure 6.112

Figure 6.113

File_122

Now we can attach both wheels together to make one double wheel. Weld the inner hub faces to the back of the outer wheel edge. Once this is done, mirror the wheel to complete the set. It would be wise to look over all the wheels that you have created and make sure that they are cleanly built and that all the vertices are welded. Ensure that all of the polygons and normals all look okay. You can also sort out the smoothing groups, if you wish; an auto-smooth would be fine for the wheels.

Figure 6.114

Figure 6.115

File_123

Now we can start to model the suspension. To start this process, create a cylinder with six sides and a height segment setting of 5 to create the rear axle.

File_124

Scale the middle of the cylinder slightly to make the starting shape of the rear differential. Scale last two edges in to make the shape slightly rounded.

File_125

Split the center of the differential and scale it slightly to round off the shape again.

Figure 6.116

Figure 6.117

File_126

Select the inner faces of the differential and extrude them to pull them out. Scale the faces so that they are planar (that is, flat). Scale them again to taper the faces to more of a point.

File_127

Clean up unnecessary polygons from the axle by removing them.

Figure 6.118

Figure 6.119

File_128

Create another cylinder, this time with eight sides, but set the height segments to 0. Move this cylinder to the outer edge of the axle. This is now is the brake drum, so it now needs to be mirrored and attached to the axle.

File_129

Copy the rear axle to the front. Delete the differential (the round chunky bit in the middle of the axle), as the truck is rear-wheel drive. Scale the width of the axle so that the brake drums fit within the front wheels hubs. To do this, move the hubs and the axle at the sub-object vertex level.

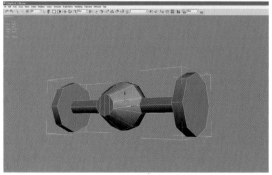

Figure 6.120

Figure 6.121

File_130

Create a box below the rear axle, between the differential and the brake drum. Create it with width sections set to 5; this will form the leaf springs.

File_132

Convert to an editable mesh and move the outer bottom vertices to make the box curved at the bottom.

Figure 6.122

Figure 6.123

File_133

Now, with the Bend Modify, bend the leaf spring slightly.

File_134

Select the center section of the leaf spring, scale the width, then select and extrude the face on the bottom. Select and chamfer the extruded face's edges.

Figure 6.124

Figure 6.125

File_135

Because we altered the underside of the trailer at the rear, we need to make some alterations to the main chassis. We need to add a new division to the edge so that we can move the edge of the chassis up to the rear of the trailer to fill the gap. You can now make the leaf spring larger or smaller to match the blueprints if you didn't create it at the correct size in the first place.

File_136

The leaf springs need to be fixed onto the chassis with brackets. These will be created using boxes with chamfered ends. You may need to scale the thickness of the leaf spring to fit in the brackets you have created. Attach the bracket to the leaf springs, then copy the leaf spring and move it to the front. Attach both leaf springs to the chassis, then copy them and mirror the whole chassis.

File_137

Now we shall look at finishing off the cab. Fill in the bottom of the cab and delete some unnecessary polygons from it. Delete the windows, as the truck in the photos doesn't have any.

Figure 6.126

Figure 6.127

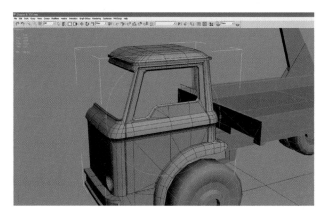

Figure 6.128

File_138

Welding the center loops in the headlights and reducing the polygons around the back end of the mudguards is a good place to start. The roof can also be cut down a little.

File_139

Keep removing the polygons that don't add anything to the overall shape or form of the cab. Often, divisions that we make as we perform specific tasks to make the modeling process easier will need to be removed at some point. If you build one side of an object and then mirror it to complete the build, quite often the center line is a good candidate for this. Have a look through your model to see whether you can spot any others.

File_140

Now we need to fill in the bottom of the cab. Select the edges of the mudguards and extrude them until they meet the thickness of the mudguard.

File_141

Cap the mudguard and then delete the unnecessary edges that were left from the creation of the mudguard.

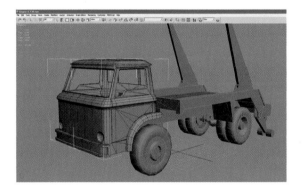

Figure 6.129

Figure 6.130

Figure 6.131

Figure 6.132

Figure 6.133

File_142

Do the same with the mudguard at the bottom. Also pull the edges down on the engine cover at the back of the cab. Next, pull the edges down to the top of the chassis.

File_143

Start to fill in the whole underside of the cab. Extrude the outer cab edges and weld the vertices to make a solid closed shape.

File_144

You need to incorporate the chassis in the underside construction of your cab model. Take a look at Figure 6.133 to see how I have closed the bottom of the cab fully. You will notice that I have reduced the polygons slightly and cleaned up some of the faces to make it a neater model.

File_145

So all we have to complete to finish the cab is a basic interior. We could start the interior off by using the shell modifier; however, I find that for this model it gives us a very complex interior to clean up, so the alternative is to create it manually. Start by selecting the open edges of the front window and extruding them in, then extruding again and scaling them larger.

Figure 6.134

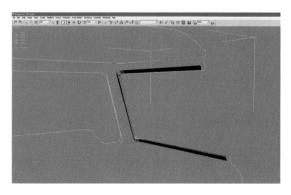

Figure 6.135

File_146

We will do the previous step with all of the open edges on all the windows to create an inner shell.

File_147

Now we can start to weld and create new polygons from these starting points to fill in the interior. Remember that it should be pretty basic, though.

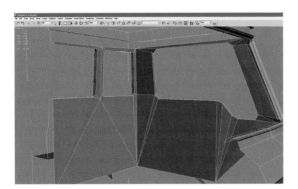

Figure 6.136

Figure 6.137

File_148

We need to build two chairs and a steering wheel and steering column. These will also be very basic. In fact, they are pretty much made from single polygons. To make them look more detailed, they will be textured, but with alpha maps applied, so that you can see the frame of the chairs and the steering wheel.

File_149

With the model nearly complete, we just need to finish off a few remaining details. Create a box-type shape underside the cab to act as an engine and gearbox. We can map this shape with an engine-type texture to make it look more detailed. Once we have modeled the engine/gearbox, we can link up the prop shaft to the rear differential.

Figure 6.138

Figure 6.139

File_150

We can now add the final touches. Create a six-sided cylinder to make the bar that connects both the hydraulic arms at the top. Create a low-poly bracket box and a cross-section set of polygons hanging down from the bar so that you can map a chain texture to make it look more detailed without using lots of extra polygons. Feel free to add the extra fuel tank and the control box at this point, but try to keep the poly count as low as you can.

The basic model is now complete.

File_151

Create a new material and load TextureGrid.jpg into the Diffuse slot. You can find this texture in \Chapter 6\Textures\ on the DVD.

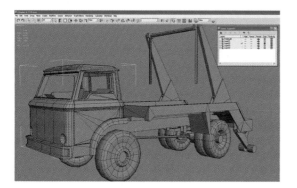

Figure 6.140

Figure 6.141

File_152

Under Modify in the modifier list, choose UVW Mapping and tick the box called Mapping Method.

Figure 6.142

Figure 6.143

Figure 6.144

Figure 6.145

File_153

Under Modify, choose Unwrap UVW. Open the modifier stack and click Face. Select most of the front faces on the cab and select Planar in the map preferences. If the mapping is from the wrong angle, you can choose Align; for example, if you view the cab directly from the front view, you can select Align from View. If you use the Align using the axis method, use your axis guide in the bottom left-hand corner of the window to help you choose the correct one. This method will be repeated pretty much for the whole of the unwrapping of the truck. So the rest of the instructions for the unwrapping will be a little more brief.

Once you have planar-mapped the front faces, open up the Unwrap window by clicking on the Edit button under the Parameters heading and move the new mapped faces away from all the faces in the model. You're doing this so that you can organize all of the polygons in the model on the texture page in the future.

One important thing is to try to keep the mapping of the faces consistent in size (which includes their aspect ratio). This effort is where the texture grid comes in very useful. Use the grid to make sure that the mapping is equal all over the whole model. There are some circumstances in which you can alter the aspect ratio and size, but as a basic rule, try to keep it consistent.

File_154

To actually make the making process a little quicker, convert the cab to an editable mesh or editable polygon and delete half of the model. Now reapply the Unwrap UVW to the cab and continue with the mapping process. Using the same method that we did for the front of the cab, select the side polygons and move the new faces away from all of the other faces in the

Unwrap window. You may have noticed that there are some areas that look stretched. This issue will be rectified when we lay out the maps in a more organized fashion.

File_155

Using the same method as before, continue to unwrap the back of the cab and the roof. When working on the lip of the roof, you might want to include the relevant sides that correspond to the front side and back view, or you can unwrap the roof as one whole piece to hide as many of the texture seams as possible. Choose whichever method you prefer; for this model, I am going to keep the roof as one whole object.

Figure 6.146

File_156

You should now be left with the underside of the cab to be unwrapped (excluding the wheel arch, bumper, rear engine cover, and interior at this point). Because we used a box-mapping technique from the outset, you can select the faces of the different parts of the underside and move them out individually in the Unwrap viewport. You may find that some pieces are separate from each other that should be connected, but if you go to the menu at the top and then into Display and turn on Show Vertex Connections, you can see where the faces should be linked. All that remains is for you to flip the faces using the mirror function.

Remember that you can mirror both horizontally and vertically, or even use the Flip Vertical or Horizontal functions. As you can see from this figure, I have moved the underside of the wheel arch. It was in two parts, but using the previous method, I have put it back together again. I will use this method for the rest of the underside of the cab.

Figure 6.147

File_157

All the underside components have been organized and connected to the relevant parts. You should have only the wheel arch, front bumper, rear engine cover and interior now remaining to do. Notice that the underside cannot physically be unwrapped as one whole piece, so some of the faces must remain separate. Although this limitation can be annoying, it can also be used to your advantage when placing all the unwrapped faces on the texture page—but this is really done only at the very end of the whole unwrapping process.

File_158

Now we can finish the front bumper and rear engine cover, like we did with the underside of the truck.

Figure 6.148

Figure 6.149

File_159

And we can now finish the exterior mapping of the cab with the wheel arch. Map this using the cylindrical mapping method. You will no doubt have to alter the texture gizmo. Use the cylindrical mapping modifier from the Unwrapping menu. Remember that you can put the polygons back together if the cylindrical mapping doesn't work like you want it to.

I have manually straightened some of the vertices on the wheel arch, as you can see. Also notice that I have altered some of the colors for the background and the mesh itself. You can do this by using Options > Preferences. I have turned off Display Seams and Show Grid. I have also performed a mass weld on all the cab polygons in the UVW Unwrap Editor to get rid of unnecessary texture seams. If you do this step, make sure that you don't weld the wrong vertices. You may have to adjust the weld threshold in the bottom right-hand corner of the Unwrap window higher or lower to achieve the overall weld.

Figure 6.150

File_160

We can now adjust vertices around the front corner of the cab to minimize as much of the stretching as possible. It is virtually impossible to eliminate all stretching, but it can be improved or hidden with natural seams or natural shapes in the model.

File_161

The interior UV unwrapping should be the only thing left on the cab model. It is a good idea to double-check your model at this point to make sure that you haven't missed any faces that need mapping; this is a common mistake that is very easily made. If you have rogue faces, I suggest that you fix them now before you go on with the texturing, as they may be harder to find later.

As we have already done with the underside of the cab and the other various parts of the model, our aim here is to organize the interior into as close to a one-piece unit as the model and faces will allow. If you look at the next figure, you will see that all of the faces for the interior are now laid out by the same methods we've used earlier.

Figure 6.151

Figure 6.152

File_162

It is now time to mirror your cab model. Be sure that when you have mirrored the side, you move the copied model's texture coordinates away from the original cab. This step makes things easier to stitch together when you put the two sides together. If you look at Figure 6.153, you'll see that I have mirrored the cab so that it is now complete again and the texture coordinates have been reorganized. I am still keeping the cab texture coordinates away from the center of the UV Unwrap window so that they are easy to select once more of the model has been

Figure 6.153

textured. Next I have changed the background color in the Edit UVW window (from Options > Background Color) just to show you this step a little more clearly.

File_163

Let's move on to the trailer section of the model. The process is the same as it was for the cab. Start with a cube mapping method and then sort out all the faces of the trailer by hand.

File_164

Next, I apply the Unwrap UVW modifier to the trailer and start to organize the different faces of the trailer. I have used the exact same methods as for the cab. The trailer in this image has its faces unwrapped.

Figure 6.154

Figure 6.155

File_165

Once the trailer polygons have been unwrapped, mirror the model and stitch up the mirrored trailer UV coordinates to the original, as in the cab model. Take a look at this image to see the end result.

File_166

Now we can move on to texturing the trailer arm and the hydraulic arm. Again, the method is the same. The only slight variation is the use of a cylindrical mapping technique for the hydraulic arm. (You may find that some of the cylinders already have cylinder mapping applied to them; these are usually created when you create the cylinder with "Generate mapping coordinates" checked. If this is the case, it just makes your life a little easier!) To map the hydraulic arm, move the end cylinder faces away from the main central cylinder, which makes

Figure 6.156

it easier to select the middle so that you can apply cylindrical mapping to it. Also, move the two boxes and the end cap polygons away from the main cylinder. Once you have mapped the main cylinder, use the same technique on the end cylinders.

A good tip when using the cylindrical mapping technique is to try to hide the seam. For this example, the seam on the hydraulic arm is on the bottom of the model. The final step is to layout the polygons for the hydraulic arm.

File_167

Now we can mirror the objects like we have done with the previous models. Once you have mirrored the models and sorted the unwrapped faces, attach the models together to make one whole model—be sure to include the trailer.

Figure 6.157

Figure 6.158

File_168

Next, hide the trailer and unhide the stabilizers. We will map these in the same way as the trailer arms. Once you've finished, they should look something like Figure 6.159:

File_169

Mirror the stabilizer and attach it to the rest of the trailer. Your unwrapped trailer should look something like Figure 6.160:

File_170

Let's start unwrapping the wheels. Unhide and unfreeze the chassis layer (or layer 04, if you have not named your layers). We have only one front and one back to do, as they will obviously be mirrored.

Figure 6.159

Apply cylindrical mapping to the wheel in the UVW Unwrap window (if one wasn't assigned upon creation). Move the outer polygons away from the central hub and map the hub and side wall of the wheel with a planar map. The inner hub cylinder should be cylindrically mapped, just like the outer faces of the wheel. The outer polygons will be mapped with a tread texture; this will be the same on all of the wheels, so the faces should occupy the same UV space on the texture page. In fact, only the hub front and back faces are unique on the front and rear wheels. After you have finished, you should have something that looks like Figure 6.161:

Figure 6.160

Figure 6.161

File_171

Now we can follow the wheels with the rest of the chassis UV mapping. Again, you should see that there are some parts of the model that can occupy the same UV space, like the main chassis girders, brake drums, leaf springs, and leaf spring brackets. When you have unwrapped all of the chassis, attach together all of the pieces, just as we did for the trailer.

File_172

Unhide and unfreeze the cab layer again, as we just need to unwrap the engine block, prop shaft, seats, and steering wheel and column. Now it's time to attach the entire truck model.

Figure 6.162

Figure 6.163

File_173

Now comes a tricky part. Once you have the entire model unwrapped, it needs to fit into a square. What I mean by a square is a texture page that is basically of a resolution to the power of 2. In this case, we are going to make the entire unwrapped model fit in a texture page with a resolution of 1024 × 1024 pixels. You might want to create the texture slightly larger—2048 × 2048, for example—so that you have a higher-resolution map for renders or your portfolio. When you are finally organizing your texture page, keep in mind the priority of the model. For example, I suggest that you make the interior, the underside parts, and the objects that are obscured or seldom seen a little bit smaller on the texture page. This method allows you to assign more of the texture page to the most visible parts of the truck.

It is time to experiment and see what you consider to be the best compromise. Once you have all of the faces into the square, you can either take a screenshot and paste that into Photoshop or in the UVW Unwrap Editor under Tools or use the Render UVW template. Make sure that the resolution is set to 2048 × 2048 for the original map.

Figure 6.164

Creating the Texture Map for the Truck

Photoshop_file_1

Open the texture template in Adobe Photoshop. I suggest that you use the layer functions in Photoshop and even the layer folders to keep the collection of your textures together. What we need first is base rust texture template. To get that, I am going to use what images I can find in the reference photos and seamlessly stitch them together using the Clone Stamp and/or Healing Brush tools.

Photoshop_file_2

Grab as many of the truck parts as you can from the reference images and line them up with our model UVs. Don't worry if they look a bit odd and the perspective is a bit off; you will probably need to do a lot of editing to line everything up and make them seamless. Tidy up parts of the textures as you go, just to make things

156

Figure 6.165

Figure 6.166

clear on the page. Actions like trimming the images as you are placing them into the file will make your blending job that much easier when it needs to be done.

Photoshop_file_3

Use Photoshop to blend, copy, clone, color-correct, and generally fix all the photograph parts of the truck for the parts of the images that we have copied into our texture file. Feel free to use the other photographs or references for the tire tread and front wheels. If you find that there is a reference missing or if you don't think that there is enough information in some of the texture parts, use an Internet image search to complete your texture map.

Photoshop_file_4

You should now have something that looks like Figure 6.168 when you have finished the texture corrections:

Figure 6.167

Figure 6.168

Photoshop_file_5

The only remaining tasks are creating the alphas for the seat, steering wheel, and chain by making an opacity map in Photoshop. Keep the original alpha in channels within Photoshop or create a new layer set and keep a layer as an alpha, but save a copy of your alpha map as a JPEG to be used in 3ds Max. If you intend to do any

Figure 6.169

close-up render shots of the truck, you might want to create a higher-resolution chain texture on your main texture page. This process is easy—and you should have plenty of space on your texture page.

The Finished Truck

In 3d Max, apply the texture map to the truck.

Congratulations! You should now have a fully modeled and textured truck.

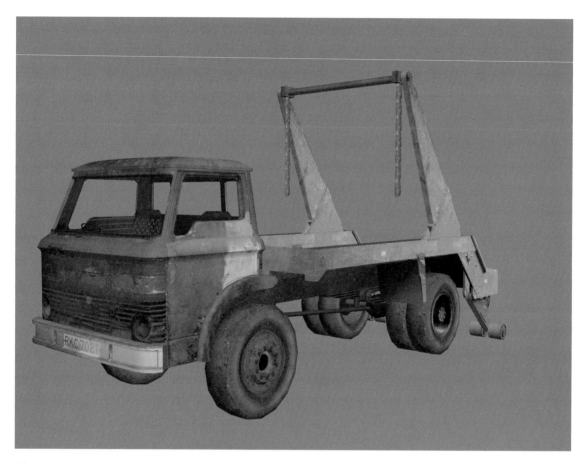

Figure 6.170

Chapter 7

High and Low Poly Characters

Introduction

Being a 3D character artist is an incredibly rewarding job—it's great fun to turn your raw ideas into living, breathing beings, and there is always a challenge around the corner. To create photorealistic and believable characters, you must balance your 3D technical expertise with a sound knowledge of human and animal anatomy. Without a doubt, your most important asset is your "eye"; you must objectively scrutinize your creations at each stage of their development.

It is beyond the scope of this chapter to guide you through each and every one of the thousands of operations required to build this character. Instead, I would like to guide you through my working process, my way of thinking, and the tools I use. You need a competent working knowledge of 3ds Max, and you need to solve your own problems from time to time. This tutorial starts off fairly basic and gets into some more advanced concepts as we move along. If you get stuck on a problem with any particular tool, your best friends are the help menu (press F1) and Internet search engines. This is how I advanced my knowledge of 3ds Max once I had absorbed everything that the entry-level tutorials had to offer. As long as you make regular incremental saves (i.e., man01. max, man02.max and so on), it's pretty hard to break anything—so press all the buttons to see what they do!

Our "Pipeline"

The way we work, the tools we use, and the order in which we do things are known as our "pipeline." I have refined my pipeline over many years to get things running as smoothly as possible.

Before we start the 3D work, let's first plan out exactly what we will do. Once we know precisely what we will be creating, we will make a rough, low-polygon "proxy mesh" that will capture all the basic proportions and main shapes of the character. From this mesh, we will develop a high-polygon mesh that has all the little details that bring the character to life. We will apply UV coordinates to the high-res mesh and create realistic surfaces by applying a number of different textures to the surfaces of the character. We can use this high-polygon mesh for portfolios, advertising materials, in game cut scenes, and any other prerendered media.

Next, we will return to our low-polygon proxy mesh and optimize his level of detail so that he is suitable for real-time videogames. After we bake down all the details from our original high-polygon mesh onto this new low-polygon game mesh, you might be surprised how similar it looks to the high-polygon mesh. This mesh will be suitable for inclusion in any modern Sony Playstation 3, PC, or Microsoft Xbox 360 game, ready to be rigged and imported into the game engine.

Before You Start: The Concept

Perhaps the most common beginner's mistake is to rush headlong into modeling without sufficient planning. Modern video game characters can take more than five weeks of solid work to finish, so you don't want to get to the end only to find out that the basic design is flawed. The best approach is to have everything drawn out in color *before* you start. Most studios will have at least one concept artist for this job, often recruiting specialist character artists to do the job. If you draw out your idea and it doesn't work out, only hours or days are wasted—not weeks or months!

Often a good character starts with a simple thought, like "I'm going to make a tough-looking, futuristic commando," but it is the concept process that will prove whether your idea works visually. As you draw out a detailed character concept, you are visually solving problems that might not have been apparent when it was just a rough idea in your head.

It is usually much quicker to experiment with designs on paper than it is to make a series of changes to your 3D model. Early in the concept phase, many fast and loose pieces are produced to try out as many different ideas as possible in a short period of time. Once the concept artist is happy with a final look for the character, he drafts up detailed blueprints to be scanned and colored on a computer. Using paint packages such as Photoshop makes it fast and easy to experiment with alternative colors, hairstyles, costumes, accessories, and so on. After the art director approves these concept designs, they are sent to the character artist for production.

Many character artists use a two-monitor setup; typically, one monitor is used for working in 3D applications and the other is used to display reference and concept images. This two-monitor setup works well; however, I recommend that you print out your most-used images and hang them on the wall near your desk. For the weeks that you will work on this character, you will save lots of time browsing folders looking for your reference and you will free up your precious RAM and processor resources for those greedy multimillion polygon meshes!

An extensive knowledge of anatomy

If you're serious about specializing as a concept artist or 3D character artist, you need an extensive knowledge of human anatomy. Even the most weird and wonderful alien characters will most likely have some similarities to us and your knowledge of human anatomy can add believability to your other-worldly creations.

The most intuitive way to learn anatomy is to spend a good amount of time in life-drawing classes studying direct from life, but it is essential to read up on your anatomy, too, unless you fancy cutting up some cadavers!

Although there are many medical texts that will familiarize you with the inner workings of the human body, I've found it much easier to learn by reading artists' guides to anatomy. Artist-specific guides are more relevant, as they concern themselves only with representing the main forms and the surfaces of the body, without getting too bogged down in the details. You don't need to learn the names of each individual element, but it is essential to learn where all the major groups of muscles, tendons, bones, and areas of fat are on the body. It is quite common for beginners to focus on modeling all the muscles but forget about bony protrusions such as cheekbones, shoulder blades, and ankles. Your models will look formless and blobby without a good consideration of the bones that hold the body together.

The proportions of body parts in relationship to each other are of critical importance in character modeling, if you get the basic proportions wrong, your character will look terrible, even if you include loads of cool, small details. Small changes to proportions make a big difference in how people perceive your character—especially in the face, where tiny adjustments to the eyes can have a massive effect on the personality and mood of the character.

I heartily recommend the classic series of books about drawing the human figure by Andrew Loomis. The first editions are now out-of-print collector's items, but you can find the books freely available for download on the Internet. *Drawing Comics the Marvel Way* by Stan Lee and John Buscema (Fireside, 1984) and the *How to Draw Anime & Game Characters* series by Tadashi Ozawa (Graphic-Sha) are also great, as they are very specific to the typical, idealized characters you often find in a contemporary game.

It may help to study classic artists such as Leonardo da Vinci. Leonardo shows in his art that there are many general proportional rules that loosely apply to almost everybody. Many of Leonardo's works (and those of many other artists) make extensive use of the "golden ratio", a number, known in mathematics as *phi*, that can be observed in many instances in nature. This number (approximately 1.6180339887) can be measured in the proportions of spirals in seashells, the length of bones in animals, and the distances between stems on plants. Look at the joints in your fingers; each successive joint is roughly 1.6 times longer than the last.

The ancient Greeks and Egyptians used the golden ratio in their classic architecture like the Parthenon and the pyramids. Modern studies have deemed these proportions to be aesthetically pleasing and closely linked with our perceptions of beauty. You could even apply your knowledge of it to your own fantasy creature creations; it would be fair to hypothesize that if aliens do exist, they too might have evolved with "golden" proportions.

Ask questions

Upon receiving the "future commando" concept, our first job is to get to know him. As we want our character to be realistic and believable, let's start by assuming that he *is* alive. Usually I ask the team and myself a number of questions, such as the following:

Q. Where does he live?

A. *The scene is based in the United Kingdom; the reference was taken in an abandoned factory in the Northwest of England. It's not terribly important to tie the character to a location, but a Union Jack flag on his shoulder might be a nice detail.*

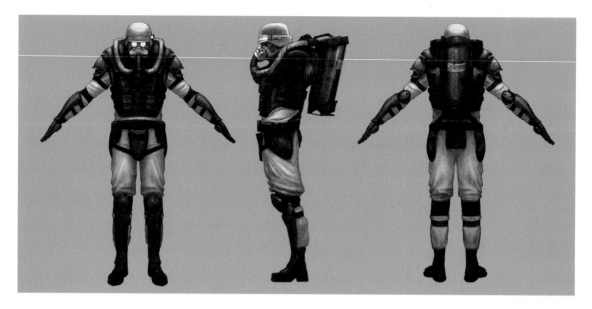

Figure 7.1

Q. What material is his suit made out of?

A. *He wears an NBC (Nuclear Biological Chemical) suit. The lightweight material is fairly tough, but flexible. The fabric has a charcoal layer in between the layers to protect him from nuclear fallout, gas, poison, or germ warfare. The fabric is unique; although it is flexible, it has a crisp quality and will hold creases. See if you can get your hands on an NBC suit in an army surplus store.*

Q. Has he had any previous battles and have they left him with any damage to his suit?

A. *Being on his hands and knees in various combat situations has left him with many surface scuffs and areas of ingrained dirt on his suit, but there is no real damage. His suit is his lifeline; it is replaced every six months and if its function is compromised in any way, it is replaced immediately.*

Q. What sort of soldier is he?

A. *He is part of a specialist fighting unit, a real bad ass.*

Q. What kind of gloves is he wearing? It is unclear on the concept sketch.

A. *They are slash-resistant Kevlar gloves with lead lining. Perhaps it would be a good idea to extend the gloves to half-gauntlet size, to give better protection from his flamethrower.*

Q. How old is he?

A. *To become this tough, he must have been in various branches of the military for a number of years—he is in his early 30s.*

Q. How old is his gun? What type of gun is it?

A. *It is a flamethrower, maybe with a small shell launcher or other weapon on the bottom.*

Collecting references

Before we get into the modeling, it's mandatory to gather a wealth of reference material. You might think you know what things should look like, but reference photos always help you add that extra touch of authenticity. Detailed reference materials show you things about your subject material that you might have overlooked: the way it fades in the sun, the wear from children scratching their names into it, or the bits of chewing gum that get stuck to it. These observed details put your object into a real-world context and prevent it from looking unrealistically new or featureless. When it comes to the texturing stage, your reference will help you analyze the materials that make up your character—and you might be able to use a reference photo directly in your final textures.

For each object you research, it is advisable to get reference shots from as many different camera angles as possible. We need to know about every inch of the object's surfaces; within your range of images, there should be no blind spots where important details are hidden. Don't settle for just front, side, and back views. If you take the time to observe reference shots from the more obscure angles, such as the bottom, the back, and three-quarter views, it will add a professional level of depth to your models.

I use a Google image search for most of my research, set to "high-res images only" in the advanced settings. If this search is unsuccessful, I change the settings to medium- or small-size images. The Internet has a wealth of information and there are many Web sites specific to whatever subjects you are researching. If you can't find what you are looking for, try using alternative keywords; use a thesaurus to come up with as many different names as possible for the thing that you are researching.

One of my favorite sites is http://www.3d.sk. For a subscription fee, you can download very high-res professional photographs of *real* humans—no airbrushed skin tones here! The library covers all shapes and sizes of humans: fat, thin, young, old, black, white, Asian, bearded, armored—pretty much whatever you might need as reference for your modeling. The images are all shot in scattered white studio light with no harsh shadows, which is perfect for use in your textures. The average subjects are normal everyday people, so you end up with lots of acne, spots, skin diseases, blemishes, moles, and birthmarks—all the things that add character to your creations!

You should make sure to have folders full of images concerning every aspect of what you are about to model.

Getting ready to start—setting up image planes

Image planes are used so that you can trace over the concept artwork inside 3ds Max to ensure that your model remains true to the original vision. I strongly recommend that you do not trace photos directly in the viewport, but instead use your reference as a reference—not as the blueprint for your model.

All photos are distorted by the camera's lens, which exaggerates and warps the image. Wide-angle or "fish-eye" lenses like the one used in this page are an extreme example of lens distortion. If you study some catwalk fashion photography, you will notice that models are often shot from afar with a strong zoom lens to minimize the lens distortion effect. Ideally it is this type of photograph, if any, on which you should base your dimensions—but be warned that tracing warped images directly will lead to warped models. It's better that you study proportions from life instead of relying on tracing.

Figure 7.2

To get a photograph with truly zero perspective distortion, you would have to be an infinite distance away from the object, with an infinitely powerful zoom lens just like the orthographic viewports in Max! Good concept artwork is drawn like this, with zero perspective, free from all lens distortion.

It is very important that the different views of the concept art are drawn out next to each other with ruled lines to ensure that the features match up accurately across the range of views. It can be very tricky to work from wonky and inaccurate concept art.

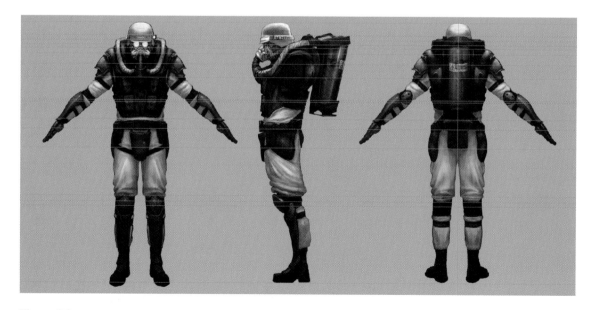

Figure 7.3

Starting to Build the Character

Let's open the concept art in Photoshop now to prepare it for use in 3ds Max as the blueprint for our character. We need three square images for front, side, and back that line up perfectly with each other.

Use the rectangle selection tool while holding down the Shift key to make a precise square selection around the front view, then copy and paste it into its own image file. Go back to the original concept art image again and use the right arrow key to nudge your square selection over to the side view. Copy and paste the side view into its own image file, then repeat the process for the back view. Our use of a nudged selection to produce our three images ensures that they will line up perfectly in 3ds Max. Save each of these three views as a separate jpeg file.

Figure 7.4

Rather than use 3ds Max's Viewport Background functionality, I prefer to create the image planes myself as geometry. I find it easier to manipulate the scale and position of the blueprints if I just map images onto planes. If I want to scale or transform the model, it's easy to include the image planes in the transformations and keep everything in sync.

Open up 3ds Max and create a square primitive plane (Create > Standard primitives > Plane). It is important to hold Shift as you drag out the dimensions of the plane to ensure accurate square proportions like the images we prepared in Photoshop. Be sure that Generate Mapping Coords is checked to save yourself the trouble of manually creating UV coordinates. Apply a Blinn material to this plane object, with 100% self-illumination

and the ambient color set to white, and load the front concept image into the diffuse slot of the material. Now position the plane so that the character is centered on the origin (the center of the world coordinate system) with his feet directly above the origin.

Select the "front image plane" object that you have just created and rotate it 90 degrees; my favorite way to do this is to hold Shift while rotating the object to copy and rotate the object in the same operation. Be sure to turn on the angle snap toggle button on the main toolbar to ensure an exact rotation of 90 degrees.

Figure 7.5

Apply a new material to this new copied object and map the side concept image onto it to create the "side image plane". Now copy/rotate the side image plane another 90 degrees and apply another new material to it to create the "back image plane", translating it back slightly to move it away from the front concept plane. The use of square images on square planes ensures undistorted and perfectly aligned features: no more messing around with translate, scale, and rotate trying to get everything to match up correctly.

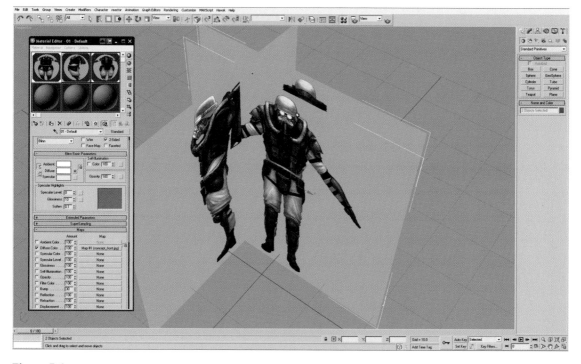

Figure 7.6

Expert mode, hotkeys, and scripting

Most modeling work involves a heavy amount of repetition, so it is more than worth your time to learn all the hotkeys for the major tools. If hotkeys are not assigned to your favorite tools by default, you can do it yourself using the Customize > Customize User Interface options. Sometimes I write a script that performs a series of commands that I repeat again and again—it's really not that hard to write basic scripts, so don't be afraid to try it out yourself. Over the years, I have customized my workflow quite extensively to save me hours of repetition per day. Once you have made a couple of characters and want to save some time and energy, you should look at using scripting and hotkeys as a way of saving lots of time.

Figure 7.7

As I've been using 3ds Max for more than nine years, I'm very comfortable with the tools and my hotkeys for each modeling function that I use on a daily basis, so I don't often use the icons. I usually run Max in Expert Mode (Views > Expert mode), which keeps my interface free of clutter, giving me more room for looking at my character. If you are just starting out, you probably won't want this, as it is good to explore the interface and each tool that is available, but it is a great option once you know exactly what you are doing.

As we are concerned with modeling, not animating, you can definitely turn off the track bar to save some room on your interface (Show UI > Show Track Bar).

Viewport preferences

By default, 3ds Max's viewports display rather low-res textures by today's standards. If you select Customize > Preferences > Configure

Figure 7.8

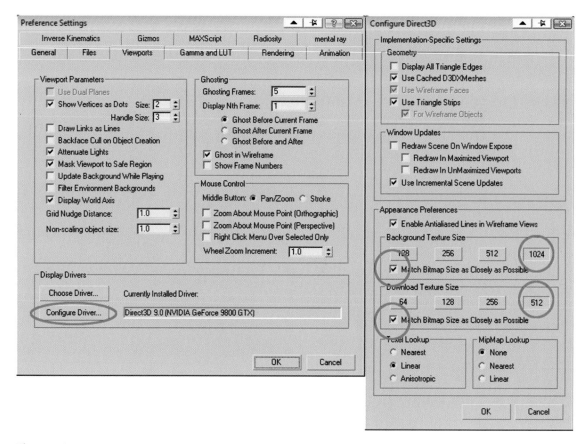

Figure 7.9

Driver, you can increase the maximum texture size. Select "1024" and check "Match Bitmap Size as Closely as Possible" for both "Background Texture Size" and the "Download Texture Size."

Getting the Basic Proportions Right

Let's start the modeling with the classic starting point: the "primitive cube", known in 3ds Max as the "box primitive". Right-click your cube to convert it into an editable poly. We will make half the character initially. Press 4 to select polygon mode and the top polygon to select it. Now use the Extrude tool to extrude the polygon upwards to make a chest, select the top poly on the left side of the shape and extrude out to make an arm, and select the bottom poly and extrude out to make a leg.

You might need to move the side image plane out of the way a little so that you can see what you are doing as our character widens. Ensure that you move it only by sliding the X transform handle; this way, we will not lose the vertical "registration" with the front and back concepts. Press 1 for vertex mode and move all the

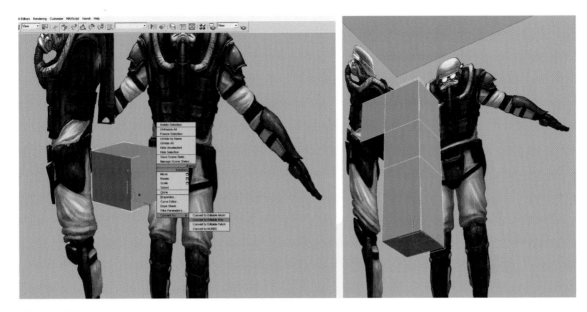

Figure 7.10

object's vertices into better positions to match the concept. It is easier to see what you're doing if you apply a new material to our object, with 30 percent opacity and a strong red color.

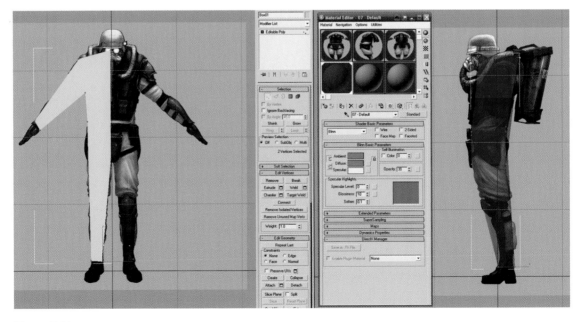

Figure 7.11

Next you should select the polys on the inside of the mesh, where the line of symmetry will go, and delete them. Press F4 to show the edged faces clearly.

Let's mirror our mesh to make the full form—it would take twice as long to do everything if we didn't use symmetry to our advantage. Activate the Affect Pivot Only button in the Pivot panel and move the pivot to the origin; be sure to deactivate the button after you have finished. Next, apply a Symmetry modifier; you might need check the

Figure 7.12

Flip box and then adjust the threshold slider until the center vertices snap together. We now have a full figure.

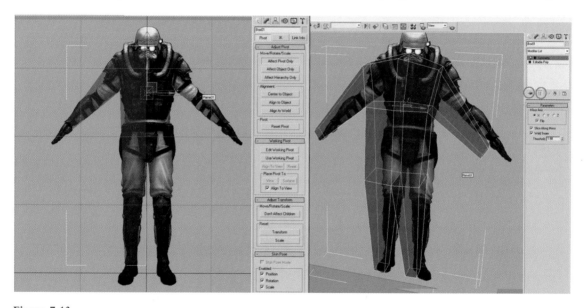

Figure 7.13

If you click on Editable Poly on the stack, the symmetry will disappear. You must press the "Show end result On/Off toggle" button (the little test tube under the stack); this will switch on all items further up the stack, which is invaluable for modeling with most modifiers. As we work, you can also switch on and off the light-bulb icon next to the Symmetry modifier to turn its effect on and off.

Let's add some more geometry to refine the shape. Select one of the horizontal edges running down the leg and press the Ring button, which selects all the parallel edges running down the leg. When the mesh gets

more complex, the Ring and Loop select functions become invaluable for making quick, accurate selections. Next, hit the rollout box to the side of the Connect button in Edit Poly to connect these edges with new polys and select two segments.

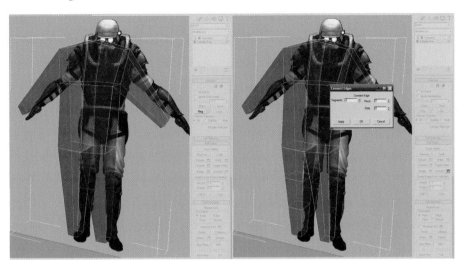

Figure 7.14

Repeat the select Edge, select Ring, and Connect process for the vertical edges running across the arm and the torso to increase the detail level further. Now spend some time moving these verts around to fit the concept sketches. The key to modeling fast is to add new geometry only as you need it. Before you add any new polys, make sure that the ones that are there already are well-placed; this reduces the amount of translating work you do substantially, as any new geometry you make will already be somewhat in the correct area. Create, refine, create, refine: our basic workflow.

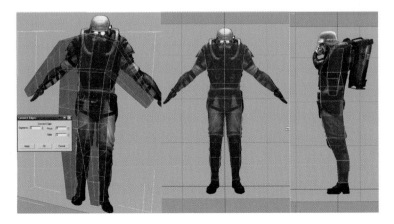

Figure 7.15

Click the poly at the end of the arm and extrude it out to make a hand. Do the same at the end of the leg to make a foot.

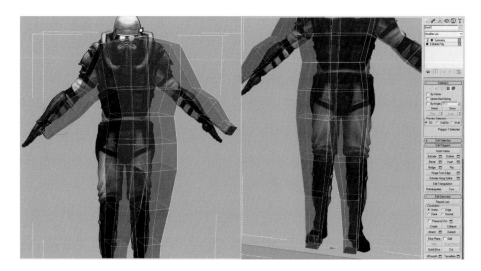

Figure 7.16

Extrude out the poly at the front of the foot to make it more natural-looking and refine all the verts of the hand and foot into better positions.

Figure 7.17

Now let's add more geometry so that we can match the concept closer. Select Poly mode by pressing the 4 key, then press Ctrl + A to select every poly on the model. We will turn every poly into four polys by pressing the Dialog Box button next to the Tessellate button in the Edit Poly rollout.

Figure 7.18

Now refine the verts to match the concept shape better. If you like, you can change the opacity of the material a little to make it easier to see the concept underneath.

Figure 7.19

Figure 7.20

To make the fingers, connect the edges at the end of the hand to make four columns of polys.

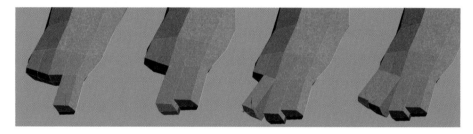

Figure 7.21

One by one, extrude each column of two polys to form each finger.

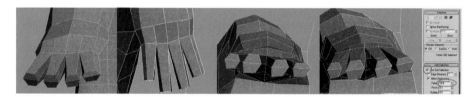

Figure 7.22

Refine the new vertices to make more natural finger shapes. I used Soft Selection with a larger Falloff setting to put a natural bend into the hand without having to move each point separately.

Figure 7.23

When moving verts in the Perspective view, I find it useful to switch the coordinate system from View to Screen. Screen coordinates aren't locked to the world x,y,z axes like the View coordinates are, making fine adjustments in a perspective view much quicker and more intuitive.

It's important with nearly all models to keep a clean, quad-based topology. A pure quad mesh is much easier to "read" and you can work faster using the Loop and Ring functions. It's hard to see what's going on if you use a lot of triangles in your mesh and they subdivide very unpredictably.

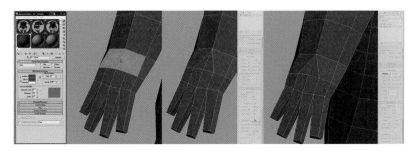

Figure 7.23

If you study the previous figure, you will notice that the two selected polygons have five vertices each; these faces with more than four verts are called "Ngons". Ngons are just as bad as triangles when subdividing; during rendering they are triangulated unpredictably, so it's better that we turn them into quads. Use the Cut tool to cut some new edges as shown previously, then select the center edge and use the Remove button to eradicate it. Do the same on the bottom of the hand, too, to rid our mesh of all the evil Ngons.

Figure 7.24

Let's add more detail to the upper arms. Select and connect the top two rings of edges.

Figure 7.25

Work the forms into the mesh, adding new edge loops wherever you need more detail.

Figure 7.26

Add more edge loops to the legs and then shape the details. Try to model the edge loops along the main creases. Notice where I have angled the edge loops down to fit the shape of the kneepads.

Figure 7.27

Extrude out a head from the top center polygon, making sure to delete the polygon that the extrusion creates on the line of symmetry, then Tessellate the head to add more detail.

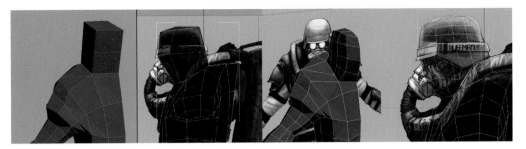

Figure 7.28

Cutting in More Detail

Now that we have the basic character shapes, let's cut in the medium-frequency details. These are the sub-shapes within each major shape, such as the main shape of each piece of armour, each strap, and the main flow of the fabrics. Add more geometry to the head, taking care to preserve a clean quad-based surface as you go. Try not to make tiny details in one area before you have cut in all the main shapes—keep the level of detail consistent across the mesh.

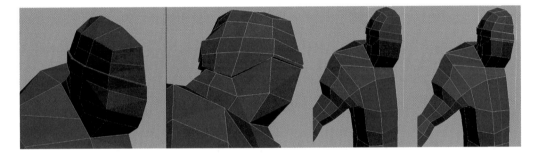

Figure 7.29

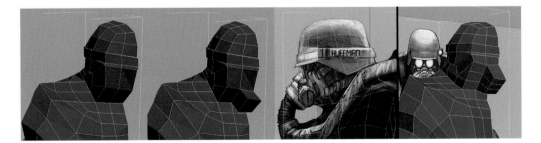

Figure 7.30

The flow of the edges is very important; our aim is to try to make all the edge loops join together in flowing and continuous lines. Good edge flow makes much smoother and more natural surfaces.

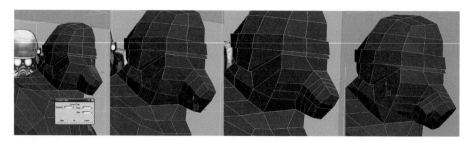

Figure 7.31

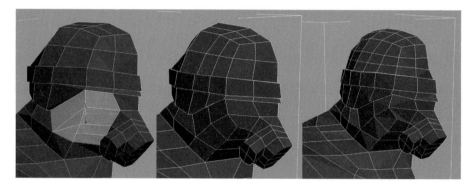

Figure 7.32

Notice the bad edge flow on the selected polygons in Figure 7.32. There is a triangle in there, too, which isn't ideal. If we add edges and rework the topology, we can create a more organized surface. Don't expect the art of a perfect quad-based surface to come to you overnight, but with lots of practice, you will prevail. If you need some inspiration, visit some Internet forums and study other people's meshes to see how they are arranging their edge flow.

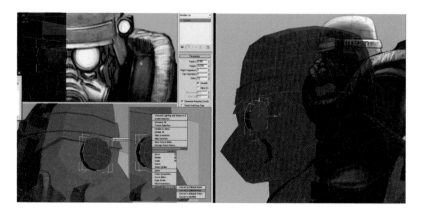

Figure 7.33

A primitive cylinder makes a great starting point for the eye, as it is perfectly round. We must make efficient use of our polygons, so play with the parameters until you get a good balance between a nice model and a reasonable amount of geometry. I chose twelve sides and only one height segment. Convert the primitive into an Editable Poly when you are done and remember to delete the back facing polygons. A classic beginner's mistake is to have loads of unnecessary polygons that are never seen because they are inside the mesh hidden by other polygons—don't do it!

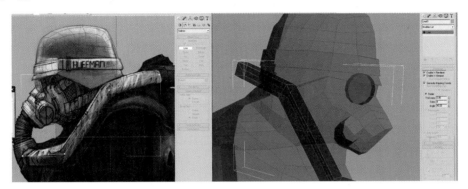

Figure 7.34

Another great starting point for your pipes, legs, and other twisty cylinders is the Line primitive in the Shapes section of the Create panel. First, draw out your line with a few simple vertices, then in the Modify panel, enable the line in the renderer and viewport, generate Automatic Mapping Coords (saving you UVing time later), and play with many aspects of the topology on the fly. It's easy, fast, and versatile, but best of all is that it creates very accurate meshes.

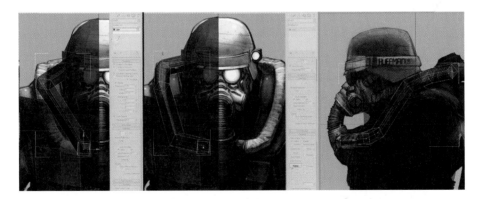

Figure 7.35

You can select and move the vertices in the Line, similar how you would in Edit Poly by using the stack in the Modify panel. Once you get the verts in the right place in each viewport, you can use the Refine tool to add more points to get the correct shape. Change the Sides parameter to give your line four sides and perhaps

adjust the Angle setting, too. If you are happy with the shape, you can convert it into an Editable Poly. Before you do so, make a copy of the line and hide it—you can return to this hidden line if you want to make quick changes to the pipe topology later on.

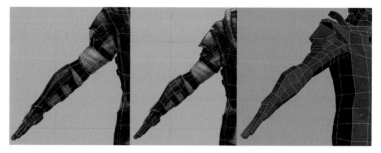

Figure 7.36

Once you have the main shapes and the edge flow working well on the arms, it's time to start extruding the pads and the straps to block out the detail. Be careful that your extrusions do not create hidden polygons inside the main geometry. The Hide/Unhide Polygon tools in Edit Poly are your best friends when things start to get a little more complex.

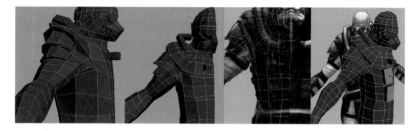

Figure 7.37

Remember to work on your model from as many angles as possible as you develop it. It will start to look flat if you only use only the front and left views.

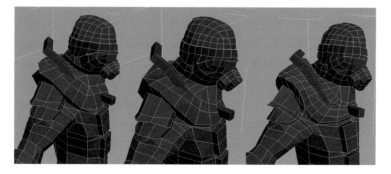

Figure 7.38

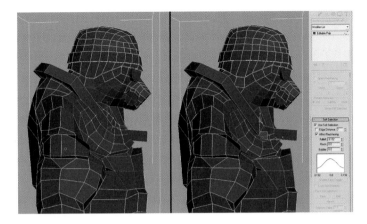

Figure 7.39

When meshes get more complex, it can be time-consuming to make changes to the overall shape, so remember to use Soft Selection. Why move one vertex at a time when you can move hundreds together? Adjust the falloff and away you go.

Figure 7.40

A primitive cylinder makes a good start for the oxygen tank; another Line primitive does a great job for the central pipe on the mask.

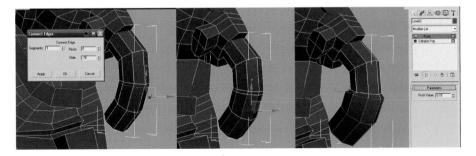

Figure 7.41

Select the line that makes the central pipe on the mask and convert it to an Editable Poly. Select the ring of edges where we want to increase the diameter of the pipe and connect the edges; use the Slide parameter to move it higher. Select the two lowest rings of edges below and apply a push modifier to flare out the pipe a little, then collapse the stack back down to an Editable Poly.

Figure 7.42

Right-click on your pipe object and choose Isolate Selection. This command is very useful when you want to see all sides of the object without other objects getting in the way. Delete the hidden faces at the top and click the Exit Isolation Mode button.

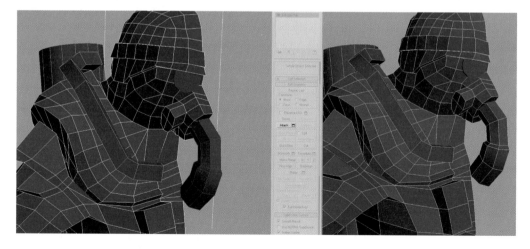

Figure 7.43

To add this pipe geometry to the main mesh, first delete the left-hand side of it so that it can be mirrored like the rest of the model. Select the main mesh, click the Attach button, and click the pipe.

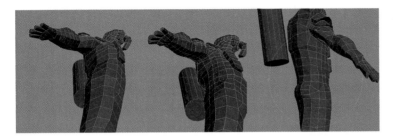

Figure 7.44

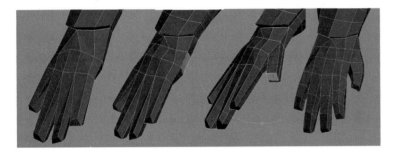

Figure 7.45

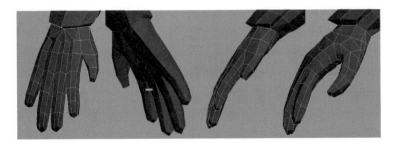

Figure 7.46

Add some more geometry around the torso and under the arms. It's important to visualize the body underneath the clothes as you mold your character. Imagine where the major muscles are sitting and how they are pushing on the clothes. It's a good idea to look at the model from underneath quite often; if you make your model look correct from this often-overlooked view it helps make your model more accurate.

Start the hands by extruding a thumb and cut in some more loops on the fingers to add a slight curve to each finger.

As you develop the hand/glove, it's useful to have your reference by your side, so that you can copy the real-life hands/gloves as closely as possible. If you're having trouble making your hand look correct, study your own hand. One of the most common beginner's mistakes is to make the thumb bend like the fingers. The thumb should bend at 90 degrees to the bend of the fingers. It's also very important to build curvature into the palm.

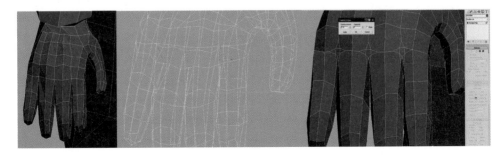

Figure 7.47

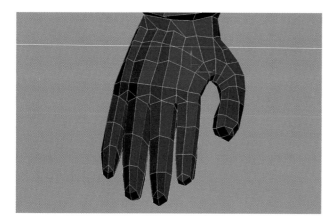

Figure 7.48

Let's make the gaps between the fingers less angular and more natural; select the edges between each finger and chamfer them.

Cut some edges and weld (I like to use Target Weld) the rogue points together so that you get a topology something like Figure 7.48. The aim is to get a smooth loop that flows around the rim of the glove. The glove isn't perfect yet, but let's move up the arm so that we keep an even amount of detail across the body.

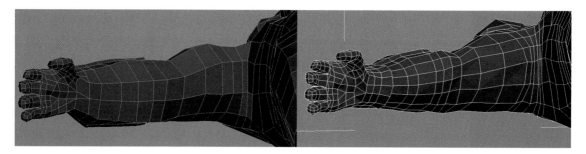

Figure 7.49

Try to improve the look of the arm as much as you can without adding any more geometry. Once everything is in place, cut in more loops to define the straps and pads on his arms. Pay attention to the direction of the loops; they must follow the contours of the outfit.

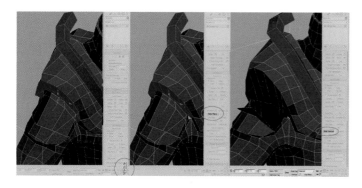

Figure 7.50

When modeling hard-to-reach places such as the cavity near the shoulder pads, you have a few secret weapons in your arsenal. It will be much easier to rotate around your selections if you activate Arc Rotate SubObject near the bottom right of the interface. You can flatten areas by selecting the relevant polygons and pressing the Make Planar button. If you wish to smooth out a selection of polys, press the Relax button. Another top tip for

being able to see what you are doing in difficult places is to hide some polygons. Press the Hide button to hide your selection of polys; Unhide All brings them back when you have finished.

Continue going around the body, looking at it from different angles and tightening things up. Be sure to study some reference material of a suitably tough-looking male, shot from as many different angles as possible. Good anatomical references help you build up the volumes of muscle, bone, flesh, and fat that lie underneath our character's clothing. Again, working from the obscure top and bottom angles really helps give an extra "punch" to the forms.

At this point, you should have all the major shapes modeled in like shown in the following images. The total character at this point contains approximately 5,000 triangles.

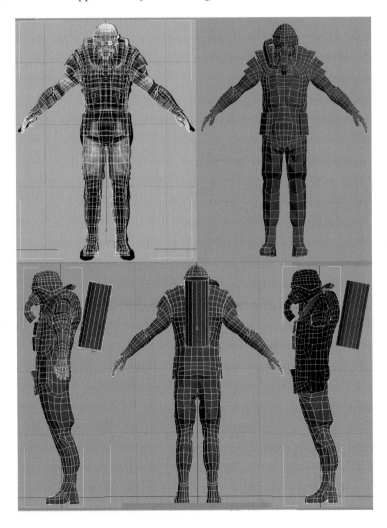

Figure 7.51

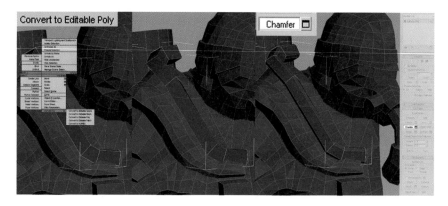

Figure 7.52

Once you are happy with the air pipes that you made with the Line primitive, you can convert them to an Editable Poly. The edges are a little sharp, so use the Chamfer function to round them out a little.

Continue to work more detail into the main lines of the mesh, using all our old favorites such as Cut, Move, Loop, Ring, Connect, Extrude, Relax, and so on.

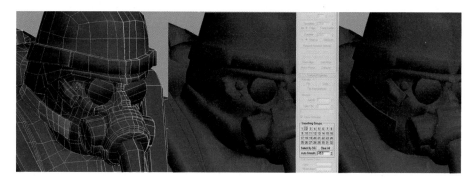

Figure 7.53

I find it easier to work with the mesh if I give each major group of polygons (kneepads, sole, glove, and so on) a different smoothing group; this allows me to better see the boundaries between different areas. A fast way to do this is to use the Auto Smooth button, but you might need to refine its work in places.

Keep adding details until your mesh is about 13,500 triangles; you can use the following images for rough reference. Don't go crazy trying to match my model exactly, but the detail should be evenly spread throughout the body, with a slight emphasis on the face.

Make sure to save your mesh around this point. Although it isn't detailed enough for our high-res mesh, it is certainly a good starting point for additional detail. Also, with a little tweaking, it will make an excellent game mesh when we load it back up later on. I call this mesh the "proxy mesh", as mentioned earlier, because it is approximately the same form as both the game mesh and the high-res mesh.

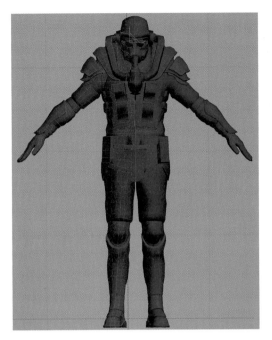

Figure 7.54

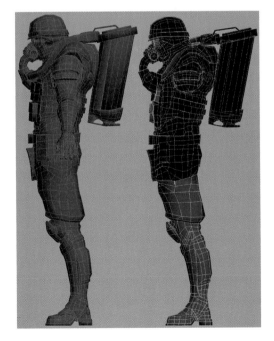

Figure 7.55

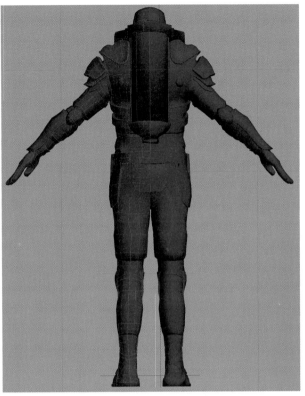

Figure 7.56

The High-Resolution Mesh: Breaking Up the Shapes

Now it is time to start the high-res modeling. As the level of detail increases, I find it much easier to work if we break up the mesh into each individual component. Select the polygons for each distinct part of the body and break them into separate meshes using the Detach button. Each mesh can then be isolated if you need to work on the hard-to-see areas.

If the separate parts of the mesh aren't actually welded together, you can easily select them for detaching using the Element selection.

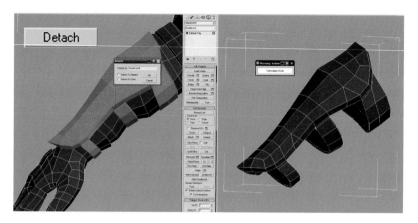

Figure 7.57

Figure 7.58

The Shell Modifier

It's very important to give even the thinnest shapes some amount of thickness. The quickest and also the most accurate way to do this is to apply the shell modifier and increase either the Inner Amount or Outer Amount parameter. You might want to delete some of the polygons on the inside, as they won't be seen.

The High-Resolution Mesh: Adding More Detail

As you add all the sub-shapes that make up each piece of the character, you should not need any other tools than the ones we've used already. Just study the concept and the reference material very carefully as you work. Be careful not to get into too much detail in any one area of the character. The aim is to roughly mark in all the shapes until you get to about the level of detail in the following images:

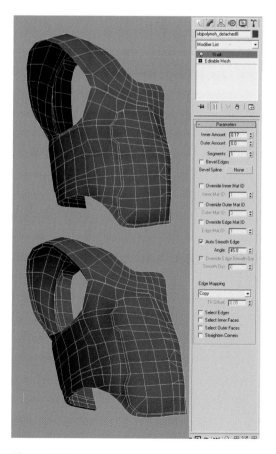

Figure 7.59

Helmet

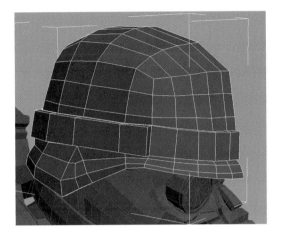

Figure 7.60

Mask

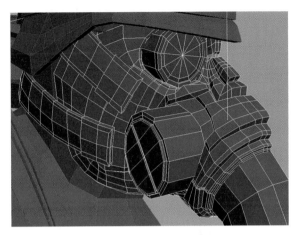

Figure 7.61

Vest

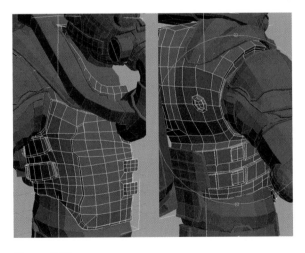

Figure 7.62

Shoulder Pads

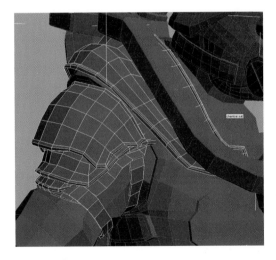

Figure 7.63

Forearm pad and kneepad

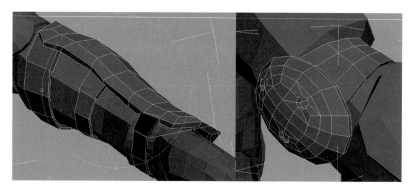

Figure 7.64

Gas Tank

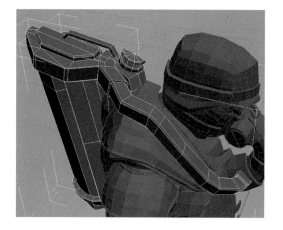

Figure 7.65

Glove

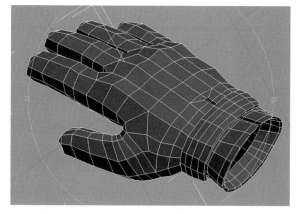

Figure 7.66

Belt and details

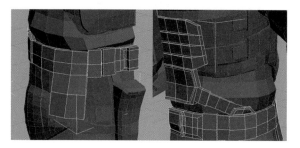

Figure 7.67

Codpiece and other details

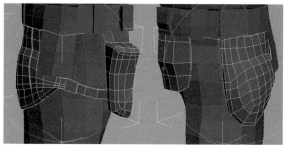

Figure 7.68

Shin Pads

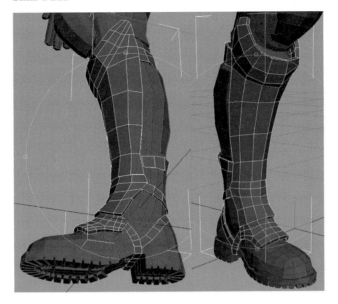

Figure 7.69

Kneepad and Shoe

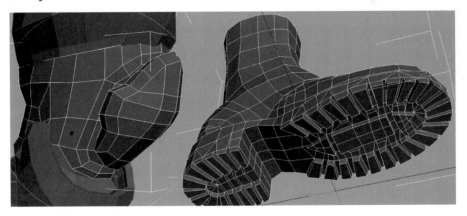

Figure 7.70

Most importantly, the chemical suit is modeled underneath everything. This will make sure that there are no gaps left in our mesh. A common beginner's mesh will have lots of holes in it where the various meshes meet and this is a great way to avoid that. Don't model any creases or folds yet; we will tackle that later.

Chemical Suit

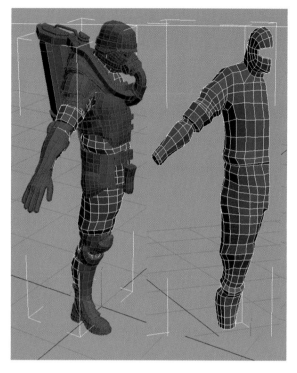

Figure 7.71

Breathing pipe

An accurate and super-fast way to make the breathing pipe is to use the Loft compound object. Delete the old breathing pipe and in the side view, draw out a rough spline using the Line primitive. I've indicated on Figure 7.72 the three clicks that I made to draw the line. Be sure hold the left mouse button down as you drag out each point so that you can control the shape of the line as you create it.

If your line is anything like mine, it still looks a little wonky! Go into the Modify panel, select Vertex, and then click on each point and adjust the handles to get a good, smooth line. Also check that your line is correctly positioned in 3D space; it should be centered on the symmetry line of the model. We will call this line the Path of our loft and it gives the shape to the length of the object.

Let's draw the shape of the Profile curve that will give the volume to our Path line. For this we will use a circle primitive from the Splines rollout. Drag out the circle from the top view and scale and position it at the top of the Path curve. Take care to *not* rotate it.

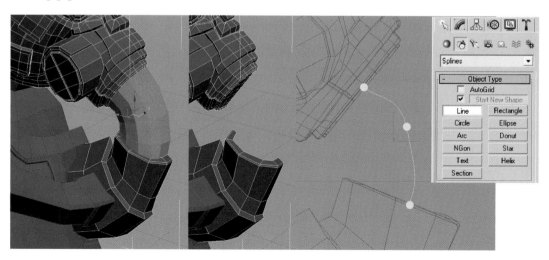

Figure 7.72

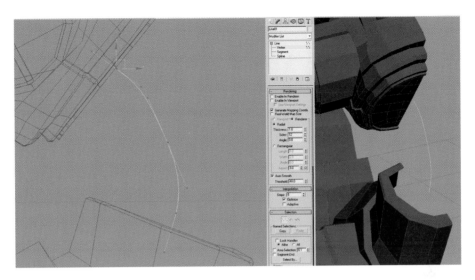

Figure 7.73

Figure 7.74

The next step is to reset the Xform of these two splines. Reset Xform resets the translation, scale, and rotation information back to how they were when the object was created. Having "zeroed out" transform values is critical for operations such as lofting that rely on this information. Reset Xform can be found in the Utility panel; with each of the two loft curves selected, press the Reset Selected button.

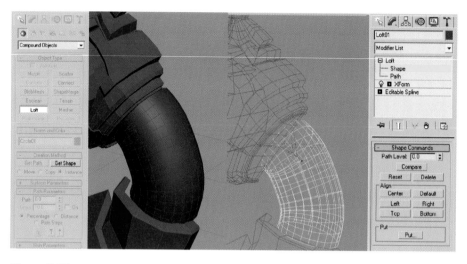

Figure 7.75

Select the Path shape and execute the Loft command, which is hidden in the Create panel's Geometry section (select "Compound objects" from the drop-down menu). Click on the Get Shape button, then in the viewport, select the Profile circle, and 3ds Max should create a basic Loft shape.

Figure 7.76

We have the basic shape looking pretty good now, but the real power of Loft shapes comes with the Deformation controls. Let's use the Scale deformer to add the ribbed details to the surface. At the bottom of your new Loft object's modifier panel, click on the Scale Deformation button. Adjust the graph that pops up so that it is long and thin as shown in the previous image. You might find that the zoom extends the horizontal button—useful for framing the graph correctly in the window.

Figure 7.77

Select the Insert Bezier Point button from the Scale Deformation interface.

Figure 7.78

With the Insert Bezier Point tool active, click on the red line to add a Bezier point at roughly every four units along the X Axis, across the line; your line should look something like Figure 7.78.

Figure 7.79

With the Move Control Point tool active, select any one point on the graph. You can see the xy coordinate of the selected point in the bottom right-hand area of the Scale Deformation window.

197

The "x" represents how far along the Path we are and "y" represents the scale (which is constant at 1 the whole way across, at the moment). To get our ribbed details spaced apart with precision, let's type in an exact number into the left-hand x coordinate box for each point. Here, your knowledge of your "3" multiplication tables will pay dividends! Repeat after me: 3, 6, 9, 12, 15, 18, 21, 24 … 96, 99.

Figure 7.80

To create the bumps in the ribbed surface, select every other vertex (that is, the ones at 3, 9, 12, 18, and so on), and in the "y" coordinate box, type in 90. Boom! The details appear. Open the Modifier panel and check the Generate Mapping Coords option, which will save us time when generating UVs later.

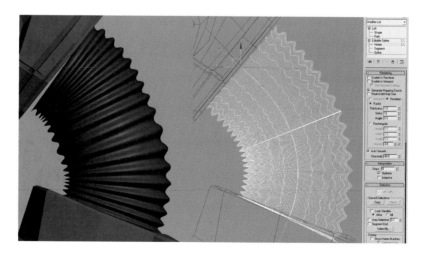

Figure 7.81

Subdividing Your Model with TurboSmooth

The mesh is getting pretty detailed now, but it would take an eternity to keep adding geometry until we lose the harsh, angular look. This is where the TurboSmooth modifier comes in very handy.

Each iteration of TurboSmooth subdivides each polygon into four smaller polygons, relaxing them at the same time. Similar technologies exist in all major 3D applications. These types of surfaces are generally known as "sub-divisional surfaces", or SUBDs for short.

The key advantage to using TurboSmooth is that we can make fast changes to a simple poly mesh and not get bogged down tweaking millions of vertices to make a smooth curve. This smoothness is also the biggest drawback; at times it can be very tricky to preserve areas of the model that require sharp edges.

Micro-Bevelling

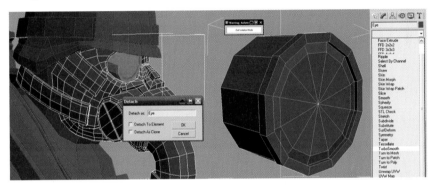

Figure 7.82

Let's start our smoothing process with one of the simplest objects, the lens of the goggle in the mask. Select just your eye geometry and detach it to create a separate mesh.

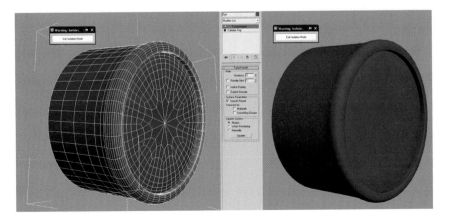

Figure 7.83

Apply a TurboSmooth modifier and push the iterations up to 2. As you dial up the iterations, the circular form of the eye gets rounded nicely, but we lose the crisp edges on the corners.

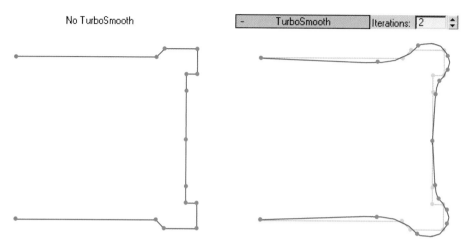

Figure 7.84

We can see the TurboSmooth effect most clearly by studying the side profile. TurboSmooth works by averaging out the positions of the vertices; those that are far apart from each other get moved quite substantially, and not always to your advantage. If you build your models with vertices closer together in areas with drastic changes of shape (sharp edges), they will be less dramatically affected when TurboSmoothed.

Figure 7.85

Go down the object stack and select Editable Poly. Select all the corner edges that you would like to sharpen up using the Loop tool. Chamfer these edges so that you get a nice corner bevel on each edge; I used the

setting 0.012 for the chamfer amount, but this will vary depending on the scale of your scene. Select two segments for each chamfer.

Figure 7.86

Your cylinder should look something similar to this figure from the side profile; the extra geometry locks into place the effect of the smoothing.

Figure 7.87

The results should be like the previous image: a perfectly round cylinder with hard edges at the corners. This technique is dubbed "micro-bevelling" in the industry, because sometimes the detail you must put in on an awkward corner areas gets pretty tiny.

If you build your models with nice, orderly quads, it is very fast and easy to add micro-bevels by selecting loops and chamfering them. Another advantage of doing your modeling operations on loop selections is that it keeps everything uniform across the edge. Most machined, inorganic forms like this goggle lens are made

on a production line in a factory and, as such, are very regular shapes. Unless you want this type of shape to look worn or old, you should try to avoid going in and hand-tweaking individual vertices; it will lead to irregularities that make them look hand-made. Instead, do your inorganic modeling using modifiers and operations on loop-based selections.

Micro-bevelling the shoe edges

The really tricky SUBD stuff comes when we have edges on more than one axis coming together. For example, take the edges of sole of the shoe where the tread pattern might involve bevelled edges meeting on all three axes at many corner points. The simple solution is to do all your chamfering at the same time.

Figure 7.88

First, select all the edges that you would like to perform the chamfer on.

Figure 7.89

Then use the Chamfer button and tweak the amount to control the roundness of the edges.

This way is much faster and cleaner than doing your bevelling one piece at a time. If you select some edges, chamfer them, and then repeat the process for other nearby edges, things quickly get messy. If we perform the chamfer operation to all the edges at the same time, we create a relatively orderly and even topology.

Figure 7.90

The last thing to do is to go through the mesh and reorder the topology to get the nice and clean square-quads look that characterizes a high-quality SUBD mesh. I've detached the sole from the shoe to help keep things simple.

Figure 7.91

Finishing the symmetrical details

One by one, work through your objects, adding TurboSmoothing, refining the details, and taking special care with the details of sharp and bevelled edges. Avoid creating any asymmetrical details (such as the creases and folds of his trousers); we will tackle these details later on.

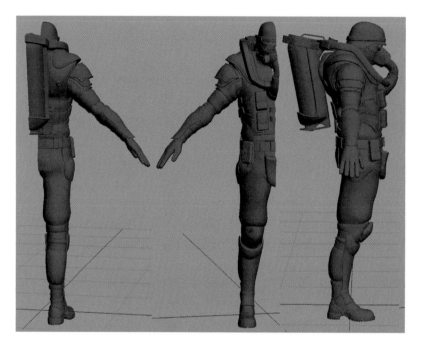

Figure 7.92

Your mesh should now look something like the previous image, with everything apart from the asymmetrical folds and creases of the clothing modeled in fine detail. Once you are happy with your half-character, give it another quick check for holes and other defects. It's much quicker to fix things now, before we copy the mesh across the central line of symmetry and create a right side and a left side that both need identical repair work.

In 3D modeling, it is always beneficial to use symmetry to your advantage. If you take care to get things as good as you can before you mirror them, it will make your modeling almost twice as fast.

Making the UVs in UVlayout

In order to get a texture onto our high-res model, we need to give it UV coordinates. This procedure can be time-consuming and, dare I say it, tedious and boring! Typical high-res meshes have polygon counts measured in the millions, so we need every trick in the book to get these UVs done well in a reasonable amount of time. 3ds Max has some fairly good UVing tools for production like the Pelt Mapper and the Relax function, but

I've found a small program called UVlayout to be far superior when generating UVs for complex high-res shapes. UVlayout optimizes your UVs for subdivision, taking into account how the UVs will be stretched when subdivided.

The UVlayout interface is not very pretty or intuitive, but if you watch the tutorial videos available for download from http://www.uvlayout.com, you will see just how amazing the program is. So don't judge this book by its cover! In my experience, unwrapping in UVlayout is more than twice as fast as unwrapping in Max, Maya, or XSI. The quality of UVs that UVlayout produces is also much higher. The distortion free UVs generated by UVlayout will save us lots of time and prevent frustration later when we come to texture this object. A trial version of this software is available on the DVD under \UVlayout\.

To keep things simple, we will import and unwrap each part of the character one piece at a time in UVlayout, so export each part as a separate Wavefront (.OBJ) file from 3ds Max (File > Export Selected). You should now have a list of objects organized in a UVing folder (such as belt.obj, boots.obj, vest.obj, and so on).

Figure 7.93

In UVlayout, click the blue Load button and browse to your UVing folder where you saved all the OBJ files. Load kneepad.obj first; it's a simple object that will make a nice introduction to UVlayout. Remember to check your Load Options before you load the mesh; UVlayout will take the effect of the TurboSmooth SUBD's into account if you select Type "SUBD". Be sure to select the UV's New button too, which deletes any old UVs that might be already applied to your object. Check the Weld UV's and Clean boxes to ensure a tidy mesh, and then, with the correct object highlighted in blue, click the green Load button.

Figure 7.94

The first thing that you might notice is that your kneepads are being viewed from below. Open the Display panel and select "Y" to change UVlayout's coordinate system. If you hold the Alt key, you can navigate in the 3D scene using the left mouse button to orbit, the middle mouse button to pan, and the right mouse button to zoom in and out. In the Display section of the interface, there are three different types of views, which you can select quickly using the 1, 2, and 3 keys:

- UV view shows in 2D your unwrapped UV coordinates.
- Ed or Edit view shows in 3D only your objects that currently have no UVs assigned yet.
- 3D view shows the original 3D object intact.

Figure 7.95

When you load the kneecap object into UVlayout, the default view is the Edit view. As you selected NEW when loading the object, it will have no UVs, and therefore its surface should be gray. If you move the mouse cursor over the main plastic kneecap shape at the front of the object and press D, the kneecap will disappear. The shape has not been deleted; instead, UVs have been assigned to it, so it is not shown in the Ed view anymore. Press 1 to jump to UV view and locate your kneecap UVs, which should still be a gray color, as they are not flattened out yet.

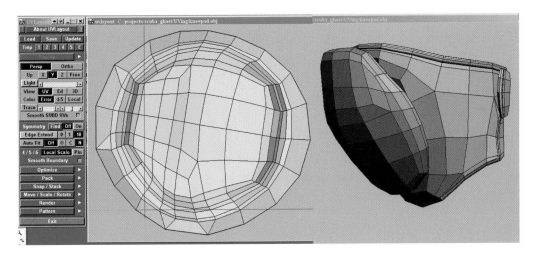

Figure 7.96

While you are still in the UV view, hold your mouse cursor over the kneecap UVs, hold the spacebar, and press F. Watch with joy as the UVs unfold themselves in a weird and wonderful way. Colors appear on the UVs now: red represents areas that do not have their fair share of UV space and blue represents areas that have too much UV space. Both red and blue areas show distortion, and we must seek to minimize that. If you press 3 to jump to the 3D view, you can see the colors now applied to the kneecap, showing in 3D space where the distortion is occurring.

Let's help the UV shell relax a little more by making some cuts; cuts in the correct places will help our geometry unwrap. For most "closed" objects, cuts are mandatory—anything circular like a cylinder or sphere needs at least one major cut in order to be able to unwrap at all. I like to think about unwrapping similar to how a primitive stone age hunter might skin an animal to make a cave jacket. A less gory analogy is to compare your final layout of UVs to how a tailor cuts shapes from a blank piece of fabric to make a garment.

Like the seams that a tailor deals with, cutting up your shell generates UV seams in UVlayout. The UV seams are a necessary evil that you must minimize. These could cause problems later if you want to paint your textures quickly and easily in Photoshop. You will need a 3D paint program such as ZBrush or Bodypaint in order to be able to paint continuous textures over seam areas. Furthermore, each UV seam can cause problems further down the line with normal mapping.

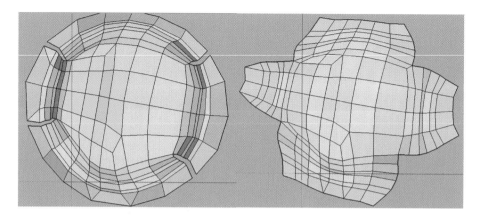

Figure 7.97

Press 1 to jump back to the UV view and then zoom into the top half of the kneecap UVs so that you can clearly see the details of each edge. With the mouse hovering over the relevant edges, press the C key a number of times to make cuts as shown above. Remember that the first cut you make must start from an open edge on the outside boundary of the shell; you cannot start your cuts from the middle of the shell. If you make a mistake, you can weld your cut edges back together by hovering over them and pressing the W key. With the mouse cursor hovering over the object, hold the spacebar again and press F to unfold the object once more. It should be able to relax much better now with the new cuts, giving you a new relatively distortion-free unwrap.

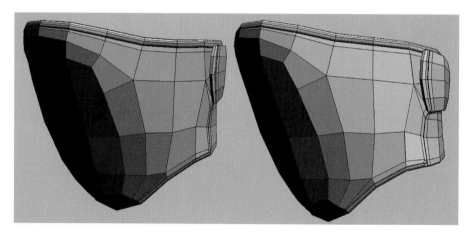

Figure 7.98

In Edit mode, the C and W keys have extended powers, in that they work well with Loop-based topology—another great reason to model in clean quads as much as you can. As UV seams hinder our texturing, we must hide them away, thinking carefully about their placement before we draw them.

On character legs, the most unseen areas are the inside surfaces—they are normally hidden by the opposite leg. Go to the inside leg side of the "kneepad elastic" shape and press the C key on one of the vertical edges. Your "cut" edge is marked in red. UVlayout will try to predict how you would like to continue the cuts along the loop with lines marked in yellow. If you disagree with any of these yellow lines, you can weld them back together with W. It takes only two or three clicks with C and you should have made enough cuts to unfold this area successfully.

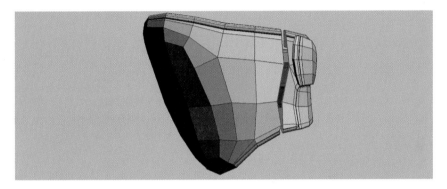

Figure 7.99

As we are dealing with a "closed" shape, before we drop the shell into UV space, we need to "split" the cut edges. Hold your mouse over the red and yellow edges that you wish to split and press Shift + S to use the Split Seams command. The edges should split apart like in the previous example.

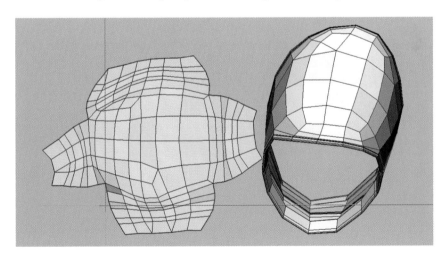

Figure 7.100

Now you can press D on this mesh to drop it into UV space, press 1 to go back to the UV view, and then unflatten it as shown in Figure 7.101.

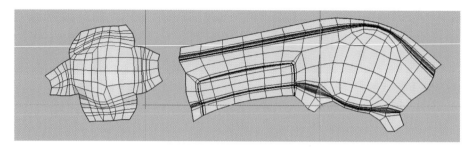

Figure 7.101

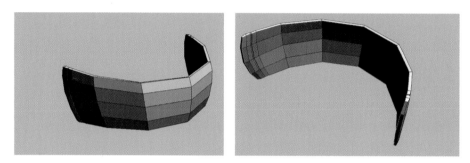

Figure 7.102

Press 2 to jump to Edit view and you will see that there is now just the strap which doesn't have UVs. Use the C key to make cuts until you have a closed loop of cuts going around in a circle. As always, it is best to hide the seam on the inside surface of the strap where it won't be seen clearly; you will get an intuitive feel for where to place seams after spending plenty of time unwrapping various objects.

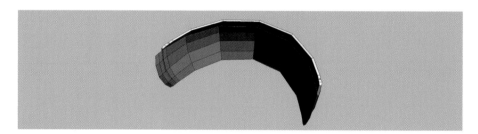

Figure 7.103

Again, press Shift + S to split the seams, then press D to drop each piece into the UV mode. Press 1 to go back to UV view and unflatten each piece.

Figure 7.104

If you press W on a few of the shared edges of these two straps, you can see the matching edges turn red to indicate that it is possible to weld them back together. Press Return on one of these shells once you've marked some red weld lines and UVlayout will join them back together. Unflatten the shells again to finish and save your work.

Figure 7.105

For anyone from the old school of UV unwrapping, UVlayout is nothing short of a revolution. It would take me days to unwrap a simple 1,000-poly character in 3ds Max 3 with the Unwrap modifier; the same job now takes less than an hour and I get much better results, too. UVlayout is incredibly powerful software, but I can't hope to cover all the cool features like pinning UVs, straightening UVs, and auto-packing UVs in this chapter. If you want an easy life with UVs, you would be wise to watch all the tutorial videos posted on the UVlayout Web site.

It's essential to unwrap our half-character *before* we mirror over our character; this precaution will make things go almost twice as fast. Once you are happy with your half-character unwrapped, you can add a Symmetry modifier to the mesh, collapse the stack, and then select and flip the UVs from one side to the other. It is then a simple job to weld the left and right halves together to get rid of any unnecessary seams. When arranging my UVs, I start with the largest shapes first; the smaller shapes will fit in the gaps once you have the main shapes in place. Try not to waste big areas of space in your UVlayout, because in video games memory is critical and shouldn't be frittered away on half-empty maps.

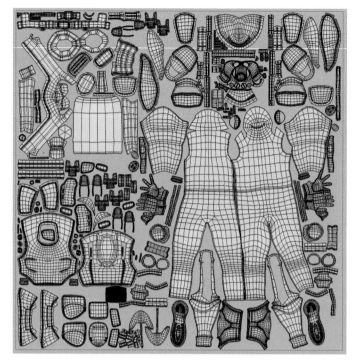

Figure 7.105

I like to lay out my UVs in a meaningful arrangement, with the head at the top and the feet at the bottom, arranged as if the character is looking straight at you. If you pass your work through a production pipeline, anyone who has to pick up your work and make some tweaks to the texture will thank you for making the texture layout as readable as possible.

The Asymmetrical Details: Making the Folds and Creases

It is now very common in professional modeling production pipelines for two or more apps to be used, as each application offers its unique advantages. More and more studios are turning to ZBrush to make the organic shapes that characterize the folds and creases that occur on clothing and anatomy. ZBrush can make the process of organic detailing quick and easy, but as this book focuses on 3ds Max, we are going to make the folds the old way: with SUBD surfaces. Traditional SUBDs take longer to produce, but one benefit will be the efficient use of polygons and system resources. Our Max clothing will be perhaps ten times lighter (very high-poly assets are described as "heavy" in industry jargon) than a typical garment detailed in ZBrush and it is good practice for making flowing SUBD geometry.

On the concept that I have been given, the creases are symmetrical—probably a measure taken by the concept artist to shave some hours off his busy schedule. Copying this symmetry into the 3D model is not good for realism, as the creases in all clothing are asymmetrical. Knowing when to follow the concept and when to

correct it is very important. Keep a sharp, critical eye on your work so that the mistakes of the concept artist don't get transferred to your models.

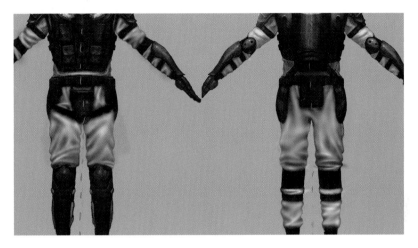

Figure 7.106

As the creases and folds of the fabrics can take a couple of days to model in SUBDs, I've sketched out a quick plan for my creases first. This way, if I don't like the flow of the creases, I can quickly amend them in minutes not hours.

Flow, flow, flow!

When modeling organic shapes like the creases, it is critical that each curve flows smoothly into the next; look for unnaturally straight lines and eliminate them. Use Relax to melt the polygons into each other. It makes sense to assign a hotkey to the Relax button, as you should constantly use it.

Take care that your creases don't all point in one direction; study some photos of people in clothing and you will see the multilateral qualities that creases take on as they try to conform to the shape of the body.

If you use Relax multiple times and the geometry still looks jagged and awkward, the problem is probably your edge flow. Put your mesh in wireframe and adjust any areas where the edges don't run together in nice smooth lines.

Gravity, tension, and the feel of the fabric

Be aware of gravity and how it affects your garments: baggy areas sag, but areas supported by the body remain firm. Imagining the body underneath the clothing is very important. Be aware that protruding parts of the body, belts, and straps pull on the fabric creating areas of tension. I keep lots of reference of the material that I'm modeling handy as I work to make sure that my model has the same look and feel as the fabric that I'm trying to mimic.

Figure 7.107

To start, just model in all the major creases of the body without too much care for the topology. Try to get the edge loops pointing in the same direction as the flow of the fabric for now—it should look something like Figure 7.108 I have isolated the mesh for better system performance, but for many areas, it's important to view the rest of the character as you create an NBC suit so that you can really get the feeling of the suit material bunching up in areas where it is restricted by the pads and elastics straps on top of it.

Figure 7.108

Figure 7.109

Once you have cut in the basic shape of each and every crease and fold, you can add additional details to refine each part. When all the details have been modeled in, it is just a matter of reflowing the topology to eliminate any awkward areas that don't look so smooth and natural. It is good to preview your suit all smoothed out with the TurboSmooth modifier at regular intervals so that you can see how it will look when it is finished.

Bear in mind that although it is possible to model on the Editable Poly with the TurboSmooth showing further up the stack (using the Show End Result toggle), in the industry, it is generally considered bad practice. Meshes created in SUBD mode like this quickly get messy and tangled up, and are very confusing to work with if you have to drop back down to the Edit Poly level to make a change. With SUBDs, experience is the best teacher; a few projects down the line, you will be able to accurately predict how your meshes will subdivide. Don't rely on TurboSmooth to create a smooth mesh for you—it's only as good as the base mesh that you feed into it.

Once you've finished adding all the creases, reflatten your NBC suit UVs in UVlayout and make any final tweaks to the layout. It's important to get the UVs as distortion-free as possible to make life easier when texturing.

The ambient occlusion bake

Ambient occlusion (AO) maps are an industry-standard method of baking subtle lighting information into models. AO maps describe how exposed each part of the surface is: the cracks and gaps hidden away in cavities receive very little light and render in dark tones, and the flat, exposed surfaces render in light tones. An AO's soft, scattered light adds a great feeling of depth to your creations. I find it very useful when finishing off my model to render an AO map and apply it to the model. Rendering AO maps in Max is very simple:

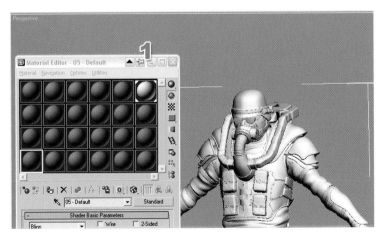

Figure 7.110

- Apply a white Phong material to your character.

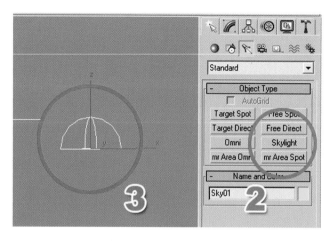

Figure 7.111

- Go to the Lights creation panel and select Skylight. Click to create a Skylight anywhere in the scene. The placement is not important; anywhere will do.
- Select Render > Advanced Lighting > Light Tracer. Be sure that the "Light tracer active" box is checked.
- With the character object selected, click Rendering > Render To Texture.
- Choose an output path for the AO map. Be sure that this render will use the Existing (UV) channel.

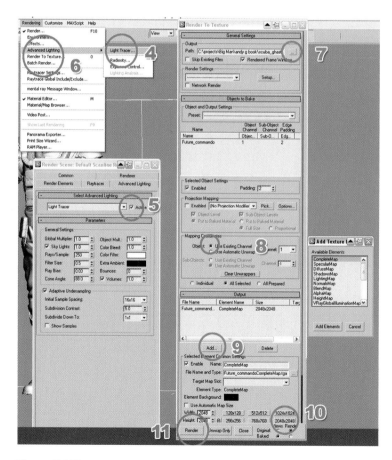

Figure 7.112

- Add a CompleteMap render element. Choose a map size of 2048 × 2048.
- Hit Render and watch as 3ds Max calculates the AO and renders it to a texture.

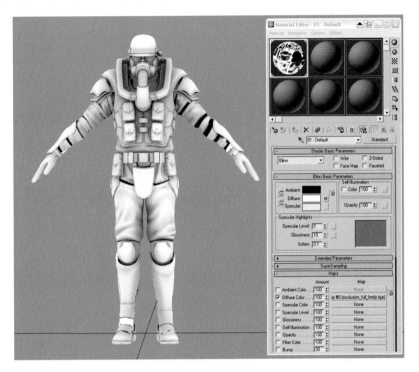

Figure 7.113

- Apply the newly created AO map to the diffuse map slot in the character's material and set the diffuse color to white.

Figure 7.114

With AO applied to the model, it is a lot easier to see where all the overlapping geometry, holes, and other UV errors are occurring.

If you get areas that have rendered with weird-looking patterns on them, the chances are that you have overlapping UVs. Apply the UnwrapUVW modifier and make sure that all the UVs have their own space; get rid of all the overlapping UVs.

Figure 7.115

AO helps me a lot when fixing overlapping areas, as it really highlights anything that's not right. Have a quick look over your model to see if you have any problems with intersecting geometry.

Once you've fixed all these problems, you can render the ambient occlusion map again; if there are still problems, repeat the process until you are entirely happy with the model and the UVs.

Final Tweaks

So you think youve finished the modeling? I ask you to take another detailed look over your model—you will probably find some mistakes. Perhaps wait a day and come back to your work with fresh eyes. I know some artists who like to flip their work upside down or mirror it horizontally when reviewing their work, as this can give you a different perspective on that model you've been staring at it nonstop for upwards of three weeks! I like to squint my eyes when looking at the overall proportions, which blurs out the details and leaves me to focus on analyzing just the basic colors and shapes.

Art is subjective and it is important to note that no artist is perfect; this is why getting other people's opinions of your work is very important. If you have no immediate group of peers, Internet forums can be an important place to get constructive criticism of your work. Good constructive criticism offers ideas for improvement of your work and does not dwell on the mistakes, apart from as a positive way of improving your work.

People make mistakes. This is why the work of companies is often (but not always) superior to the work of individuals, more eyes checking for mistakes—too many cooks don't always spoil the broth! Get opinions from your friends; maybe even your family can help you spot weak areas that need improvement. Everyone is an expert when it comes to looking at people and even your little sister might be able to spot something that you overlooked, like a nose that is too big or legs that are too small.

On my first check of the model, I noticed and fixed lots of little gaps between the objects and added the bumpy creases to the two breathing pipes leading to the mask. I also tweaked a few of the folds on the NBC suit to make them look more natural. On my second pass around the character, I moved the head back and the shoulders forward a little, as his head looked too far forward on the concept. To make the gloves look used, I added some creases and bumps to the gloves. On my third check of the character, I noticed a big gap under the shoulder pads, so I built some geometry to act as the inner padding.

The following figure shows the final high-res model.

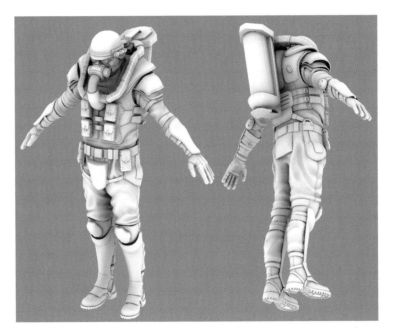

Figure 7.116

Texturing Eats Your RAM!

The texturing process can really put strains on your system, and in particular your RAM, which holds all the texture information in temporary memory. During the texturing process, I sometimes need to use from two to five applications at the same time, which can really stretch the multitasking capabilities of your machine to the limit. If you encounter long periods of down time as you swap applications or perform operations, you probably don't have enough RAM.

To compound the RAM problems during the texturing process, I will be working with a rather large 4 K (4096 × 4096-pixel) PSD file, even though the final textures will be only 2 K (2048 × 2048 pixels). Working like this with a higher-resolution PSD file ensures that your final textures won't lose clarity after you have resized, warped, and liquefied them several times. Another advantage is that you can use the full 4 K maps for detailed close-up renders of your character—this will win you the dream job for sure!

I recommend a bare minimum of 2048 MB (2k) of RAM in your system, especially on the RAM-greedy Microsoft Windows Vista. There is really no such thing as too much RAM when working in the CGI industry. If you have problems, you could consider networking your desktop to another computer, like a laptop, which you could use beside your desktop computer to run Photoshop and create the textures, freeing up your main system's RAM for the demands of 3ds Max. If you really have problems with texturing on your system, you might want to halve the dimensions of all the textures I use during this chapter; this will make the texture size four times smaller. Instead of previewing my textures in large, uncompressed TIF format, as some people recommend, I prefer to use high-quality JPEGs to save on RAM.

Today's 32-bit operating systems like Windows XP Home Edition register a maximum of only 3.2 GB of RAM; any more than this is wasted, as the 32-bit OS will just ignore it. An emerging solution to your RAM woes is to use one of the new 64-bit operating systems like Vista 64 or XP 64, which theoretically work with up to 16 exbibytes of RAM! That's more than enough for your needs.

Baking the Basic Colors

Let's get some colors on the model now. We could paint them on in Photoshop, but I prefer to apply the colors in 3ds Max and bake them onto the texture. Baking the colors is much faster and usually better quality as you don't have to do any fiddly paintwork in Photoshop. Painting the color texture by hand in Photoshop can be time-consuming and problematic, as it can be hard to work out what's what in the confusing sprawl of UV shells. I find it much easier to apply the base colors if I assign them to different selections of polygons in 3D, where I can preview the results in real time. What really makes the baking method a winner is that each baked color will generate a coverage alpha channel, which we can use to quickly select and tweak different materials inside Photoshop.

I have identified thirteen different materials on the character: gray steel, self-illuminated lights, black leather, dark gray Kevlar, elasticized straps, painted steel on the oxygen tank, black plastic, dark cloth, fire retardant piping, rubber-soled shoes, gray plastic mask, black rubber, and NBC suit.

Break up your model into thirteen corresponding pieces using the Detach and Attach buttons in Edit Poly. Each object that you create should be assigned a different colored material. The colors are not important; we will throw them away later. I've used crazy colors just to help myself differentiate between the various types of surface.

Once you are happy with the material groups, bake these different surfaces onto the texture using the Rendering > Render to Texture dialog. For each object, repeat this process:

- Choose the output path and give each file a descriptive name, such as Gray Steel.
- Be sure that "Use existing (UV) channel" is selected, as it would be a shame to waste those lovingly crafted UVs!

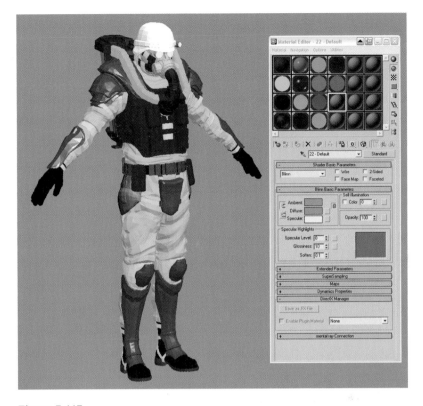

Figure 7.117

- Add a DiffuseMap output.
- Choose a 4096 × 4096 texture size (4k).
- Hit render (see Figure 7.118).

If you open up the black leather texture, it's just a black square, because we rendered a black material onto a black background! Open up the Channels window, though, and go to the alpha channel to see that we have a map that describes perfectly which areas on our UV sheet are black leather.

Let's make a new 4096 × 4096-pixel (4k) document to collect all these alpha channels together. Save the new document as Future_Commando_01.psd.

One by one, click on the alpha channel of each of your fourteen material renders, copy it (Ctrl + C) and paste the channel (Ctrl + V) into a new channel in the Future_Commando_01.psd file. Once you have named each channel accordingly, you will have a collection of channels like Figure 7.120.

Click on the RGB channel at the top of the Channels window and open up the Layers window again. Let's make a new layer for the NBC suit. Select an off-white color and fill your new layer with this color.

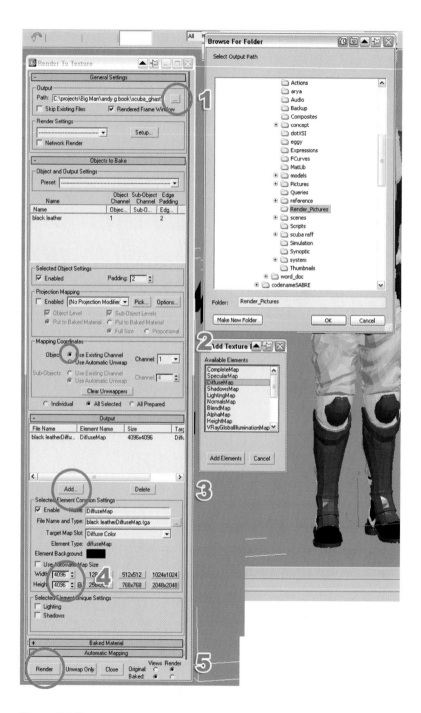

Figure 7.118

Figure 7.119

Figure 7.120

Figure 7.121

Masking each layer

Now comes the cool bit: go back to Channels and hold Ctrl as you click on the NBC suit channel to select all the white areas of the channel. Go back to the Layers window and click Create Mask.

Figure 7.122

If you have done this correctly, the mask will hide the areas outside of the NBC suit UVs. The gray color of the NBC suit layer shows only where the mask is white; areas where the mask is black are transparent, so we can see the Background layer underneath.

Figure 7.123

A black-and-white mask icon should have appeared in the NBC suit layer. If you hold Alt when you click this mask, it will be isolated so that you can see the mask clearly in black and white. To de-isolate the mask, click on the eyeball icon (Layer visibility) of the NBC suit layer.

Figure 7.124

Masks and channels are the professional way to edit images in a nondestructive manner; if you want to make changes to something, it often makes more sense to do this with masks. If you don't like your mask, you can throw it away, keeping the original image intact.

As an advanced PhotoShop user, it is imperative that you learn all the ins and outs of layers and masks. Masked layers have two thumbnail images instead of the usual one thumbnail. Click the thumbnail on the right to edit the mask, click the thumbnail on the left to return to editing the color layer. You can Ctrl + click on the mask to select all the areas that are white, which can be incredibly useful for making selections. Shift + click on the layer to toggle its effect on or off.

One by one, you can repeat the "fill new layer" with color and then apply the relevant mask process to each of the thirteen different materials that we have a channel for. Try to avoid coloring things black or white, as there aren't many things that are truly black or truly white. It's better to settle for off-tones that are more realistic.

Figure 7.125

When all thirteen materials have their own color layer and mask, the texture will look something like the previous figure. I don't like the color of the suit I've applied, but it's too dark, so let's tweak it with levels. Click on the NBC suit RGB color icon (the one to the left of the black and white icon) and press Ctrl + L to bring up the Levels command. Move the little triangles in the levels around to adjust the colors. This is a powerful way to make sweeping changes to your layers or selections.

Open up the old AO map that we rendered earlier, go to Image > Image size, and convert it into a 4k map, then press Ctrl + A to select all, Ctrl + C to copy it into memory, and Ctrl + W to close it. We now have the AO map at 4k in our clipboard.

Select the top layer in your PSD and press Ctrl + V to paste in the AO map from the clipboard. Name the layer AO. With the AO layer selected, select the Multiply layer mode from the drop-down menu. The Multiply

Figure 7.126

Figure 7.127

command takes the dark parts of an image and multiplies them with all the colors in the layers below, darkening them. Anything that is white in the Multiply layer is invisible and lighter shades have little effect.

To preview the work-in-progress (WIP) in Max, save out a copy of the PSD as a JPG. Apply a new Standard material to your model in Max and load the WIP jpg into the Diffuse color slot. I like to give the material 100 percent self-illumination so that I can see clearly every surface on the model—there is plenty of time for gloomy, atmospheric lighting later on. It's also good to raise the specular levels to about 50; the specular highlights will help us to see some of the details of the surface.

If your colors are anything like mine, you probably made them all too dark, so go back to Photoshop and sort them out with the levels. Keep tweaking until you get something you are happy with. I've put the "Self-illuminated lights" layer above the AO to get the effect that it is lit from within.

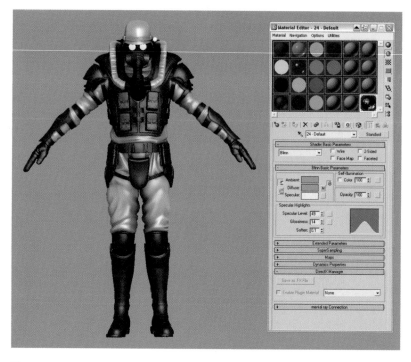

Figure 7.128

Once you are happy with the basic color layers that you just made, it is a good idea to merge them. We still have the channels if we want to make specific selections quickly, and merging all the layers will save us lots of RAM. Select all the layers apart from the AO and the self-illuminated yellow layer (for the eyes and torch) and press Ctrl + E to merge them together. When you have finished, it is a good idea to rename the Background layer: double-click the background layer and type in the name Base Colors.

Figure 7.129

3d paint applications

When painting textures by hand, it is much more intuitive to use a 3D paint application—you are not faced with the problem of working out which areas in the UVs correspond to which areas in 3D space. 3D paint applications allow us to paint seamlessly across multiple seams, something that is nearly impossible when painting in 2D in Photoshop. Painting in 3D has another advantage in that if you have any distortion in your UVs (sometimes a little distortion is hard to avoid), the 3D paint app will automatically make predistortion adjustments to your 2D texture to compensate for the distortion. The results will look distorted in Photoshop but perfect in 3D—something that you could never do without the 3D paint app.

Bodypaint 3D is a good standalone 3D paint application, but I recommend the use of ZBrush for your 3D painting. ZBrush's ZAppLink feature allows it to plug straight into Photoshop for an unrivalled texturing workflow. Why learn the inferior painting tools of another app when we can use the already-familiar and industry-standard Photoshop tools?

Graphics tablets

Trying to draw with a mouse is a bit like brushing your teeth with a toilet brush—it's not the ideal solution! Professional texture artists use graphics tablets (digital pens) for any demanding hand-drawn texturing. I recommend the use of the Intuos 3 tablet by Wacom; the pressure sensitivity of pen is excellent.

Rendering the UV template

If you do not have access to a good 3D painting package, you can render a UV template to help you with your painting in 2D in Photoshop.

Figure 7.130

Add an UnwrapUVW modifier to your model and click Edit to open up the Edit UVWs window. Select Tools > Render UVW Template.

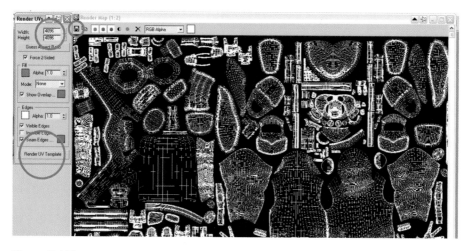

Figure 7.131

Select 4096 for the width and height and click Render UV Template. A Render Map window should appear with your UV coordinates nicely rendered; press the Save button (the disk icon) to save the image to a file. Open up this image in Photoshop, select all (Ctrl + A), copy it (Ctrl + C), and close it (Ctrl + W).

Figure 7.132

Click the top layer in your PSD and paste this image (Ctrl + V) at the top, renaming it "UVs". Put the layer into Screen mode to ignore the black areas. Now only the white areas should show through to lighten the

layers below. You can turn on and off this layer as you require while painting your texture; sometimes it is really useful for seeing the boundaries of the UVs. I often reduce the opacity of this "UVs" layer to something like 20 percent.

Painting the dirt map

Our character is looking pretty good now, but he lacks the small, real-world details that will really bring him to life. I almost always paint some kind of dirt map to give a more realistic look to our characters. If you study anything in the world around you, you will notice dirt and small imperfections on the surfaces of objects.

When creating a texture for a character, I try to imagine their history and lifestyle. What does the character do on an average day? Where has he/she been? Has your character been relaxing in a pristine palace all his/her life? Or bathing in mud? When treated with subtlety, the incidental effects will really bring your character to life—the eye of the viewer will pick up on these small details that give credibility to your digital creations.

Figure 7.133

Figure 7.134

Many companies specialize in producing photo libraries of dirty surfaces, available for royalty-free use in your textures, but they can be quite expensive. A cheaper solution is to take photos of dirty surfaces yourself. Go to your local industrial area and you will find an area rich with grime. No one appreciates a good dirty surface quite like the 3D artist does!

Figure 7.133 is an example detail from one of my dirt images that I've collected, before I cleaned it up and adjusted the levels. I like to photograph smooth white surfaces, as it makes it very easy to get just the dirt without any other surface features that will need to be removed to isolate the dirt. Get as many different types of mud, grease, and dust as you can; the more images you have in your library, the more variation you will be able to include on your characters' dirt maps.

I like to paint on the dirt generously to start with, working fast and rough and not caring too much about any specific details. I mix manipulated dirt images

231

Figure 7.135

Figure 7.136

Figure 7.137

from my photo library with hand-painted dirt using the Paint Brush and Burn tools. Next, I go around the model and clean off the dirt with a white paintbrush in the most exposed areas. If an area looks unrealistic I will give it a heavy blur, paint in more detail, blur a little more, then add more detail again. It is this iterative process that helps me to build up a history of past incidents on the surface of the character.

Painting your dirt in a 3D app will really make it come alive, as you can see very clearly which parts might not get cleaned as easily and which areas might get cleaned on a more regular basis. Remember that weathering, friction, and collisions will remove the dirt from the most exposed areas, leaving behind the dirt that is protected in the cavities.

If you change the dirt layer to Multiply mode, you will see the dirt on top of the Base Colors and AO layers. If you want a quick and dirty effect, sometimes this is enough, but this technique produces dirt that is only monochrome, because of the limitations of Multiply mode. The multiplied dirt layer does not show up very well on any of the darker fabrics, as dark × dark = very, very dark. Dirt usually makes dark objects lighter, so it's a better idea to use another image to create a muddy color and use our dirt map to mask it.

Figure 7.136 is a photo that I took of a muddy area of a field, I've used the Rubber Stamp tool to repeat the texture across the surface. This will make a good color for our dirt.

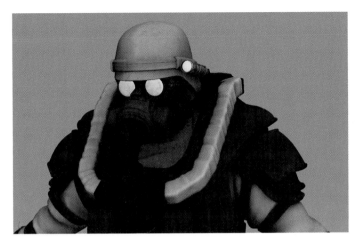

Figure 7.138

To apply our B&W dirt map as a mask to this muddy layer, select the original B&W dirt layer, select it all (Ctrl + A), copy it to the clipboard (Ctrl + C), and then delete the layer. Create a new mask on the color muddy field layer, Alt + click the mask to isolate it, and paste (Ctrl + V) in the B&W image from the clipboard. With the mask still selected, invert it (press Ctrl + I), because it is the wrong way around.

Here I've reduced the opacity of this layer to 40 percent. Subtlety is the key to getting it right, as we don't want the guy caked in mud, but his costume must look like it has been used in a real-life combat situation. We can make certain parts more or less muddy by selecting those areas of the mask with our channels and applying a levels adjustment. I've deliberately understated the dirt here a little, because later we will apply the dirt to the specular map, too, to strengthen the dirt effect. In some areas, I have blurred the muddy colors of the layer to get an ingrained, old dirt look, and I have left other areas of the layer quite sharp to get a new mud feel.

Painting the scratch map

In the real world, things get scratched in everyday use—especially on the battlefield! On a new white layer I've painted black scratches; again I've used a 3D paint app to help me get the scratches placed well, with the heaviest ones on the most exposed edges. Like the dirt map, I paint super quick and rough to start with and as I do so

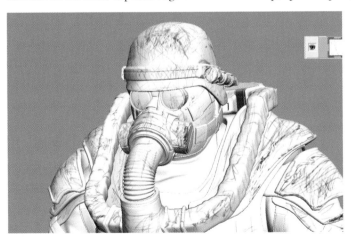

Figure 7.139

I try to imagine how the scratches came about. Maybe the scratches on the helmet came from a fall, so they all go in one direction, maybe scratches on the Kevlar forearm pad have built up over time, so they all point in unique directions. Don't just paint dumb! Think as you paint.

Fabrics don't often scratch sharply like hard surfaces do, so let's blur them out a little.

Select all the areas where there are soft fabric materials by holding Shift and Ctrl while clicking each the relevant fabric channels one by one to add them to your selection. Now select

Figure 7.140

Filter > Blur > Gaussian Blur and give these areas a moderate amount of blur. To add more realism, add a mask to the scratch layer and paste in a copy of the AO map, which has the effect of removing the scratches from occluded areas. This newly AO masked scratch layer works well, but we must flatten it so we can use it in another mask—the complexity increases! Add a pure white scratch background layer below the scratch map, select the two layers together, and then merge them (Ctrl + E). Now select and copy the contents of this new merged layer to your clipboard for use in the next step.

Layered scratch masks

Many surfaces, such as the gas-tanks, have been painted and they will reveal their underlying materials in areas where they have been scratched. Let's create this layered effect by duplicating the Base Colors layer (right-click on the layer and choose Duplicate). Name the top layer Base Colors and the layer underneath Under Colors.

Figure 7.141

Paste the contents of your clipboard (the merged scratch map from the last section) into a new mask applied to the Base Colors layer.

Now we can paint in the Under Colors layer to create our underlying material colors. The gas tank should reveal bare metal under the paintwork where it has been scratched, so paint a grey color here. Other metals will typically get lighter where they have been scratched, so just lighten those areas. Some plastic areas might be darker where they have scratched and something has created dirt-filled cavities.

If you export the WIP color map to 3ds Max, it should be easier to see how the colors underneath are shaping up. You can use the channel selections to select specific areas and make sweeping changes to many undercolors at the same time. I have also used the Levels command on the scratch mask itself to tone down the effect a little.

For additional realism, let's remove the dirt from the scratched areas, as it would often be removed by friction as the scratches occurred. I have put the dirt layer in a new folder (group) and masked this new folder with a copy of the scratch mask from the Base Colors layer. Nesting masked folders inside folders is incredibly powerful, but can quickly get confusing! Our scratch map will really come alive later, when we can use the spec map to make the scratched areas shinier.

Painting the high-frequency detail layers

Next let's paint the high-frequency (HF) details—the things that crop up again and again across the surface (for example, skin pores, the pattern of the sole of the shoe, the ribbed pattern on the belt, and so on). Details on this small of a scale are much easier to create using texturing rather than modeling.

I like to create the HF details as black and white maps; this means that later we can easily pop out these details in the normal map.

Figure 7.142

The first step is to gather high-resolution images of each fabric type we will use. Many of the surface types, like the rubber and the plastic, are smooth surfaces that don't require HF detail maps, but we will need images to make the micro bumps of the leather, elastic, cloth, NBC suit, and the fire-resistant material on the piping. Like with the dirt, I keep a library of photos of different fabrics; you can buy disks full of fabric textures from the Internet, but I sometimes find it quicker and cheaper to source my own from around the house and quickly take photos/scans of them. Like most reference material you use in your textures, it is much better if it is shot in diffused lighting conditions with no harsh lighting, shadows, or hard contrasts.

Adjust the maps so that they look similar to how the AO map would look if we had actually modeled every HF microcavity in to the surface of the object. Black represents the lowest areas and white the highest points

Figure 7.143

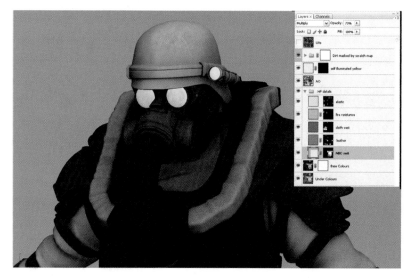

Figure 7.144

that are more exposed to the light. Figure 7.142 shows my HF detail layer, which describes the creased, wrinkly texture of the leather.

Each type of surface should tile to completely fill its own HF detail layer; to keep things tidy, put all the layers in a folder called "HF details". We can use the channels we saved earlier to quickly create a mask for each layer, Ctrl + click the relevant channel to select the areas it masks, then back in the Layers palette you can click the "Create mask" icon to quickly mask the active layer with your selection.

Set each of the HF detail layers to multiply, so they have a similar effect to how our AO layer works, darkening the occluded areas.

Normal and specular maps

Let's add another layer of realism to our creation using Normal and Specular maps. Normal maps are used to fool the eye into thinking that there is much more detail than there actually is modeled into the character. They work in a similar way to bump maps, by cheating in the details. Specular maps control how shiny the surface is in different areas: white pixels make the metal look shiny and the black pixels make the dirt look totally matte.

We can see the effects of the normal and specular maps in real time in the viewport if we use a special DirectX shader written by Ben Cloward.

Figure 7.145

Figure 7.146

If you visit http://www.bencloward.com/resources_shaders.shtml, you can see that Ben has created a wealth of different shaders that you can use in the Max viewport to simulate various surface effects. Read all about these shaders here: http://www.bencloward.com/shaders_NormalMapSpecular3lights.shtml. He has kindly allowed us to include the "Normal Map Specular Shader—3 Lights" shader on the book DVD. Find Ben's shaders on the DVD ROM here: \Chapter7\Max Files for chapters\5_highres_mesh_textured\directx_shaders and copy them to somewhere easily accessible on your hard drive. Before we set up the shader, we need to use Photoshop to make some quick, temporary normal and specular maps to plug into the shader.

To make a temporary normal map, use the Paint Bucket tool to fill a new 4k image with RGB color 127,127,255. This purple/blue tone has the effect of perfect flatness in normal maps; it's the normal map's equivalent of black or zero—it has no effect. Save this as something like Future_Commando_Normals.jpg.

To create a temporary specular map, let's use the Paint Bucket tool to fill a new 4k image with RGB color: 127,127,127. This is a good medium gray color for a moderate level of shininess. Save the image as something like Future_Commando_Specular.jpg.

Now we have a color and a normal and a specular map. Let's set up the DirectX shader. In 3ds Max, apply a new material to the character model, then click on the Standard button in the Material Editor to select a DirectX type of material.

Click the top-left box in the DirectX Shader Panel, the one with the long path name in it. This box loads a specific DirectX (.FX) shader onto your

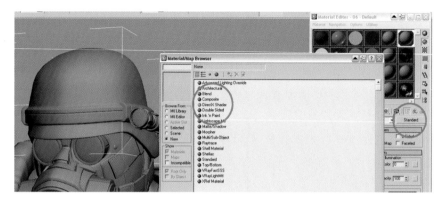

Figure 7.147

Figure 7.148

Figure 7.149

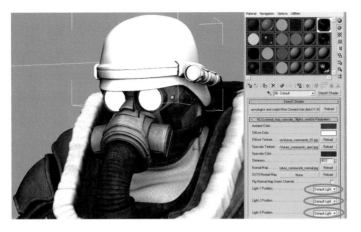

Figure 7.150

material. Browse to the folder to which you copied Ben's shaders and select the one named HLSLnormal_map_specular_3lights_world.fx.

Now Ben's shader is applied to your character. Most likely, the model will turn black, as the maps are not loaded in yet. Click on the slots next to Diffuse Texture, Specular Texture, and Normal Map, and load in the relevant maps.

Once you have loaded the three maps into the relevant slots, you should see the shader displaying correctly. The normal and spec maps are just filled with temporary, basic colors, so we are not really getting the benefit from this shader yet. The default settings use the Max

Figure 7.151

Default Light, but it is better if you make three omni lights that surround the character and load each one into the Light Position slots, as explained below.

Using Create > Lights > Standard Lights > Omni, make one Key light that has an intensity of around 1 and is positioned at the front of the character but a little to one side. At the other side, make a Fill light with an intensity of about 0.5, and at the back a Rim light with an intensity of around 0.5, too.

You can tweak the light settings to your own preferences; it's all just to help you see what is going on with the normal mapping later on. You can even animate the intensity and positions of the lights so that you can play the timeline to see the character in different lighting conditions.

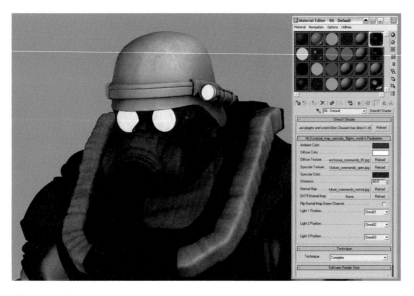

Figure 7.152

Normal mapping the high-frequency details

We can really give the HF details much more punch if we pop them out using a normal map. As it is just a texture-mapping effect, this illusion breaks down when viewed up close, especially when seen at angles perpendicular to the viewing angle where it is obvious that the details are not truly 3D. Normal mapping does not work well as a replacement for modeling the larger geometry, as it does not affect the silhouette of the shape in the way that modeling does.

To follow my style of normal mapping, you will need to install the NVIDIA Normal Map Filter for Photoshop, which is available for free download from here: http://developer.nvidia.com/object/photoshop_dds_plugins.html.

One by one, feed the contents of each of the HF Detail layers to the Normal Map Filter. The Normal Map Filter does not work on PSDs with more than one layer, so one at a time, copy the contents of each HF Detail layer and paste each one into a new document, being sure to flatten each image down to just one background layer.

Figure 7.153

With your one of your temporary, one-layer HF detail documents selected, choose Filter > NVIDIA Tools > NormalMapFilter to bring up the options for our normal map.

Although there are lots of options here, all you really need to do is type different numbers into the Scale Box. The Scale setting describes how powerful the effect of the bumpiness of the surface is. I find that 6 works well for me most of the time. You can also press the 3D Preview button if you want to see how your normal map will look in real-time 3D. Press OK to create your normal map.

Figure 7.154

Create a new PSD file called Future_Commando_Normals.psd and one by one, paste in the normal maps that you have generated for each HF detail layer.

Figure 7.155

To blend all these maps together, copy over the masks from the original HF detail layers in the color PSD (Future_Commando_01.psd). Your Future_Commando_Normals. psd should look something like the Figure 7.155. I've zoomed in to 300 percent to show the details. I like to add a little note for myself on the name of each layer: L3 means that I generated the map with a scale of 3, L6 a scale of 6, and so on. These notes will help us if we decide to tweak the strength of each one later on.

In the normal map PSD document, select "Save As" and overwrite the temporary Future_Commando_

Normals.jpg map that we made earlier. If you go back to 3ds Max now, the new map should have automatically

Figure 7.156

loaded into the material and the normal map should be displaying nicely now. You should export your normal map to 3ds Max frequently as you work, because reviewing the normal map applied to the character in Max is much easier than staring at a bunch of blue colors in Photoshop.

In the previous figure, I've decided that the NBC suit material is too bumpy, so I've toned that down by changing the opacity of the NBC L3 layer to 6 percent. I've also gone back to the color PSD and made his vest a little bit lighter.

Adding more small details

Before we finish the texturing with the specular map, there are a few finishing touches to add to the color and normal maps. As these details are all very flat, we won't be generating normal maps from them, so they can all be painted on the Base Colors layer.

The danger label on the gas tank

I drew the shapes for the Danger label using the Rectangle and Polygon Selection tools, using the Brush tool to fill the selections with color and the Edit > Stroke command to outline them where needed. I used the Text tool to create the typography, then merged everything down onto the Base Colors layer, making sure to preserve the (scratch) mask. Be sure to make the yellow tones a slightly desaturated yellow; in the real world, most things are not completely saturated with color, but usually faded from weathering.

Metal textures

At the moment, your metal areas are probably looking a little flat and boring; better that we give them an interesting texture. To build up the texture, use Filter > Add Noise, then Filter > Blur > Gaussian Blur a number of times, entering smaller numbers into the Size parameter on each iteration.

Glowing bulbs

If we were working on a character for a feature film that would be viewed close up, I would probably model the inner workings of the glowing eye and torch, and add some cool render effects. However, as this texture will eventually need to be baked down onto a 1k game mesh, it is probably too much work on this project to get bogged down in this level of detail. In production, you have to draw a line somewhere on the level of detail or you will make too much work for yourself and miss your deadlines.

I drew the glowing torch and eye lenses by hand using the Brush tool and then overlaid a grid image in Color Burn mode. When I was happy with these layers, I merged them together onto the self-illuminated yellow layer to save a little RAM.

Micro bumps layer

Many surfaces are not as perfectly smooth and flat as you might assume. Accidents, daily use, weathering, factory defects, and warping caused by sun exposure all lead to small imperfections on surfaces.

To create this effect of less-than-perfect surfaces, let's paint another black-and-white map that we can feed into the NVIDIA Normal Map Filter. Starting with a mid-gray background, you can use the Burn tool to darken areas that you would like to push down in the normal map. If you hold Alt when using the Burn tool, it will dodge instead, lightening the areas and thus raising them in the normal map. You can paint these micro bump dings onto the helmet, gas tank, shoes, and anywhere else where you'd like to make the surface less regular. Generate a normal map from this black-and-white image using the NVIDIA filter and place it in the top layer in the normals.psd. If you put this micro bumps layer into Overlay mode, it will blend over the top of the existing normal map layers.

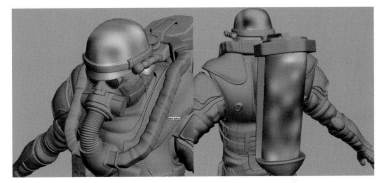

Figure 7.157

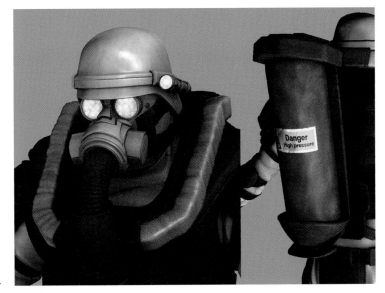

Figure 7.158

The high-res specular textures

Creating the spec map is fairly straightforward; for the most part, we will use already-existing elements from the color PSD. We will create a number of new "Spec" layers that we can turn on to convert our color PSD texture into a spec map.

Figure 7.159

The adjustment layers (icon shown in Figure 7.159), which are found at the bottom of the Layers window, are great for making nondestructive changes. Adjustment layers can be turned on and off and masked, and if you don't like them, you can just delete them to return to how things were before.

Select the top layer in your PSD (probably the UVs layer), click the "Create new fill or adjustment layer" icon, and Select Hue/Saturation. Drag the Saturation control down to −100 to totally desaturate everything underneath this adjustment layer and press the OK button. Right-click on the new adjustment layers mask and choose "Delete layer mask"; this step will save a little of our precious RAM, as we don't need the mask. Now give the layer a meaningful name, like "Spec Desaturator".

Figure 7.160

Create a new layer above the Base Colors layer called "Spec Colors". One at a time, select each channel that we saved earlier and fill that selection with a color. Fill Spec Colors with black for nonreflective (specular is just a cheated reflection, really) things like cloth. Fill Spec Colors with medium gray for things that have a moderate amount of shininess, like the NBC suit and plastics, and fill it with white for very shiny things like metal. This layer should completely block out any layers below it.

My aim when creating the specular map is break up the highlights; the spec map is where I concentrate the majority of the grime and dirt in the textures. As I've mentioned earlier, if you look at even the newest objects around you, you will notice that the reflections on their surfaces are broken up by imperfections, fingerprints, dirt, and scratches.

Let's improve our spec texture by making the dirty areas less shiny and the scratched areas shinier. Copy the dirt and scratch masks that we made earlier and paste duplicates of them at the top of the Layers window next to the Spec Desaturator layer. Name them "Spec–dirt is darker" and "Spec–scratches are lighter", respectively. Now

Figure 7.161

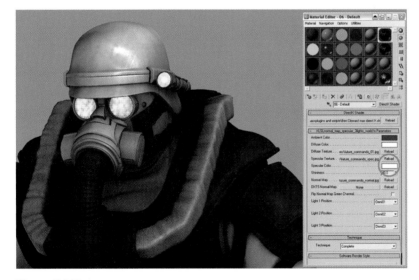

Figure 7.162

if you put the "Spec–dirt is darker" layer into Multiply mode, it will make all the dirty areas not shiny; if you put the "Spec–scratches are lighter" layer into Screen mode, it will make all the scratched areas more shiny. (You might need to invert it, too.) I also adjusted the levels of these maps to amplify their effects.

Right-click on all the new spec layers one at a time, selecting Layer Properties and applying a gray color. It will now be easy to identify which layers are for the spec map, an ability that will reduce user errors when we toggle our PSD between color and spec modes. If you use Save As and save this image over the temporary Future_Commando_Specular.jpg texture, you can check the new spec map in Max.

In the DirectX shader, make sure that the Specular Color is set to white, so you can accurately tweak your spec map. It's now just a matter of tweaking the three textures to your taste. When you are finished, you can re-export the textures in TIF format to increase the quality.

The gun

After a discussion with the team, it was decided that an over-the-top, multi-function gun would best suit the battlefield needs of our soldier. As we didn't have a concept image for the gun, I blended together elements

from several existing weapons into one design, mixing together a flamethrower and a chain-gun. It had to be big, as we didn't want our soldier to feel inadequate on the battlefield! The weapon required additional fuel tanks to be fitted to the existing gas tank to supply the flamethrower with fuel. As these are detachable items, the gas tanks and the weapon both have their own separate texture sheets.

In-game mesh modeling

For our game mesh, we have been allocated a polygon budget of 12,000 triangles. This is a reasonable amount for a prominent game character for a first-person shooter on the Xbox 360 or the Playstation 3. Background characters that don't receive all the limelight might get only 2,000–5,000 triangles, but lead characters that are designed for talking in close-up shots might get 15,000 or more polys.

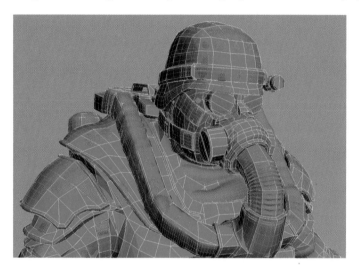

Figure 7.163

Earlier, during the modeling of our high-res mesh, we wisely saved a copy of our work-in-progress proxy meshwhen it was around 6,000–7,000 triangles (for half the mesh). This basic, approximate form will make an excellent starting point for our game mesh. If we load up this old .OBJ mesh (File > Import), it should fit perfectly over the top of our high-res character. Add the Symmetry modifier and give this proxy mesh a green material with opacity of 50 percent so that we can clearly see the high-res mesh underneath it.

Using all the familiar Edit Poly tools, we now need to optimize this mesh for use in videogames, aiming to get the half game mesh to around 6,000 triangles. The core idea when creating real-time assets such as this is that each triangle/polygon is precious. If we can reduce polygons in one area without any detrimental effect, we can spend these elsewhere in the model to improve the overall appearance. Ideally, we can keep a clean, quad-based topology, but a few triangles here and there are fine.

The way I construct my game meshes owes much to my previous experience with using normal maps. Normal maps are great at representing the many small details, but they are very poor when used to fake the larger features, which should always be modeled in. Sometimes we can delete many polygons from a relatively flat area and let the normal map do the work instead, without the surface looking much different.

I spend lots of polygons on creating a detailed silhouette, because only geometry can give us a detailed and interesting profile. Sometimes I change the material so that it has 100 percent self-illumination, which makes it easy to focus on just the silhouette. View your game-mesh model from every angle and see whether its

Figure 7.164

silhouette looks correct. If you press F4 to toggle edged faces, you can see whether there are areas with lots of polygons that are contributing very little to the silhouette, then track them down and delete them.

Typically, an in-game character will be rigged and animated through a wide range of poses, so we must take care that the geometry we build around areas that bend (knees, elbows, shoulder, wrist, and so on) has enough detail to support a full range of movement. The best way to get a feeling for this is to rig your own meshes and test-animate the rigs so you can experience firsthand exactly where geometry is needed and where you can scrimp on it.

Figure 7.165

Figure 7.166

One edge loop on a joint is often not enough once you start animating the character.

When in doubt, a good rule of thumb is to have at least three edge loops around each joint to allow for correct deformation during animation.

Modeling for games sometimes involves using some low-down dirty tricks! Knowing when you can pull these off and when to do things the proper way is an art form in itself. Some people might tell you to make sure that all areas of your mesh are welded together. Granted, this approach works better in some situations, but we can save lots of polys in some areas if we disregard this advice. Andy Gahan showed me the following trick when I first started work on PS2 games, but it's as relevant as ever for the current generation of games.

Figure 7.167

As an example, take a typical cylindrical object with some bevelled detail like the one in the following figure. The highlighted polygons here contain twenty-four triangles; let's delete them.

Select two opposite edges and use Edit Polys Bridge command to join them together; repeat the Bridge operation for each set of opposite edges.

Now we have two overlapping shapes rather than one whole mesh. The new polygons we have added contain only ten triangles, a savings of almost 60 percent!

Figure 7.168

Figure 7.169

Figure 7.170

If we use this trick on the ends of each cylinder on the gas tank valves, we can make substantial savings. Here I saved 30 triangles by deleting the old welded ploys and replacing them with new bridged edges. There is a gas tank valve on each side of the character, so this is a total savings of 60 triangles. Look for other areas to perform this trick and save additional polys that we can use to improve the detail in complex areas, such as the creases and folds of the NBC suit.

You should avoid the use of this trick in certain deformable areas, as the open edges may get exposed during animation. The only way to get a good feeling for how far you can push this is to get firsthand experience with rigging and animating game meshes.

When finishing off the model, I like to turn on the Edged Faces in the viewport and squint my eyes at it so I get just a hazy general impression of the mesh topology. This makes it easier to see areas where the polygons are denser and areas that are relatively sparse. Unless there is a special reason (animation, silhouette, or mapping), all the meshes should have similar levels of detail. Sometimes I rob from the rich to give to the poor, taking polygons away from areas that don't need them.

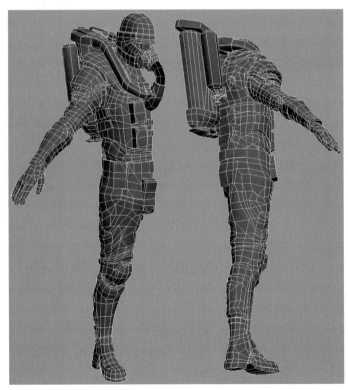

Figure 7.171

Many games give a bias to the head when it comes to detail. The viewer's eye naturally focuses here, so it is worth spending a bit more of your budget here. Some games feature the characters up close in animated dialog shots, so they are built with lots of detail in the face, designed to smoothly morph between different emotions and mouth shapes.

In-Game Mesh UVing

Like the high-res mesh, its good to UV the half game mesh before you mirror it. You should try to minimize the number of UV shells. The fewer shells, the fewer seams, so join them together whenever possible.

When you have the Unwrap UVW modifier applied to your object, the seams show up as bright green lines. I try to hide the UV seams in areas that won't be seen easily, like the inside of the legs or the inside of the arms. Better still, I line up the seams with areas where there are already fabric seams in the high-res mesh (the areas where the garments are stitched together or the intersection between two different surfaces).

Figure 7.172

Figure 7.173

It's worth noting that sometimes developers give a bias to the UVs of the head and the eyes; that is, they make them larger to fit in more detail. But as our character is intended for a fast-paced arcade game with few dialog scenes, this won't be necessary.

Once you're happy with the UV seams, add a Symmetry modifier and collapse the stack into an Editable Poly to create the full mesh.

Now that we have the whole mesh, we can create the creases and folds that are unique to the left-hand side of the NBC suit. It is also possible to save some more polys by deleting any edges on the line of symmetry that aren't contributing to the character's form. Once you have finished modeling, select the new half of the mesh and horizontally flip the UVs. In UVlayout, it is now straightforward to complete the UVs by welding all the seams that run up the center line and reflattening all the pieces. In the previous figure, I have cut off the codpiece as a separate UV shell to avoid having a seam that runs down the line of symmetry. As always, remember to pack your UV shells as tightly as possible.

Baking Down the High-Res Details

To produce the highest quality meshes for Playstation 3 and Xbox 360 games, the colors and details of the high-res mesh are often baked down onto the comparatively low-polygon game mesh. The game mesh's normal map does a great job

of faking the high-res details, giving us almost the same effect for a fraction of the system resources of the original multi-million-polygon mesh.

The high-res and in-game meshes should now sit perfectly over the top of each other like the following figure. Be sure that the high-res meshes have standard 3ds Max materials, with the color, specular, and normal maps applied to the relevant map slots. Make sure that no DirectX materials are applied to the high-res objects, as they cannot be baked down onto the game mesh.

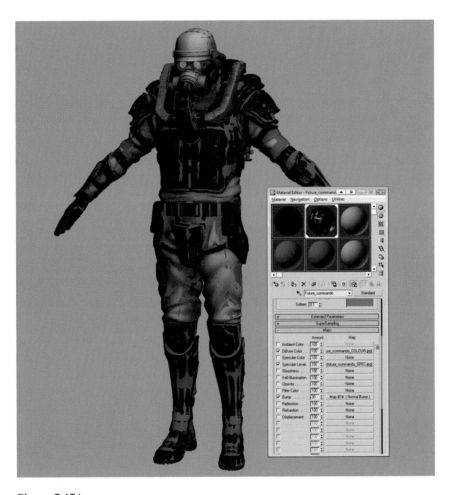

Figure 7.174

We could go through and bake our maps one by one, but it is easier to bake all three maps (color, spec, and normal) at the same time. Select the game mesh and select Rendering > Render To Texture. In the General Settings tab at the top of the Render To Texture settings, choose an output path for the textures.

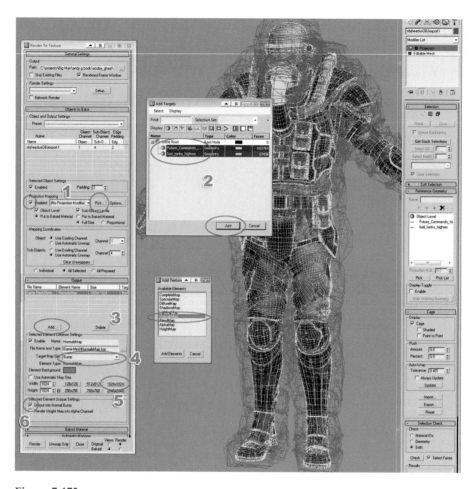

Figure 7.175

Be sure to check the Enabled box in the Projection Mapping section and click the Pick button to bring up the Add Targets menu.

In the Add Targets pop-up box, select all of the objects that make up the high-res mesh; in my case, this is the main body of the future commando and the gas tanks. Click Add and a Projection relationship will be set up between the game mesh and the high-res objects.

To set up the normal map output, click Add in the Output section and choose a NormalMap Texture element. Choose Bump for the Target Map Slot to ensure that Render To Texture will plug our new normal map into the Bump slot of the new material that it will apply to our character. Click the 1024 × 1024 button to choose a 1k map size. Be sure that "Output into Normal Bump" is checked, so that the normal map gets plugged into bump slot via a Normal Bump node.

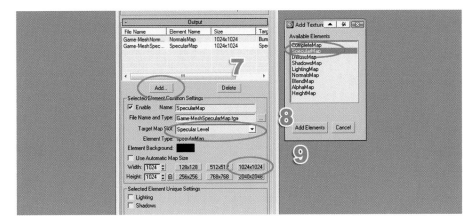

Figure 7.176

Now we have the NormalMap output all set up, let's configure the specular map bake. Click Add and choose a SpecularMap Texture element. Choose Specular Level for the target map slot. Click the 1024 × 1024 button to choose a 1k map size.

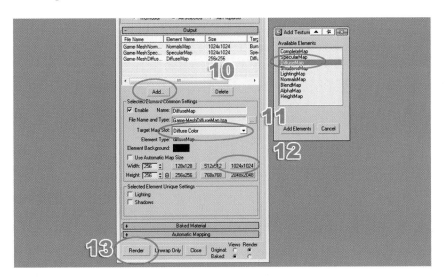

Figure 7.177

Finally, let's set up the diffuse/color map bake. Click Add and choose a DiffuseMap Texture element. Choose Diffuse Color for the target map slot. Click the 1024 × 1024 button to choose a 1k map size. Click Render to render out all three maps at the same time and apply them to a new material.

Isolate the game mesh or hide the high-res mesh to view the work so far. In Photoshop, browse to the location where you saved these textures, and open them up to take a look at them.

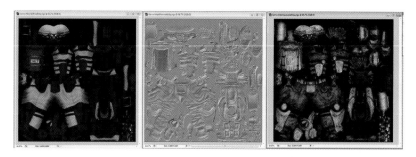

Figure 7.178

Back in 3ds Max, you will notice that a blue cage has appeared around the game mesh and that a Projection modifier has been added to its stack. The blue Projection cage is a visual tool to help you control how the information is baked down from the high-res target mesh onto the low-res one. During a render, rays are fired out from each point on the game mesh until they get to the cage, from where they take the information from the nearest high-res surface.

When baking from high-res to low-res, there are often some problems. Cavities and other complex areas with overlapping details cause problems for the renderer, because when there are many high-res surfaces close to each other, the renderer doesn't know which one to take its information from. The Projection cage is designed to solve this problem, as each vertex in the cage can be tweaked by hand, but because we have more than 6,000 vertices in this mesh, the prospect is daunting!

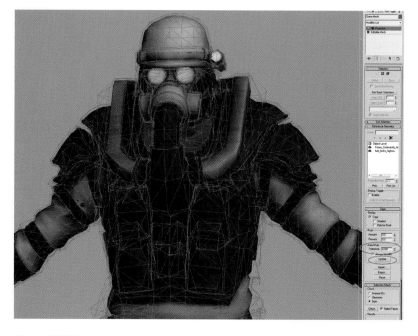

Figure 7.179

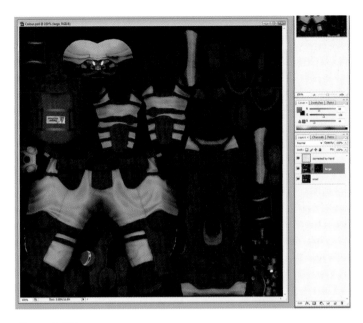

Figure 7.180

Figure 7.181

Luckily, there are controls in the Projection modifier that can move each vertex on the cage all together at the same time. If you type various values into the Auto-Wrap parameter and hit the Update button, you will see the cage recalculate at different distances from the game mesh.

My favorite and fastest way to get perfect game mesh maps is to bake each of the maps a number of times, each with a differently sized cage. Often I will bake a small, medium, and large version of each map, which I blend together in Photoshop using masks.

To fix the color map, I rendered first with a small cage and then in the areas with missing information, I painted in (using a mask) another version of the map I had rendered with a larger cage. To quickly finish it, I used the Brush tool, Rubber Stamp tool, and Healing Brush tool to make a few quick and dirty fixes on the layer that was corrected by hand. I fixed the problems with the specular map using exactly the same techniques.

To fix the normal map, I used the same process as I did for the color map, with a couple of additional techniques. I corrected some of the areas that had rendered incorrectly by painting the blue/magenta color R127, G128, B255 on the hand-corrected layer.

The low-frequency normal maps that we obtained from the baking process do not include all the high-frequency details that are in the normal map of the high-res version of the character. To add these details to our mesh, apply the normal map of the high-res character to its diffuse color channel instead of its usual bump channel assignment. Then when you bake the maps again, the high-res normal map has been baked into the DiffuseMap

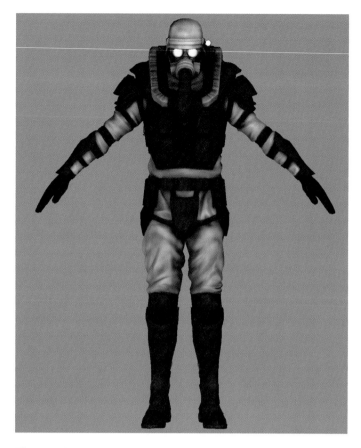

Figure 7.182

texture. Copy and paste this map into our game mesh normal PSD and put it in Overlay mode to blend it over the top of the other normal map layers.

It is very useful to apply the DirectX shader that we used earlier so that we can preview the effects of the spec, normal, and diffuse maps all working together in real time. If you keep a sharp eye out, you can make the game mesh incredibly similar to its original high-res counterpart.

Rendering Your Character

So we've finished the character now and although he looks pretty darn good in the DirectX shader in the viewport, we can make him look nicer still if we render him using the Scanline renderer. True high-end rendering is beyond the scope of this chapter, so we will use specular highlights to approximate blurry reflections and AO maps to approximate the diffuse scattering of light.

I will show you how to render the high-res asset, but I recommend that you render the game mesh, too; potential employers are keen to see what you can do with a restricted polygon count. Dramatic, shadowy lighting looks cool but doesn't give a detailed view of your model; perfectly flat, even lighting looks unrealistic and doesn't show off the contours of your model. Here we will create a lighting scheme somewhere between these two extremes. To start, delete any old lights from the scene and apply a blank, gray material to the character.

The studio wall

Although it will not be the focus of the renders, a simple and well-lit scene can help show off our character and put him in a real-life context. I used the Primitive Plane object and a couple of bend modifiers to make a primitive photography studio wall like you see below. Gradually curved wall-to-floor backdrops like this allow photographers to get the most minimal backgrounds possible, with no hard corners or other visual distractions. To add a little real-world believability to the studio floor, I've added a color texture with some marks on the floor where people have been standing with their dirty shoes on.

Figure 7.183

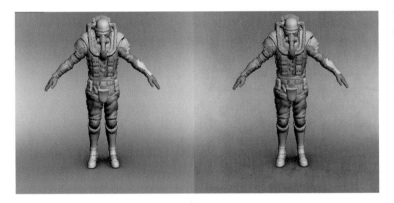

Figure 7.184

Be sure that the Studio Wall object and the soles of the character's shoes are exactly touching, without penetrating or crossing each other. A floating character or one that sinks through the floor will destroy the illusion of realism.

Using the AO baking, like we rendered previously for the character, we can calculate the lighting for the studio wall. Render the AO map and apply the texture to the diffuse slot of the Studio Wall object.

The AO shadow texture on the floor will add a subtle "this character is really standing here" ambient shadow effect. If you take this AO map into Photoshop and multiply it over the top of the dirt-textured floor, you will mix the two for a nice-looking background.

The camera

Create a camera a good distance away from our character and point it at him. Now zoom in until he fills the screen in the Camera viewport. Remember, the further away the camera, the less perspective distortion. We will be doing square renders, so in the Render Scene options, set a width and height of 512 pixels for our test renders. Right-click on the camera name in the viewport and turn on Show Safe Frame in the options so that you can see the proportions of the camera in the Viewport.

Creating the lights

When creating lights, it is essential to add them one at a time so that you can see the effect each one has on the scene. With lighting, more is less, so make sure that each light you create has a purpose.

To create our key light, go to the Create > Lights panel and choose a Target Spot light; drag to create the light and point it directly at the character—the default intensity of 1 is usually okay. Normally, key lights are

Figure 7.185

in front of the subject, often to one side to help show off the form of the shape. Lighting that is too close to the camera makes your objects look flat, so it's better to have this main light off to the right-hand side.

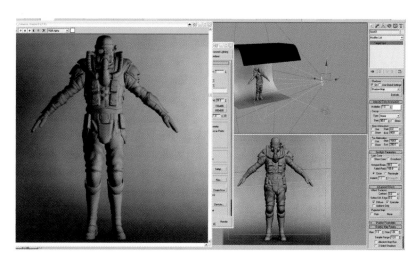

Figure 7.186

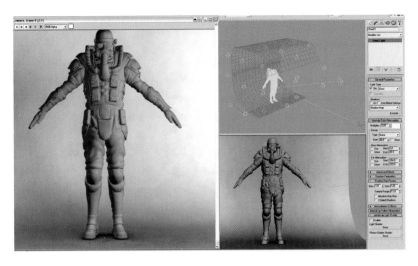

Figure 7.187

Be sure to check the Shadows On box to turn on the shadows. If you were to render now, you would get the hard-edged shadow look so common in CGI (Computer Generated Images). Interior light is usually quite soft, as the light bounces around quite a lot compared to outdoor scenes. Photographers often use silk or other translucent materials in front of their harsh studio lights in order to spread out the light and soften the shadows. We can simulate this effect by changing the size of the Shadow map to 128 pixels (a very rough setting) and the Sample Range to 12 (to smooth out the effect).

In the Spotlight parameters, you might also want to increase the Hotspot and Falloff of the lamp. Do a test render and you should get something like the previous image.

Photographers often use fill lights to fill in the shadowy areas of their subjects; in CG, we use fill lights for similar purposes and also them to simulate the effect of bounced light from the environment. Add lots of

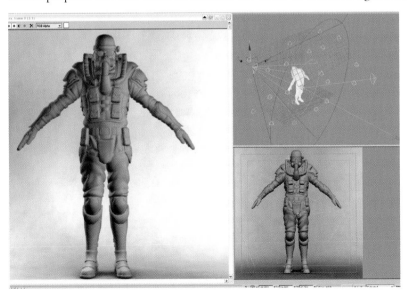

Figure 7.188

Omni lights around the character, each with no shadows and a tiny Multiplier value like 0.03. You might want to give the lights to the left a slightly blue tint to simulate the ambient light of the sky coming in from a large window. It is also a good idea to give the other Omni lights and the main key light a slightly orange tint to simulate the hue of a lightbulb.

Rim lighting is used in photography to really pop subjects out from their background. Make a copy of the key light

259

and move it to the other side of the character. This process should wrap up an interesting lighting scheme, which shows off the complex modeling we have done.

Materials in theory

An object's reflective qualities are dictated by how rough or smooth the object is on a micro scale.

Figure 7.189

Diffuse reflection occurs when light hits a rough surface and is scattered in many directions. Surfaces with 100 percent diffuse reflection look the same no matter which angle you view them from. A good example of a surface with pretty much 100 percent diffuse reflection would be a dirty, old cardboard box.

Figure 7.190

Specular reflection occurs when light hits a smooth object and bounces off at a perfect right angle. Specular reflection is easy to identify, because it changes depending on the viewing angle. A mirror is a good example of an almost perfectly 100 percent specular reflective surface.

Different ratios of mixed diffuse and specular reflection occur on most surfaces. These surfaces are not flat enough to show perfect reflections like a mirror, but they are smooth enough to ensure that most of the light bounces off in a consistent direction to create blurred reflections. A good example of this would be most metals; they are very shiny, but the details of the reflections are blurred.

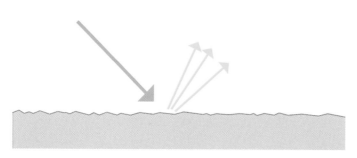

Figure 7.191

Materials in 3ds max

To simulate these different types of surface in 3ds Max, we will split up the mesh into a number of smaller meshes, each with its own material:

- Blurred Reflections should be applied to all the objects with hard, shiny surfaces like metals and plastics. This material uses the standard Specular effect to fake the look of blurred reflections; true blurred

Figure 7.192

Figure 7.193

Figure 7.194

Figure 7.195

reflections are very computationally expensive and available only on the more advanced renderers, but this cheat will suffice for us here.

The micro roughness at I talked about earlier can be achieved using the Glossiness control; a value of 37 will give tight, smooth highlights.

- Blurred Reflections Rough should be exactly as Blurred Reflections, but with a tweaked Glossiness value of 11. This material should be applied to all the fabrics with fairly rough surfaces, like most of the fairly matte clothes and straps.
- Blurred Reflections Mid represents the medium-roughness areas and should have a glossiness of something like 21. Apply this material to the NBC suit and leather areas.
- Self Illuminated should be applied just to the eyes and lens of the torch; it will be just a regular texture, but with the Self Illumination setting at 100 percent.

Now all that remains is to plug the relevant color and spec maps into the Diffuse Color and Specular Level slots of these four materials. To

apply the Normal map click on the Bump Slot and Choose Normal Bump, then click on the Normal slot to apply your bump map.

Back in the Maps section of your material, take care to change the Bump value from its default of 30 up to the full strength of 100.

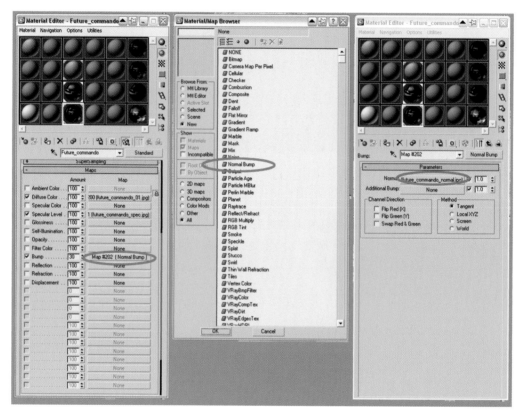

Figure 7.196

The final renders

For the final renders, increase the resolution to 1024 × 1024 or more pixels. In the previous figure, I have linked all the objects of the character to a dummy so that I can easily rotate the character (by rotating the parent dummy) for different renders.

As we have modeled some pretty awesome detail into our soldier, you might also want to do some close-up renders to showcase our attention to detail.

The renders I have produced here have a kind of stylized, cartoony feel to them because of the manual cheating we have done in the lighting. Quite often in videogames this is a good thing, as many projects require a stylized effect. Setting up the lighting manually like this gives you ultimate control.

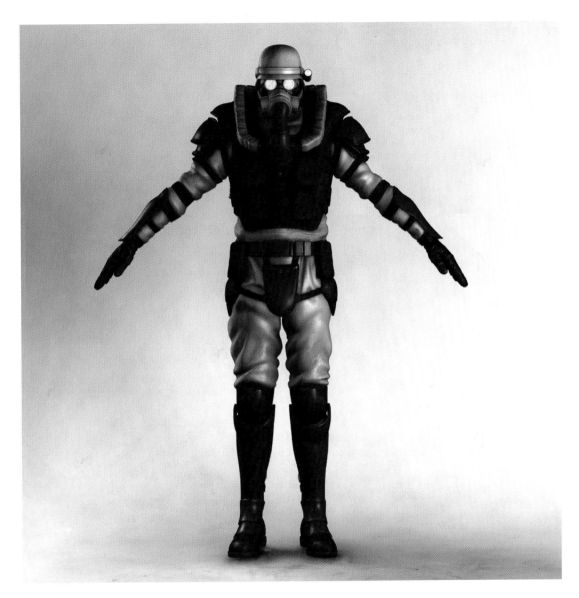

Figure 7.197

We could have gone further with the rendering to achieve a higher level of realism. To improve the quality of the light, we would have to discard the AO layers from our texture maps and use a true "global illumination" renderer such as Brazil, Mental Ray, or V-Ray. These high-end renderers can accurately render real-world lighting effects such as color bleeding, caustics, area lights (3ds Max's standard lights are infinitely small), and blurry reflections.

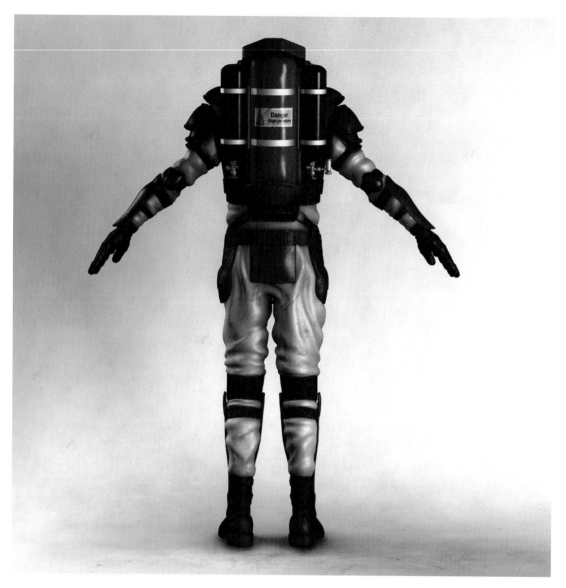

Figure 7.198

As a 3D artist, you must constantly improve your work to keep up with the rapid pace of change. And at the end of a project (after a good rest, of course!), it's a good habit to perform a little post-mortem on your work. What could you have done to make it better? How could you have made the process faster? How does your work compare to that of your peers? If you learn from your experiences, you will build your next character faster and it will be of higher quality, too.

Chapter 8

Mid-Poly Environment

Introduction

In this chapter, we will be building a simple scene for our character to be rendered against: the abandoned warehouse.

We will begin by blocking out the main structure and then we will build in the details and populate it with the objects that we've already created, although with a few more from the DVD (kindly provided by my friend David Milton).

All of the objects in this scene have been built using the same techniques that you've already learned, so there should be nothing that you can't repro-duce. Have a look on http://www.3d-for-games.com for tutorials for some of these other objects. Feel free to populate this environment with your own mod-els and assets or whatever you like. Try to make it as original as possible—use your creativity.

Maybe you already have a library of models that you've already created; if so, select the ones you consider to be suit-able and add them to your scene. If you don't have anything that fits perfectly, by all means spend a little time modifying what you have to make this scene truly your own.

Figure 8.1

Creating the Initial Textures in Photoshop

To begin with, we will block out the main internal walls of the warehouse in Photoshop. We will start by looking at the reference photos, organizing them in Photoshop, and then stitching them together to make complete walls. As two of the walls of the warehouse are really long, this step will require a lot of tweaking, but hopefully the reference images will be good enough for us to build complete walls or almost-complete walls. Because this scene doesn't have to be accurate to the original building, we will have plenty of room for adjustment and creativity.

Let's get started. Open all of the reference photos from the \Chapter 8\Source Files\Wall 1\ folder on the DVD in Photoshop. When I took these reference photos, I took the starting shot at the start of one wall and gradually moved to the other end. I kept parallel to the wall, right across to the other end, taking overlapping photos as I went. This is a very quick way of getting this type of reference.

We could build the textures up ourselves in Photoshop, but for this exercise, we want to preserve all the grit and decay, which would take longer if we were to build them from scratch. We will get a real gritty feel to the scene by building it like this. Don't worry if you can't get permission to take this sort of reference—there is lots of it on the Internet. If you see a set of photos you like while browsing, email the photographers; most amateurs will send you higher-res versions of their photos if you ask nicely, especially if you are complementary about their work.

Now back to the build. In Photoshop, create a new file. Make it long enough to drop all of the photos, ready for matching, together in one long image (20000 × 5000 pixels should be enough for now). Now we need to figure out which is the leftmost photo and drag it onto the new file. If you don't have a powerful machine, you may struggle with these large files, so feel free to quarter the reference images (as we will be scaling the final image down at the end anyway) or load the finished texture files from the DVD in \Chapter 8\Source Files\ (in each of the three "Wall" directories). I prefer to keep large source files so that I can use them in the future and for higher-resolution work.

With the first photo on the new file, slide it along to the left and drag the next one onto your new montage. Set the opacity of this new layer to 50 percent and using the Move tool try to line it up as close as possible by making it overlap the first photo.

Zoom into the image at a key area, like a window or a vertical wall support, and once you have it as close as possible, use the Skew and Perspective tools to fine-tune it. Once you have it matching up neatly, set the opacity to 100 percent again and use the Eraser tool to remove any unwanted parts of the overlapping image. Drag guides onto the image, which helps keep the walls square and to preserve the horizontal and vertical lines of the building.

Figure 8.2

Don't worry about things like the skip wagon obscuring the wall; once we have the full wall laid out, we will go back and remove them from the image.

Continue this process for the rest of the wall. If you find that some of the photos are darker than others, adjust the Levels or Brightness and Contrast to make them blend together seamlessly.

Figure 8.3

Now that we have the full wall all joined together, we need to crop all the bits off the top and the bottom that we don't need and make sure that it looks roughly balanced (so that there are no obvious seams or problems).

Figure 8.4

We've almost completed the first wall already. Using the Clone Stamp tool and the Healing Brush tool and also Copy and Paste to take areas from one place to another, remove as many of the obstructions from the image as you can (or that you have the patience for). If you manage to remove most of the big obstructions from the image like the skip truck but leave all the pipes and stuff hanging off the walls, you will create quite an interesting image without too much effort.

Once we have this "clean" image, we need to flatten it (Layer > Flatten Image) and think about cutting it up into textures. I have decided that we will use a number of square textures for the walls that are 1024 × 1024 pixels. With this in mind, we need to manipulate this image so that it can be chopped up into 1024 × 1024 squares.

Go to Image > Image Size > and make sure that Constrain Proportions is checked. Now adjust the height of the image to 1024. We are looking to note what the length turns out to be. To get the best-looking texture maps

without too much stretching, we have to look at the length (in pixels) and divide it by 1024. In this case, my image divides by 1024 by just over five times, so I will need to make my image length 1024 × 5, which is 5120.

Set the height of the image to 1024 and the length to 5120, and chop the wall texture into five equal 1024 × 1024 texture maps. As you can see from my image, I have dragged guides onto the image at equal 1024-pixel intervals along the length, which we will use as a guide to cut up the image.

Figure 8.5

Now that you have a 5120 × 1024 image, use the Rectangular Marquee tool (shortcut M) and carefully select the first 1024 × 1024 texture map on the left. Using Image > Crop to crop the image.

It is important here to go to Image > Image Size (Alt + Ctrl + I) to make sure that your cropped image measures 1024 × 1024 exactly. If it doesn't, undo the crop, confirm that your guide is in the right place, and repeat until it is 1024 × 1024 exactly.

If you fail to get this exact, there will be a visible seam on your map where the next joining texture meets and the less accurate you are at this point, the more visible the seams will be.

Once you have the texture complete, save it out as your first map. Call it something like Wall-1_1.jpg (or whatever file format you prefer). The naming of these files is again very important. We are going to create more than ten of these and it will be very difficult mapping the wall object if they are not sequentially named per wall.

Figure 8.6

Now undo the crop command to revert back to the full image, select the next texture tile along, and repeat the whole process until you have all five texture maps cropped, saved, and named sequentially.

Figure 8.7

Figure 8.8

Figure 8.9

Figure 8.10

Figure 8.11

Now that we have one wall complete, we can either choose to mirror it for the opposite wall or create a new, second wall. If we mirror it, it will look a little bit worse, unless we are planning on populating the room with lots of really large objects (hiding the obvious mirrored texture).

For this scene, I have decided not to fill it up too much with junk, so follow the same method to create the textures for the opposite wall and also the end wall.

If you are a seasoned Photoshop artist and don't need the practice in this type of work, feel free to load the other textures from the disk to speed things up. However, if you are relatively new to this type of work, at least try to do Wall 3 (the end wall), as this is quite a challenging task. The reason it's challenging is that there wasn't really a good way of taking a photo of the wall without all of the collapsing roof girders in the way, so all of these twisted girders will need to be removed from the image. Try to create this image and send your submissions in to me via the Web site (http://www.3d-for-games.com); I'd really love to see how you get on with this. I'll post some of them up on the site.

Figures 8.12 and 8.13 are my before and after shots. As you can see, there was a lot of wall to repaint. Again, this task was completed using the Clone Stamp tool (S), Healing Brush tool (J), Rectangular Marquee tool (M), Copy (Ctrl + C), Paste (Ctrl + V), Skew, Rotate, Scale (in Edit > Transform), and whatever else I could find.

Figure 8.12

The lines of the walls aren't completely straight, as the building is falling down. You could make more of this feature by chopping out of large parts of it and by having piles of rubble modeled within the scene.

Figure 8.13

Creating the Basic Structure in 3ds Max

Next, we will move on to creating the walls in 3ds Max. We could have created these first and then created the textures to fit (an order preferred by a lot of people), but as I knew that the photo reference was complete, I thought that we could get a slightly more accurate build if we got the textures to work and then created the base model for them. Either way, we would have gotten a similar result, so it's up to you to take whichever approach works for you best.

We are going to try to keep this project as simple as possible, as it will be populated with all of our models built so far and probably with a lot more that you will create yourself. With this in mind, all of the geometry will be fairly simple. And as the scene is going to be very dark, we will not need to use as much detail in areas like the roof.

Open up 3ds Max and start a new scene. Create a box with the dimensions 5000 × 2000 × 2000 cm.

The box is created at this scale so that we can easily apply the single-texture

Figure 8.14

Figure 8.15

Figure 8.16

maps. Remember that our long wall textures were cut into five texture maps; these five subdivisions will make it very easy to apply them to the mesh without stretching or distorting them.

Next, right-click on the box and convert it to an Editable Mesh from the drop-down menu. Collapse the rows of vertices along the top of the box to create the roof shape.

Select all of the polygons and apply some UVW Mapping to them. Select Box mapping and set the tiling as follows:

U Tile 5.0
V Tile 2.0
W Tile 2.0

These settings should give us perfect mapping coordinates for our texture maps. Once you're happy with it, collapse the stack.

To make texturing the warehouse shell a little easier, detach the separate walls and roof.

Before we do this, with the mesh still in one piece, flip the Normals of the polygons (as we are building the inside of the warehouse, not the outside). To do this, click Flip from Surface Properties > Normals, with all the polygons selected. This command turns our mesh inside out.

Now select and detach each of the end walls, floor, and roof, starting with the floor. Remember to name them correctly as you go.

Finally, we need to see the polygons displayed one-sided. With all of your objects selected, right-click > Object Properties > Display Properties > check Backface Cull and click OK.

In the previous image, I have clicked the Select By Name button to show the contents of the scene list.

Now, we have some walls. Let's get our textures on them to see what they look like. Select the end walls and the roof, right-click on them, and select Hide Selection to hide them in the viewport.

Open up the Material Editor (M) and change the first material to a Multi/Sub-Object, discarding the old material. We will keep the number of materials in this Multi/Sub-Object at ten and we will map both of the long warehouse walls with it.

Figure 8.17

Just as we have done before, click on the first material in the Multi/Sub-Object and in Blinn Basic Parameters, click on the Diffuse button and load in wall-1_1.tif from \Chapter 8\Textures\ on the DVD or load up the first of the textures that you created from the photographs. Click the Assign Material to Selection button and then the Show Standard Map in Viewport button. You should see the texture map on the selected polygon. If for any reason you do not, confirm that the polygon has a material ID of 1 and try again.

Figure 8.18

As each of the maps will need to reference an individual ID number, select each of the wall panels in turn and change their IDs as you go along , from left to right, in order (2, 3, 4). Continue this process on the opposite wall with IDs 6, 7, 8 until both side wall polygons have separate IDs from 1 to 10. Once you've completed this, repeat the process of loading each of the other wall texture maps into the material editor and display them in the viewport.

You may notice that the texture maps don't look like they quite line up properly. This is because they are all backwards (due to us flipping the normals earlier). To fix this, select all of the side wall polygons, add a UVW Unwrap modifier, and click Edit in Parameters (this will open up the Edit UVs window). Select all of the vertices and then Mirror Horizontal. You should find that all the UVs are now correct and the wall textures stretch seamlessly from left to right on each side. Collapse the stack.

Figure 8.19

As you can see from some simple renders in the Perspective view, our walls are coming along nicely.

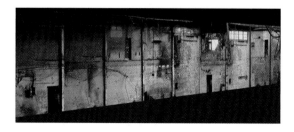

Figure 8.20

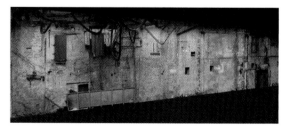

Figure 8.21

Once we start to add some of the large 3D objects in the scene like the skip truck and build lots of twisted girders and burned boards hanging off the collapsed roof, it should start to look quite presentable for a simple scene.

Let's start working on the end wall. In the reference photos, there is a gap between the end wall and the side wall, but for this scene I want to keep everything contained, so this will be closed off. Pull down the top vertex on the end wall and add a slice, so that we don't distort the textures. Unhide End Wall 1 and set the IDs to 1, 2, 3, and 4 from left to right, starting with the top ones first.

Now we need to create a new material. You could add these four extra textures to the existing one if you like, but for this scene I kept it separate (for no good reason). Load the textures in as you did before, but this time using End_Wall-1_1.tif to End_Wall-1_4.tif.

Finally, make sure that you have clicked the Assign Material to Selection button and then the Show Standard Map in Viewport button each time.

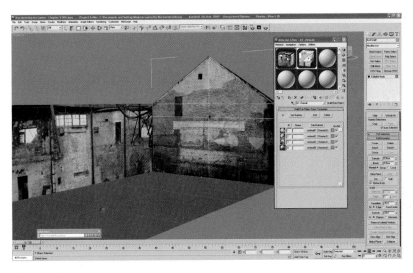

Figure 8.22

The Roof

The roof is probably the most complex part of the warehouse build. The roof is made up of three main areas:

The solid roof at one end of the warehouse, which is intact.
The broken twisted girders of the partly collapsed structure.
The big hole where the roof was and the debris on the floor.

We will start by building the solid girders. Looking at the reference photos, it's quite difficult to actually tell what's going on with the roof structure. We can see lots of girders, but as they are all overlapping, it's difficult

to see how complex the structure is. This is actually good: we will be able to get away with less detail and still have something looking quite complex.

In the next image, I've taken the best reference shot showing the girders and adjusted the levels in Photoshop so that I can see the girders defined as clearly as possible. Looking at one section of the structure, I have roughly traced over the image in Photoshop to show us what we need to build.

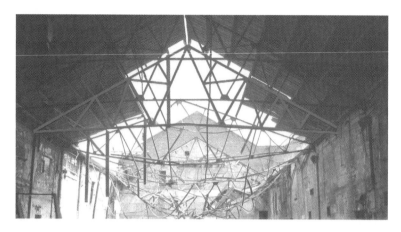

Figure 8.23

Looking at the image, the section (highlighted in green) is made up of eighteen girders welded together. You could choose to do this more simply if you like, but as these girders make up the bulk of the collapsed geometry, I think I'll model them. I'm going to make a simple web of intersecting square girders with a simple tiling rust texture on them. I'm not going to be focusing on the roof too much for my scene, but if you are, feel free to texture the rivets and support braces.

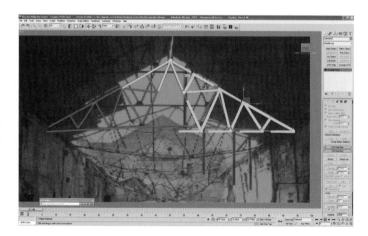

Figure 8.24

We need to start modeling the girders by creating an eight-sided cylinder at the apex and then extruding some of the faces. Copy this object a few times and manipulate it to form parts of the structure.

Continue doing this until you have half of one of the girder sections modeled. Then just attach all the parts by collapsing or target welding vertices. Once you have one half completed, apply a UVW map modifier to it and box map it. Remember to select View Align and Fit. In this case, I chose to tile the mapping six times on the x axis, four times on the y axis, and 0.2 times on the z axis. Finally, apply a basic rust texture (\Chapter 8\Textures\Rust1.tif) in the material editor and we're almost done.

Lastly, for this girder section we need to make a copy of this half using Mirror or a basic shift + drag copy and then attach those two parts together.

As you can see from the previous image, I have added extra polygons where each of the girders join and have strengthening plates riveted to them. This step was specifically done so that we could create extra detailed texture maps for them for detail at a later date.

Instead of using square bars, as I have in this case, we could delete two of the sides and have the girders built from an L shape, or we could just have them flat. It's up to you, really. Obviously, flat ones will be least expensive, but will cast thin shadows from certain angles.

Figure 8.25

You already have all the skills to complete this build, so feel free to use them and experiment. After all, what's the worst that can happen? Just remember to save incrementally, have auto backups on, and have some fun with it.

Finally, we need to fit the new roof girder to the rest of the building. It may need to be tweaked and scaled slightly to fit the shape of the building, as your build may not match all of the photographs that you used to model the separate parts from.

To get mine to fit perfectly (well, close enough), I had to scale it slightly. To do this, I adjusted the pivot point of the girder first—go to Hierarchy > Pivot > Affect Pivot Only. Then I clicked Center to Object (from Alignment) and Reset Transform and Scale (from Reset). Finally, I manually moved the pivot point (by dragging it) down on the y axis until it lined up roughly with the bottom of the girder. When I scaled the girder on the y axis, I did not modify the bottom girder much. Play around with setting the pivot point at different positions and scaling the girder to see how you can benefit from different pivot point positions.

Now that we have a solid girder, we should make a few copies and then start to twist and rotate them to make them look like the roof has collapsed. Copy a few of the more mangled pieces and scatter them around the floor and have a few copies hanging from the ceiling. As the scene is going to be quite dark, you shouldn't need to spend too much time on this—unless you really want to, that is. You should be aiming to get something that looks a little like this:

Now, don't worry if everything doesn't quite look right in the scene at this point. We will just get everything in, then look at each of the different models in turn and tailor them to fit the scene, colorizing the texture maps as we go.

At this point, I'm going to add a camera, so that I can look at my scene. Go to Create > Cameras > Target and add a camera. Press the C key and you should be looking through it. Mess around with the parameters and stock lenses to get a feel for the different controls.

Figure 8.26

Next, add the rest of the models that we have already created. The easiest way to do this is to go to File > Merge and load each of the finished models by selecting the names from the list. If you've given your models random names, you will pay for it when merging scenes of lots of models, as you won't be able to tell what is what.

If you have been untidy and not named any of your models correctly in the files, and if you've left all sorts of rubbish in the files, then you might want to go back and open each 3ds Max file individually and delete everything you don't need and name everything properly.

Figure 8.27

I have also decided to add a skylight light via Create > Lights > Skylight (from Standard lights) so that I can start to play around with the colors of the scene. At this point, the girders we've created look a bit brown so we need to create another, darker rust map or modify the one we have on there.

Here's a look at what we've got so far:

Have a look at the image and think about what to do next. As this isn't going to be going into a game engine, we can be a little flexible with what we do. On the other hand, this is just a block out to be used as the backdrop of a render, so we don't want to go mad with it.

The character is going to take up the left hand third of the screen, so we don't need to worry about that too much; thus the key remaining areas are the floor and the roof.

How much time you want to spend on this will determine what you do next with this scene. How do you want it to look? Take a few moments, with a pen and notebook maybe, and have a think about how you could make this look interesting or cool. To give you some ideas, you could try to replicate the photo. This would work; it would be straightforward and you wouldn't have to think much about what you need to do. Another suggestion is that you could produce some concept art and really try to push yourself with what you create. Something like this might work:

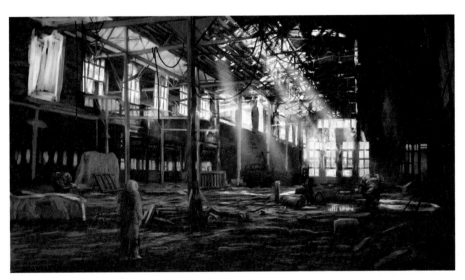

Figure 8.28

I hear you cry, "Are you mad? It's completely different!" Yes, it is different, and no, I'm not mad. Have a look at the concept image and think about what you could take from it. I'm not going to give you all the answers on this one (sorry), you're going to have to work that one out on your own. Here are a few ideas:

- You could extrude the wall back on the ground floor, modify the textures, and add the vertical supports.
- You could also modify the end wall texture map that we created, take the sunlit part off the top of it, and create an enclosed roof.
- You could add lots of windows to the texture maps we created. There are a few there already, so you can work out what they should look like.
- You could just look at the roof and take a new reference point for the structure and level of detail.

Whatever you do, it's important not to be too precious about your work. You should be ready to make major changes at any time. There are normally a lot of stakeholders on a project (art lead, art manager, producer, external producer, art director, development director, managing director, chairman…) who can and will ask for changes, some of which will be significant. So you have to be ready for them.

I had an art teacher (Mr. James) from when I was around 11 to 15 years old who taught me this lesson well. He had a very unusual method of teaching it, too. If you were working on a painting or drawing and you were working the very fine details in, right from the very start of the piece, he would come along, rip it in half (or into many pieces), stick it back together with tape, and ask you to continue with it. Obviously, the first time this happens, you're furious, or heart-broken, or totally baffled, but he had a point. In fact, he had two points. The first was that when starting a new piece of work, you should think Big, Light, and Accurate.

The Big part of the equation meant that you should start off using the whole of a sheet of paper or canvas, not just start detailing in the corner. When translated into 3D, this means that you should start by planning or thinking about the whole thing, roughly blocking out simple forms, to get a feel for the area and construction.

Light meant to use very light pencil strokes, so that you can easily change what you're doing without having any permanent marks on your page. Again in 3D, this translated to starting with primitives and low detail objects, which you would be happy deleting—not spending time on the finer details, as these should definitely come later.

Accurate—well, that's just being accurate with what you are drawing or painting. Translated into modeling terms, this means doing your research, producing the concept art, and gathering the reference images. But more than anything else, it means looking at what you're doing and looking at your reference images *continuously*. Print them out, stick them up around your workspace, and know exactly what you're building. As soon as you start making it up, unless you have the skill and experience to do so, you'll lose the quality.

The second lesson was not to be precious about your work. If he ripped it in half, was it ruined? No, it just wasn't what you'd planned. Could you recover? Well, that was up to the individual, but everyone got over it at some point. It got you thinking outside of the box: not only could you think outside of the box, but you could take a knife to the box and create something truly original from it.

The most important lesson is that you should not always labor to finish a piece of work if it is looking cruddy or isn't going your way. Shelve it, leave it for a few weeks, and go back to it with fresh eyes. If it still looks bad and you can't get it right, move on, or post it on forums for it to be crucified—none of it matters that much. But don't be precious. Change it radically, transform it into something new, but don't waste too much time on something that doesn't work—life's too short.

Before we get back to the warehouse, at the end of this chapter, there are two tips that you might want to skip ahead to before coming back to this point. One is about a basic compositional rule and the other is about a simple lighting system. The reason I mention skipping ahead to look at them is that reading them will probably influence how you construct the rest of your scene.

Back to the warehouse. First, we need to map the floor. The warehouse in real life was covered in all sorts of debris, pigeon excrement, and all sorts of other nasty, sticky stuff, but I'm going to make it more like tarmac.

Feel free to use whatever texture maps you like. You might want to create a series of maps form one large image or you might want to tile the floor, but cut parts out to add detail. Whatever you do, it's up to you.

I have taken a mix of tarmac from a photograph, blended with some of the crud on the actual warehouse floor, and created a tiling map from it, as shown in the following figure.

Next, I created a new material and applied the floor map to the floor geometry, tiling it eight times across the width and twenty times down the length (so that each floor square has a 4 × 4 tiled map on it).

Let's look at the roof. The best reference image of the set seems to be this one:

Figure 8.29

Figure 8.30

For a bit of variety, I will create two texture maps from the same image, one with the little window on and one without. If we create two maps, we can mix and match them to give the roof a bit of variety. You could opt to make just one if you like and tile it or you could use the other reference photos to build a brighter roof, but I've decided to keep mine dark. I've switched some of the central detail around to make the look similar, but individual.

To apply these maps to the roof, first we need to convert the roof shape to an Editable Poly object, then create the extra polygons to mix and match the texture maps that we need to subdivide the faces. The quickest way to do this is to select all of the edges that run along the length of the building and then click Connect from the Edit Edges rollout. Instantly, each of the ten faces should be split in half across the building.

To apply the texture maps to the roof, select all the faces and give them an ID of 1. Apply a UVW map modifier to them, this time checking the Face mapping. All of your faces should now have the first roof texture

Figure 8.31

Figure 8.32

map on them. Finally, randomly select some of the faces and change their ID to 2, giving us the mix and match variety. Depending on how you've created your texture maps, you might want to flip some of the UVs around so that they sit together nicely. You should end up with something like Figure 8.33 (I've hidden all the other assets in the scene so that you can see this clearly):

Feel free to apply these maps to the roof in any order you like, but take care if you use the texture maps I've provided—if you flip them around, be sure to line up the horizontal beams).

Figure 8.33

Next we need to chop out some of the roof where it has fallen in. Have a look at the walls at the end of the warehouse. We will make our cuts where the wall texture brightens up slightly (where it lets more light in, due to the missing roof). It doesn't have to be tied to the wall textures completely, as we can always edit them, making parts lighter or darker to fit the scene.

Make the roof an Editable Poly (if it's not already), select some of the edges towards the end of the roof, and use a combination of Connect or the Slice Plane (while the faces are selected) to make some cuts to the faces.

Once you're happy with the basic form, you can collapse the roof to an Editable Mesh and detach the chosen faces. Use the Shell modifier to add some depth to the roof pieces, then scatter a few around. I've got a couple clinging to the edges of the roof and a few mixed up in the girder debris. This is only a simple scene, so I'm not adding too many.

Next I scatter a few more of the assets around. I've added a few piles of bricks, a few barrels, a skip, and a few other bits—feel free to add whatever you like. Here are a few of the extra assets that I have provided on the DVD. Also, you can visit http://www.3d-for-games.com for more.

Figure 8.34

Figure 8.35

Once you've had a bit of fun with adding the extra objects, you should have something that looks something like Figure 8.37:

Figure 8.36

Figure 8.37

In Figure 8.38, I think that the textures on the barrels and the metal box are a little too bright, so I'll make a slight change to them in Photoshop and load them in again. I've added the character here, too, just so that you can see everything together. It isn't rigged or holding the gun, but you get the idea.

And that's it—your scene is complete. Here are a couple of extra tips to help you on your way.

Figure 8.38

Two Final Tips

Composition and The Rule of Thirds

Although this subject was covered briefly in Chapter 7, I want to go over this in a little more detail as I believe it is very important. The rule of thirds is probably the most common rule of composition. Feel free to Google it to see how different people and industries explain it. It is commonly used in 3D, fine art, design, and photography, and is really well documented and taught—justifiably so, as it is the main guideline responsible for well-composed images and renders. The rule of thirds (or sometimes known as "the golden section") was documented as early as 1757 in a book as a rule for proportioning scenic paintings, but was used much earlier as well.

The basic principle behind the rule is that your page, view, or image should be divided up into nine equal sections with four imaginary lines, two each running vertically and horizontally.

Place important elements of your composition where these lines intersect, as shown.

Figure 8.39

Figure 8.40

You can also arrange key areas of your image into bands that occupy a third of your page. A great use for this would be a horizon, but other less-obvious ones could be the eyes of a subject in a photo, or a combination of a horizon and a tree, using two intersections.

In this photograph of a seascape (Figure 8.41), the land mass is roughly taking up the bottom third and the remaining two-thirds are sky. Browse through some classic landscape paintings online and see just how many use the rule. You can also see how the photo of the child is using this rule in a slightly different way. Obviously, this rule isn't meant to be used for absolutely every one of your renders or scenes, but consider it next time you produce an image or composition. Key terms to research for additional information include: the rule of thirds, the golden ratio, and the golden rectangle.

Figure 8.41

Figure 8.42

Lighting and three-point lighting

The three-point lighting technique is another well-documented technique widely used in games, television, film, and digital media. It is a very simple but effective method of lighting a scene, which often forms the basis of most lighting.

The reason that it is so widely used is that the artist, photographer, or game designer can illuminate the subject (in our case, our future commando) while controlling or almost completely illuminating any shadows produced by direct lighting—giving us full control over how our character looks.

The technique is called "three-point" lighting (as you may have guessed) because it uses three main lights. These three lights are the key light, the fill light, and the back light. I'll explain how each one works and what it is used for.

The "key" light is the main light in the scene, as its name suggests. This light is usually the strongest in the scene and shines directly on the subject, serving as its key illuminator. The intensity, color, and angle of this light set the lighting in the scene.

Next is the "fill" light. This light is the secondary one, which is usually placed on the opposite side from the key light, illuminating the shaded areas on the front of the subject created by the key light (such as the shadow cast by a subject's nose). This light is less intense than the key light and softer (often half as much), and is used more as a flood. Not using a fill light often creates very sharp contrasting shadows from the key light.

Finally, we have the "back" light. This is also known as the "rim" or "hair" light. This is normally placed at the rear of the subject, and rather than providing direct lighting (as the key and fill lights do), it is used to create subtle highlights and definition around the subjects' outlines. These are normally used to lift the characters away from the background they are standing against and to provide a stronger three-dimensional look.

Here's how the lights look from above, looking at our future commando soldier:

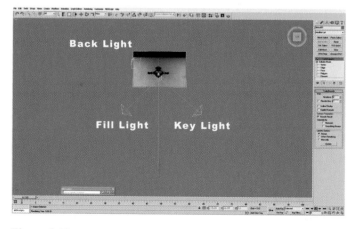

Figure 8.43

On this occasion, to give you something else to think about, I set the key light to yellow and the fill light to blue, which gives a very subtle warmth to the render.

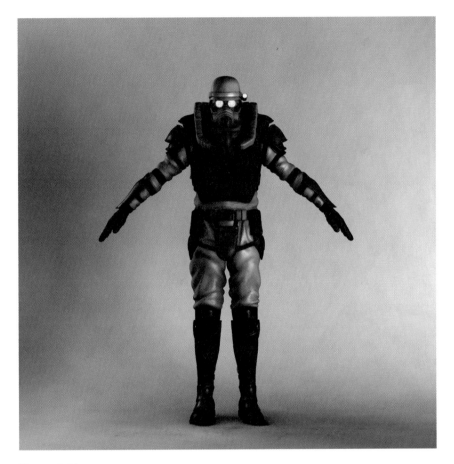

Figure 8.44

Do a little Internet research for other lighting combinations, too. There is a four-point lighting technique that we could have used for this render; do your research and see how different people use different techniques form different industries.

Moving Forwards

Congratulations, you've completed the tutorials! Well done, I'm really impressed that you got through to the end. Now that you have the basic skills, try to build on them. Use the Internet to find more tutorials and talk to people on forums—you'll get lots of help, if you look for it.

I'll be adding a few new tutorials on the Web site to accompany the book—www.3d-for-games.com—so come and visit. I will be giving stuff away regularly to help you on your way and I have a few friends lined up to teach you even more.

It would be great if you also send in some of your work. I'll post it online for people to comment on to help you out.

The final chapter is about getting all your work together into a portfolio and getting ready for interviews—assuming that you want a job in the games industry.

Congratulations once again and I hope to hear from you soon.

Chapter 9

Portfolio and Interview

Portfolio

If you've been through the whole book, you've created some images and learned how to render them, so you've got yourself a portfolio, right? Wrong! The first rule about putting a portfolio together is that ***the work must be your own***. I've put this in emphasized type, because it is the single most important rule when sending off your portfolio and applying for a job.

It's okay to show your friends and family all the great renders that you've created by working through this book, but if you're going to send work off to a professional reviewer, you'll have to throw it all out and start again, from scratch—sorry! The main reasons for this are as follows:

- Although you technically completed the projects in each chapter, don't include them in your portfolio, as it's not all your own work. You'll need to create similar pieces of work based on the skills you've learned. That way, the projects won't be recognized by anyone as a tutorial and will truly be your own creation.
- If the reviewer recognizes one piece of work in your portfolio from a tutorial that they know or a book they own, they will most likely throw the whole portfolio out and you'll never get another chance with them, or possibly even that company, ever again.
- It's important to be original. Recruiters get sent lots and lots of portfolios every day. Although you need to demonstrate that you can do the basics (as covered in this book), you'll need an edge to impress them. Also, if you've bought this book and created a portfolio from it, you probably won't be the only one. So take what you've learned, apply it to a few different models, themes, and subject matter, and create a stunning portfolio of your own work, which you can be truly proud of.

If you feel that you've gone through this book and completed some or even all of the tutorials but you're not quite ready to apply for a job (or don't even want to), then there are a few things that you can do next:

- You can go back through the tutorials that you enjoyed and redo them, this time creating something similar using your own reference or concept material.

- You can browse the texture and reference photo folders included on the DVD and build something from those.
- You can take some of your own reference photos and build something completely new, from scratch.
- You can even create something completely new that you can't take reference photos of; for example, something futuristic, some inner workings of a machine or animal, or even something fictional.

Your portfolio is your advertisement of your work. It highlights your skill and talent as well as your problem-solving abilities, so have some fun with it. Just remember to include enough of the basics to satisfy the employer. If you're not sure what to include, here's some advice.

What to include in your portfolio

I'm assuming that you want a job in the games industry (or a related industry), due to the title of the book, so I'll base my advice on that assumption. When deciding what people look for when looking at portfolios, I asked a number of industry professionals what they look for. Here are a few things that came up a number of times:

- General artistic ability and command over traditional art principles (drawing and sketching, especially)
- Creative ability
- Strong original ideas
- Controlled and manageable topology and good UV layout
- Attention to detail and good observational skills (including technical detail: naming conventions, pivot points, file formats, and so on)
- Good variety of work

The bottom line is to include only your very best work. If you have only five good pieces of work, then that's all that should be in your portfolio. Padding your portfolio out with everything you have ever done not only reduces the overall quality of your portfolio, but also advertises every single mistake you've ever made—not what you want to be doing. So, be strict and include only work that you believe to be flawless. Ask yourself, "Is this the best I can do, or are there any small improvements that I can make?" If there are, do them; it's really important not to rush getting this together. A rushed portfolio can hold you back for many years. If you've included only your very best work so far, you may have only a few renders. As you flick through them, the small number of pieces may be the catalyst you need to buckle down and produce some more work. If not, it should be. If your portfolio is brimming with everything you've ever done, you won't feel the same sense of urgency, so try to be aware of what you *really* have, and what you need to do about improving it.

How do you decide what to include? Well, it all depends on the job you want. If all you want to do is model cars and other vehicles, then your portfolio should include a lot of good examples of that—one or two just isn't enough. However, if you're happy to do anything, then you'll need to have a good variety of work. If you're not sure what position you'd like to apply for, here are a few of the more common roles:

- 3D artist (does a bit of everything). This tends to be a more junior role.
- Vehicle artist (depending on the company, this can cover aircraft, military, cars, trains, and sci-fi).

- Character artist (these range from photorealistic, real-world, cartoon, alien). This role can include weighting and rigging, as well as modeling and texturing.
- Environmental or level artist (real-world, alien, cartoon, fictional).
- UI (User Interface artist: the selection screens you navigate between game levels).

If you're still not sure whether you want to specialize in any of the specific roles, keep everything generic at this point and do a bit of everything. Remember that originality is king here. You should create brand new conceptual forms if it allows you to flex your artistic muscles. I would much rather see a beautifully dirty and damaged vehicle for an imaginary sci-fi scene than yet another shiny Ferrari.

Ask for help if you're not sure what your best work is. Luckily, there are lots of forums and galleries to post your work for your fellow artists to critique for you. Two of the most popular are http://www.deviantart.com and http://www.cgsociety.org. Some of the best artists in the industry post work on these web sites, so brace yourself: this is who you're competing with for work. Also, some of the best artists will routinely comment on your work or works in progress and offer valuable advice, which you'd struggle to get anywhere else—and the best thing is that it's *free* advice.

Let's move on to the more difficult question: what you *shouldn't* include.

What not to include

First and foremost, don't include any sloppy work (unmapped polygons, stretched UVs, holes in geometry), because the mistakes will stand out from a mile away and if you haven't spotted such errors in your portfolio, then the reviewer will wonder what your mistakes will be like from day to day and you'll probably be rejected.

Don't include old work. For some reason, a lot of artists feel the need to sign and date their work, especially life drawing. If I see a date on a portfolio piece that's more than a few years old, it makes me wonder, "What have they been doing recently?" If all the work is old, it puts me off. If you must include old work, make sure you remove any dates, or better still, don't add them in the first place. Again, if all your work is too old, you will most probably be rejected.

Unfinished work should not be included, unless it's your latest piece and it's looking really good. I love it when an artist comes for an interview and shows me a piece of work that he has been working on specifically for Evolution Studios or one of the projects we're developing. It's great when a piece of work has been created just for the interview.

Artists do this a lot if there are gaps in their portfolio, when the work they have been doing is a different style or subject matter than the company or role they are applying for, to prove that they can do the job, or even to show how much they want the job. If you do try something like this, casually drop it in at the end, saying something like, "And there's this, which I was working on last night/week while preparing for today; it's not finished, but…" (and then point out what you need to do to round it off). Obviously, only do this with work that is close to completion; otherwise, it will have a negative effect.

I spoke to some of my lead artist contacts in other companies about what they really don't want to see in interviews. Here are some of their responses:

- Clichés (spaceships, Amazonian beauties, churches)
- Sloppy work (unmapped polygons, stretched UVs, poor quality)
- Unfinished work
- Scenes or exercises from books or (worse) from the 3ds Max tutorials

Overall, get as many people to look at your work as you can and listen to what they say to you. If you really like a piece but no one else does, drop it from your portfolio. By all means, keep it in a personal portfolio, but don't send it off to companies or take it to the interview.

One very important point to note is that you should not under any circumstances send original pieces of work—that is, your only hard copy of something you've drawn. These will not be returned to you and you'll lose them forever.

Now that you have an idea of what you want to do, you have to produce the work, or, if you already have it, you get to organize it.

Producing the work

If you feel that you might not have enough good work in your portfolio, you'll need to plan what you need to do. It's really important that you make a plan and stick to it. Some people create lists and work through them from top to bottom, but I prefer to use S.M.A.R.T goals. S.M.A.R.T stands for Specific, Measurable, Achievable, Realistic and Timed. For example, if I'm applying for a new role, I might identify four new pieces that I need to produce for my portfolio, aimed at this new role. Here's how I work out what my goals should be:

- **Specific:** I want to create four new pieces of work similar to (for example) my first portfolio page.
- **Measurable:** I identify the target quality from an existing portfolio piece. I then need to list everything I need to model, texture, compose, light, and render in the scene to hit this level of quality.
- **Achievable:** I take each set of time estimates for the four pieces of work that I intend to build and add rough estimates for each task, in hours. I then add all the estimates for each piece of work and see roughly how long it will take me to make all of them. Once I have this total, I can compare it to the total amount of time that I think I can spend on this work (maybe five hours a day, for example). Comparing these estimates shows me how much work I have to do and how long I have to do it in.
- **Realistic:** If the total of amount of work is less than the time I have to do it in, it's a realistic goal. If it is slightly more, I may decide that if it all goes well, I can probably still do it, so it's still fairly realistic. If the amount of work to do is far more than the amount of time you have, it's an unrealistic goal and you should probably reconsider the amount of work.
- **Timed:** The closing date for applicants for the new role is (in this example) six weeks away, so to be sure I make it on time, I'll plan out four weeks of work.

For this example, if I think each piece will take me approximately two weeks of work, then it's obvious that I don't have the time to do the four pieces I wanted to. In this case, I'll opt for doing two of the pieces or replan the whole lot using a simpler piece of work as the quality bar.

This technique is extremely important when planning any work. Breaking down the tasks into smaller actions makes it easier to estimate accurately, which is very important for hitting deadlines, and also really useful for pricing freelance work as a contractor. To find out more about SMART goals and other planning techniques, try an Internet search—there are plenty of resources that go into planning in a lot more detail.

Now that you have your work, let's organize it.

Organizing the content

If you're sending your work in to studios via email or disc, or if you're compiling a printed portfolio, you must put your very best work first. In a lot of cases, a reviewer might look only at the first couple of pieces, so you have to blow them away with the very first piece. If you don't, you'll be in the trash—it's as simple as that. You can organize your work as simply as a set of images, or a movie, but keep it simple. Finding and downloading strange codecs to view someone's work really puts me off. A lot of people present their website portfolio, but clearly labeled folders of JPEGs work just as well.

This is how it works in some companies. A well-known developing company that makes great games and is advertising for staff might get ten or more show reels or portfolios a day from independent applicants (the number can be even higher, if recruitment agencies are involved). If the Art Manager or Recruiter looks at these once a week, they'll have more than fifty show reels to look through; if they're really busy, as most are, and do this only once a month…well you can do the math.

Whenever I'm faced with such a task, I know that I can spend only a small amount of time on each. If the first few images are well below the standard that we require, I'll make a note "thanks, but no thanks" and move onto the next one. However, if the first few images are good, I'll look a lot further through the portfolio, even if I see a few poor pieces of work, just to make sure that I'm not making a mistake or missing out on finding a good candidate. Often slightly junior members of the team are tasked to filter the applicants first. This may improve your chances if your first few pieces aren't the best, but don't risk it.

As well as putting a few of your best pieces at the start of the portfolio or show reel, you'll need to put some of your best at the end. This will leave the recruiter with a good feeling about your work, improving your chances. I prefer to use fully rendered scenes containing lots of models for the start and end of my portfolio and then focus on individual assets in the middle. I often include wireframes and texture pages as half of the portfolio, so that it is clear how efficiently the models are built and rendered. This is just my preference—have a look at some online portfolios and try to work out why the artist has organized them the way they have.

Final presentation of your portfolio

Once you've produced and organized the work, you need to present it as well as you can. If you are sending in a show reel on disc, it must be in a box, with a cover, and the disc should be either printed or clearly labeled. Both the cover and disc should have your name, your contact details (email and phone number), and also your Web site address. If you are taking in a paper portfolio to show, it should be in a clean binder of a suitable size for your work. I always use two matching leather portfolios for interviews. One is 17 × 22″ (A2) with all my illustration, life drawing, pastel, charcoal, and painting and the other is 11 × 17″ (A3) and has all my

3D modeling shown as full-color renders. The smaller portfolio sometimes has magazine scans of articles and high review scores of the games I've worked on, depending on the role I was applying for. If you're sending a demo reel, always remember to name your files properly—for example, AndrewGahan001.jpg, so that your work can be easily identified if it gets mixed up with someone else's.

If you are scanning or copying work to include in your portfolio, remember to do everything in color. Even pencil drawings should be scanned or photocopied in color, as all the gray tones will be lost if you just use the black and white settings.

Now you have your portfolio sorted out, go ahead and apply for that job.

Applying for a Job

I recommend that you look for your first (or next) job in these two main ways. The first, and the one I recommend the most, is to apply directly to companies that are hiring. To do this, look at the relevant magazines for your country (or the country you want to work in) and browse the advertisements from the companies looking for staff. In the United Kingdom, one of the best for this is *Edge* magazine, which is readily available in newsagents. You can also try looking on the Web sites for companies that you'd like to work for—often there are positions advertised that have not been in the press yet, which might get you a slight head start on the position. There are also a lot of advertisements on various Web sites such as http://www.gamasutra.com and http://www.gamesindustry.biz; just search for "games industry +jobs" in any major search engine and you'll find lots of positions advertised.

Which leads me to the second method of finding out who's hiring and the approach to take if your direct applications don't get you the results that you want. Again, look through the relevant trade magazines or Internet search engines, but this time, concentrate on all the recruitment agencies. You will probably find these a lot easier to find than the actual companies. Browse through their listings. If there is something specific that you like the look of, drop them a line or apply direct through the Web site. If there isn't, send an email with the sort of position you're looking for.

You'll find that the second method might get you more responses, but possibly not be for the exact job you want. The recruitment agencies will often fire off your CV and show reel to every company on their books and get you lots of interviews. On the other hand, you might end up in a pile of other artists while the agency does all the hard work to place the more senior jobs. Remember, interviews cost money to attend, so take care how many you agree to attend and if you are invited to one, ask if they'll pay your expenses. In a lot of cases, they will.

The recruitment agencies work on commission and they will charge from 10 percent up to 30 percent of your starting salary to the company hiring you. For this reason alone, a lot of companies will not use them, so do your research and find out which companies do.

The most important thing you need to do with recruitment agencies is to keep calling them every week and ask for an update. If you don't, you might get lost in paperwork.

Finally, if you're going to start applying, you're going to need a résumé or curriculum vitae.

Résumé or curriculum vitae and cover letter

Every good job application should come with a cover letter, a résumé or curriculum vitate (CV), and a show reel or demo disc. Let's look at them in a little more detail.

A cover letter

The cover letter is your way of introducing yourself to the company and should explain why you want this particular job. It should give the employer some insight into your desire and your personality. It should be no more than one page long and should describe how you are qualified for the position. This is a good opportunity to make an impression and maybe stand out from the crowd. This is also a good opportunity to make a bad impression, so be careful what you write. A letter that lacks specifics about the position or company that you're applying to will look like a mass mailing and will show lack of effort and thought. Always use a spellchecker on all your text; spelling mistakes show that you have poor attention to detail—this really does matter. Also ask someone you trust to proofread your letter, as they may see grammatical errors that you missed, which must be corrected.

Résumé/CV

A résumé or curriculum vitae (CV) is a list of your skills, experience, interests, and successes; nothing more. It should not contain page after page of detail about your hobbies or spare time and it should not be used as an opportunity to hype every single thing you've ever done. A good résumé will be easy to read and no more than two pages (maybe three if you have had a lot of relevant experience). It should have lots of open space and be presented in a clear, easy-to-read font such as 12-point Arial. You should print it on good-quality paper and put it in a matching envelope. Recruitment agencies routinely take personal information off CVs when they send them out; this often messes up the formatting, making them difficult to read. Obviously, if you apply for positions personally, you get full control over how you are presented. Also, it's important not to go mad with jazzy paper and gimmicks—we've seen them all before and are not usually impressed by anything that is supposed to shock or amaze us.

You can use the following checklist to produce a good CV directly:

- Contact information (phone numbers, email address, and mailing address)
- Objective (the exact position to which you are applying)
- Experience (employment dates, job titles, and brief descriptions of responsibilities)
- Skills (Maya, 3ds Max, Photoshop, Illustrator, and so on, including version numbers)
- Education (degrees, certifications, and additional training)
- Other relevant skills (related skills, personal successes)

There is also a mountain of free advice on the Internet for creating good CVs and résumés. Just search for "CV or résumé" and you'll find a lot more detailed advice.

One important point about your contact information is that if you are currently using an email address that you set up in college that is something like biggy69@hotmail or sexyboy1980@yahoo, then you'll need to change it to something more professional. You should definitely have your own Web site when looking for a

job, even if it's just a one-page résumé that you're putting online. It is so cheap to create and maintain a Web site these days that it's pretty much a no-brainer. In addition to letting you circulate your name and qualifications worldwide, it's also a permanent email address for life, which is important: you're permanently reachable through you@you.com instead of having to rely on a hotmail address. It comes off as very professional and shows good thought and consideration.

The best thing to do is to register a Web domain that is your name or similar and generate a new email address using the new domain. You should also get a Web site hosted on this domain showcasing your best work (your portfolio) and any new work that you complete. There are loads of cheap Web hosting organizations (I use http://www.streamline.net) and if you're not a web developer or don't know anyone who is, you can get cheap Web sites done for you by using http://www.elance.com or by getting your local web developer to put together a single-page site. If you do put your own Web site together, always remember to use images to show your email address or contact number—this will cut down on the amount of spam you get from bots searching your site for contact information.

At the interview

There is a wealth of advice available about interviews, techniques, and what you should and shouldn't do, but here are a few key points directed to the creative industry in general, and more specifically, the games industry:

- *Preparation.* Preparation is extremely important and will give you some confidence in the interview. Know the company you are applying to. Find out what games they've made, who the key staff are, and especially, what they are working on now. If you can't find out what they are currently working on, the project must be unannounced, which gives you a great question in the interview.

- *Arrive on time.* You're going to meet some very busy people and they will not be amused if you're late. If you have to be late, make sure you that telephone in as soon as you know and give them a realistic time when you're going to arrive. This will give them time to reschedule. If you're late and you don't call, you may miss your slot completely and it will be a wasted journey. Also, don't arrive too early. I've had applicants turn up one and a half hours early, which really put me on the spot. Do I leave them sitting in reception for 90 mins for a receptionist to look after or do I reschedule half my day? Either way it is a hassle that you don't want to cause anyone.

- *First impressions are lasting impressions.* You will never get a second chance to make a first impression, so try to get it right. First, smile when you are introduced; it will get you off to a good start. A firm handshake is next—not a vice-like grip or a clammy wet lettuce, just short and firm. If you're really nervous and your hands are sweating, ask the receptionist where the restrooms are and freshen up before you meet anyone. Dress is also important. You'll need to look professional. Wear a nice long-sleeved shirt, some smart/casual trousers, and some clean shoes. As it's the creative industry, most people will be very casual, but don't assume that the people interviewing you will be. They are likely to be fairly senior staff and may well be very tailored. You can dress down once you have the job. Finally, use eye contact, but don't glare. Keeping eye contact will make you look more confident than you may feel. If two people are interviewing you, it's easier, as you can switch between them. If you talk to people while looking away, they might think that you lack confidence or even interest.

- *Listen.* I realize that this sounds obvious, but it's really important to listen to the questions you are being asked before you answer them. Wait until the interviewer has finished speaking and then answer that question only, without waffling. Your answers should probably be only a couple of minutes long. Remember not to talk too much, too.

- *Stay positive.* Sometimes an interview feels like it's not going well, but as you can't be sure, you need to stay positive and enthusiastic. It's okay if you're asked a particularly difficult question and you don't answer it very well; just move on and focus on your successes and all the great work in your portfolio.

- *Ask questions.* If you can get a couple of good questions in early, without coming across as pushy, you will be able to tailor some of your responses to suit what the interviewer is looking for. Here are two good examples of questions you could ask:
 What would be my responsibilities if I were to get the position?
 What qualities are you looking for in the ideal candidate?
 Try to keep a good dialogue going, as well as answering the questions, and try to ask some of your own—don't just leave them to the end.

- *Be honest.* It's very important to be honest in interviews, as well as on CVs. A lot of companies check references and career histories to make sure that candidates have actually done what they say they have. A friend of mine told me that he did a background check on someone he had just interviewed and discovered that he's lied about a role on his CV. Although the candidate was very talented and would have got the job without the lie, my friend could not trust him and didn't make him any offers. It's a common myth that most people lie on their CVs; they don't and you shouldn't either. If you lack experience, then your work must stand out on its own. If it doesn't, keep working hard, posting on forums, and learning as much as you can. What we do isn't rocket science and if you persevere, you'll get your break into the industry.

There are also a number of things that you shouldn't do, but (skipping the obvious), here are a few essentials:

- *Don't disrespect previous employers, tutors, or colleagues.* One of the best ways of talking yourself out of a job is by saying negative things about previous employers, professors, or colleagues. It won't help you in any way if you do it—so don't.

- *Salary and holidays.* This question comes up more than any other when I ask junior artists if they have any questions for me. Obviously salary and holidays are important, but don't bring it up unless they do. Besides, you can always call the HR representative of the company or whoever booked the interview once you know that they like you or in the second interview.

- *Have some questions prepared.* It is not a good sign when I ask a candidate if he or she has any other questions, and the candidate says, "No." If you've prepared for the interview, which you definitely should have, you should be able to ask the interviewer a series of good questions about the company, the direction it's going in, expansion, new projects, or whatever. If you have nothing to ask, it shows that you haven't done your homework, you're not interested enough in the job, and that you're wasting everyone's time.

- Don't forget to follow up. Even if you think that you made a complete disaster of the interview, don't forget to follow up with a written note thanking everyone for the interview and reiterating your interest in the position and the company.

If after doing all of this, you are still rejected, don't take it too personally and don't see it as failure. It's just a result; not the result you were looking for, but a result that you can learn from. I have had artists apply to me more than once and in some cases, I have hired them the second time around. There are a number of reasons why you weren't picked for the role, but if you keep improving and working as hard as you can, you'll get there.

Congratulations on completing the book! Good luck, and don't forget to check out more advice and tutorials on http://www.3d-for-games.com.

Gallery

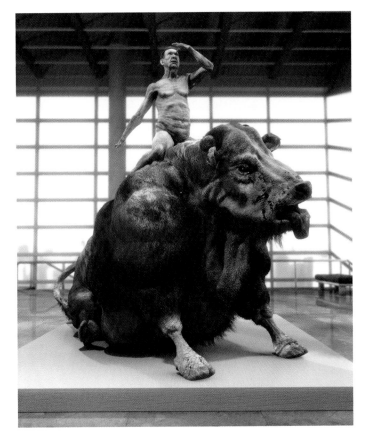

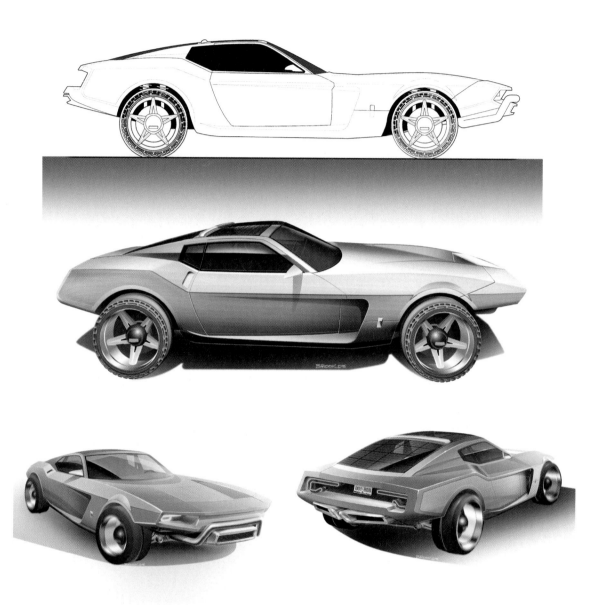

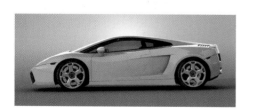

Dark Elf Scout - Game Character

High Poly for Normal generation

Low Poly 8000 Triangles

Game Ready Low Poly with Materials

Index

Index

Index

Index

Index

Index

Index

Index

Index